Walker Evans & COMPANY

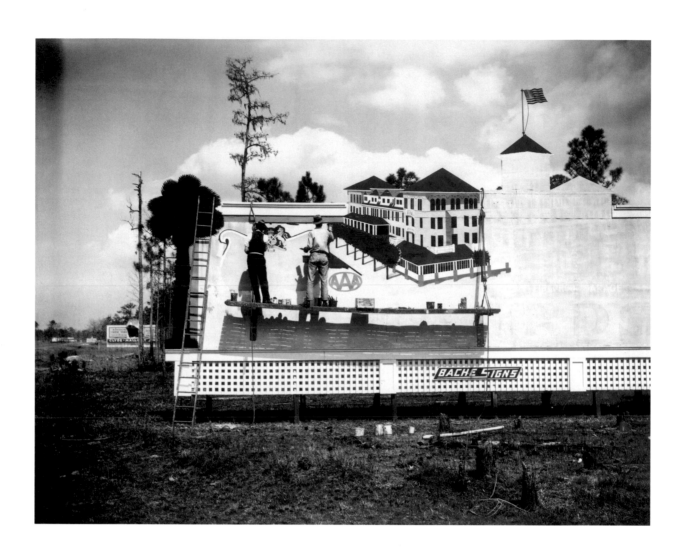

Peter Galassi

Walker Evans & COMPANY

The Museum of Modern Art, New York
Distributed by Harry N. Abrams, Inc., New York

Published on the occasion of the exhibition
Walker Evans & COMPANY, organized by Peter Galassi,
Chief Curator, Department of Photography,
The Museum of Modern Art, New York, March 16–July 26, 2000.

This exhibition travels to the J. Paul Getty Museum, Los Angeles,
California, July 10–September 16, 2001.

This publication and the exhibition it accompanies are part of
MoMA2000, which is made possible by The Starr Foundation.

Generous support is provided by Agnes Gund and Daniel
Shapiro in memory of Louise Reinhardt Smith.

The Museum gratefully acknowledges the assistance of the
Contemporary Exhibition Fund of The Museum of Modern
Art, established with gifts from Lily Auchincloss, Agnes Gund
and Daniel Shapiro, and Jo Carole and Ronald S. Lauder.

Additional funding is provided by the National Endowment
for the Arts and by The Contemporary Arts Council and The
Junior Associates of The Museum of Modern Art.

Education programs accompanying *MoMA2000* are made
possible by Paribas.

The interactive environment of *Making Choices* is supported
by the Rockefeller Brothers Fund.

Web/kiosk content management software provided by SohoNet.

Produced by the Department of Publications,
The Museum of Modern Art, New York

Edited by David Frankel
Designed by Ed Pusz
Production by Marc Sapir with Christina Grillo
Printed and bound by Stamperia Valdonega S.R.L., Verona, Italy

Published by The Museum of Modern Art
11 West 53 Street, New York, New York 10019 (www. moma.org)

Clothbound edition distributed in the United States and Canada
by Harry N. Abrams, Inc., New York (www.abramsbooks.com)
Clothbound edition distributed outside the United States and
Canada by Thames & Hudson, Ltd, London

Library of Congress Catalogue Card Number **00-130309**
ISBN 0-87070-032-4 (clothbound, MoMA/Thames & Hudson)
ISBN 0-8109-6206-3 (clothbound, Abrams)
ISBN 0-87070-036-7 (paperbound, MoMA)

FRONT COVER: Walker Evans. *Torn Movie Poster*. 1930.
Gelatin silver print, 6⅜ x 4⅜ in. (16.2 x 11.2 cm). The Museum
of Modern Art, New York. Purchase. Detail of plate 258

BACK COVER: Robert Rauschenberg. *First Landing Jump*. 1961.
Combine painting: cloth, metal, leather, electric fixture, cable,
and oil paint on composition board; overall, including auto-
mobile tire and wooden plank on floor, 7 ft. 5⅛ in. x 6 ft. x 8⅞
in. (226.3 x 182.8 x 22.5 cm). The Museum of Modern Art,
New York. Gift of Philip Johnson

FRONTISPIECE: Walker Evans. *Billboard Painters, Florida*. c. 1934.
Gelatin silver print, printed c. 1970, 7½ x 8⅞ in. (19 x 22.5 cm).
The Museum of Modern Art, New York. David H. McAlpin Fund

Printed in Italy

Contents

Foreword

Under the banner *MoMA2000*, The Museum of Modern Art has engaged in a wide-ranging exploration of modern art through its own collections, in the form of a series of exhibitions, publications, and other initiatives over a seventeen-month period from the fall of 1999 to early 2001. *Walker Evans & Company* is part of the second of the three cycles that constitute this ambitious project. Titled *Making Choices*, this cycle focuses on the years between 1920 and 1960.

All museums are places where art meets its audience. The Museum of Modern Art is also and distinctively a place where the art of the present engages the art of the immediate past. Neither of these relationships is fixed; indeed their vitality arises from constant change. The fundamental purpose of the Museum's collection is to provide the essential locus of inquiry that fosters such change. The collection honors the creativity of artists by preserving outstanding works of art and by bringing them to a broad public; it reflects the efforts of the curators and patrons who have shaped and continue to shape it; and, most important of all, it invites everyone to enjoy and to consider and endlessly reconsider the unfolding adventure of modern art. As we embark on a new century and as the Museum prepares for a major architectural reconstruction, scheduled to begin in 2001, *MoMA2000* renews that invitation by exploring the collection in a vigorously experimental spirit. *Walker Evans & Company* delves deeply into the collection to draw lively relationships among works from a broad range of dates, mediums, styles, and sensibilities. By approaching artistic tradition as an open question, Peter Galassi, Chief Curator of the Museum's Department of Photography, encourages us all to do the same.

All of the exhibitions that constitute *MoMA2000* draw upon the resources and able staff of the entire Museum, including its departments of conservation, education, exhibitions, and publications, and its library and archives, as well as its six curatorial departments. The project has been shaped by the leadership of the Museum's chief curators—Mary Lea Bandy, Film and Video; John Elderfield, Chief Curator at Large; Peter Galassi, Photography; Terence Riley, Architecture and Design; Margit Rowell, Drawings; Kirk Varnedoe, Painting and Sculpture; and Deborah Wye, Prints and Illustrated Books. Its overall coordination has been provided by John Elderfield (from 1996 to 1998) and Mary Lea Bandy (since 1999) in the capacity of Deputy Director for Curatorial Affairs; and by Beatrice Kernan, Assistant Deputy Director for Curatorial Affairs, assisted by Sharon Dec and Amy Romesburg; working closely with Jennifer Russell, Deputy Director for Exhibitions and Collection Support; Michael Maegraith, Publisher; and Jerome Neuner, Director of Exhibition Design and Production. *Making Choices* has been directed by Peter Galassi; Robert Storr, Senior Curator, and Anne Umland, Associate Curator, Department of Painting and Sculpture; with Beth Handler, Curatorial Assistant, and Carina Evangelista, Research Assistant, Department of Painting and Sculpture; and Josiana Bianchi, Public Programs Coordinator, Department of Education.

—Glenn D. Lowry
Director, The Museum of Modern Art

Preface and Acknowledgments

Walker Evans & Company aims to encourage curiosity about a crucial innovation within the tradition of modernist photography that took shape in the 1920s and 1930s—the idea of an art based forthrightly on photography's appetite for recording fact. I say forthrightly, but this bold and apparently simple idea was and remains challenging. Perhaps part of the reason is that, in opening the full range of the medium's descriptive capacities to artistic experiment, the new art abandoned flourishes of craft or style that would readily distinguish artistic experiments from ordinary photographic documents. This strategy has been enormously fruitful, but it puts quite a burden on the viewer.

Walker Evans helped to initiate the modern art of descriptive photography, and his work provides the focus of this book, but his pictures are heavily outnumbered here by the works of over 100 other artists. For the goal is not so much to celebrate Evans's achievement as to explore in some depth what has become an accomplished and sophisticated tradition. This goal has meshed neatly with the goal of exploring the rich photography collection of The Museum of Modern Art, which began to acquire photographs in 1930, not long after Evans began to make them.

The establishment of the collection was in itself forward-looking, but more prescient still was the idea of forming such a collection within a museum devoted broadly to modern art. A third goal of *Walker Evans & Company*, then, has been to draw on the resource of the Museum's diverse holdings to consider some significant aspects of photography's relationships to the other visual arts. (Only some, however; the book does touch on the relationship between photography and filmmaking, for example, but in doing so only hints at a fascinating and complex subject.)

That third goal merged with a fourth and final one, which was to tinker with the notion of tradition. The range of that tinkering was defined at one end by clear cases of what is generally called "influence"—one artist's creative response to the work of another. Such instances are the basic building blocks of art history, although they come in such obstreperous sizes and shapes that the edifice is always in need of repair. The other extreme of my tinkering involves the pursuit of relationships between works of art that may owe nothing directly to one another but that together provoke us to see each in a new light, and thus to revise our sense of tradition.

Walker Evans & Company belongs to a cycle of exhibitions and publications concentrating on art in all mediums between 1920 and 1960, titled *Making Choices*, which in turn is part of a museum-wide exploration of modern art through the Museum's collection, titled *MoMA2000*. As we pursued this experiment, my colleagues and I repeatedly discovered that the refreshing challenge of drawing diverse works of art into juxtaposition is a perilous business: the results may seem capricious rather than instructive, and in fact may diminish rather than enlarge our sense of each work. That discovery renewed my admiration for the installations of the Ydessa Hendeles Art Foundation in Toronto, which since 1988 has regularly brought together bodies of very different work by very different artists. Where many such attempts can appear at once timid and tendentious, Ydessa Hendeles's exhibitions (one of which prominently included the work of Walker Evans) have been bold and illuminating. They and my conversations with their creator, and with photographers Philip-Lorca diCorcia, Lee Friedlander, and Michael Schmidt, have nourished the development of *Walker Evans & Company*.

This book accompanies an exhibition that bears the same title, but the contents of the two are not the same. Aiming to stress the richness and complexity of tradition, the book includes many more works than could be presented in the exhibition, and I apologize to those artists whose works I have reproduced in the book but am unable to hang on the wall. In addition, the book exploits the capacity of reproduction to juxtapose works that are very different in size. On the other hand, an exhibition permits a more fluid configuration than does the rigid linear structure of a book—an important feature of a project that aims to suggest simultaneously a variety of parallel and overlapping relationships.

In recent years, authors of books and organizers of exhibitions have seemed to compile ever-longer lists of acknowledgments. In many ways this is an admirable trend, but for my taste the lists are never long enough. Here, to begin, I wish to salute Vincent Magorrian, who keeps the Museum's building running so well that no one needs to notice how hard his job is; Peter Geraci, who lights our exhibitions with an artist's sensitivity to the works and their audience; Lee Ann Daffner, who last year became the Museum's first permanent Conservator of Photographs, and who has enhanced our understanding of our photographs as well as their care; Mark Steigelman, who will help shape the design of the *Walker Evans & Company* exhibition and will oversee the installation of the works; Claire Corey, who as part of the graphics team for *Making Choices* has construed a daunting logistical problem as an opportunity for good design; Elizabeth Peterson, without whose

able assistance the Deputy Director for Exhibitions and Collection Support might reasonably have concluded that the outlook was hopeless; Willo Stuart and Christina Ochs, who efficiently and cheerfully run the office of the Department of Photography despite the many failings of its chief curator; and the entire security staff, under the direction of Ron Simoncini, who keep a great collection safe. But this is only the barest of beginnings. The plain fact is that the Museum is a big and complicated place, and virtually every aspect of its program depends in one way or another upon the dedication, skill, and good humor of the hundreds of people who work here. I thank all of them enthusiastically, and I regret the necessity of thanking them collectively.

Allow me now to stress the depth of my obligation to two smaller groups within the Museum. First, I owe to Glenn Lowry and my curatorial colleagues the opportunity to explore the entire range of the collection, with all the expert advice anyone could ask for, and with the freedom to make my own mistakes. In helping to organize *Making Choices*, I was blessed to collaborate with a splendid team— Josiana Bianchi, Carina Evangelista, Beth Handler, Robert Storr, and Anne Umland. The heaviest responsibilities fell upon Beth Handler, who dispatched them brilliantly.

The book you hold in your hands would not exist without the sustained efforts of Michael Maegraith, Publisher, and it would be rather less successful in approaching its aims without the wisdom and imagination that he brought to it. I cannot note the thoughtful help of John Szarkowski, Director Emeritus, Department of Photography, without also acknowledging the enormous contribution he has made to all of my work, and indeed to the work of any serious student of the art of photography. Most of the photographs in this book were reproduced from direct digital scans made at the Museum under a program established by Linda Serenson Colet together with Mikki Carpenter, Kate Keller, and Eric Landsberg. For their superb work in the face of the heavy scanning demands of this book, I thank Sarah Hermanson, Kimberly Pancoast, Kelly Benjamin, and Tina Gauthier.

Finally, four people played instrumental roles in the creation of the book, and I wish to highlight their contributions without suggesting that the faults of the book belong to anyone but me. Readers will recognize for themselves the elegance and efficiency of Ed Pusz's design, but only I can appreciate the skill with which he made many nasty problems disappear. All four of my collaborators suffered under the pressure of deadlines made still more unpleasant by the author's failure to meet them; Marc Sapir, who supervised the production of the book, got the worst of things and nonetheless achieved admirably faithful reproductions of a very wide range of works. David Frankel, whose outstanding qualities as an editor clearly reflect his outstanding qualities as a writer, did more than a fine job of editing the book; he helped me discover what it was about. Virginia Heckert, Beaumont and Nancy Newhall Curatorial Fellow in the Department of Photography and a seasoned scholar, masterfully oversaw the entire project and every one of its countless details. I am deeply grateful to these four people.

—P. G.

Introduction

Peter Sekaer. *Walker Evans*. 1935–36. Gelatin silver print, 8¹⁵⁄₁₆ x 6¹¹⁄₁₆ in. (22.7 x 17 cm). The Museum of Modern Art, New York. Gift of Dorothy Miller

Tradition resides in every work of art, for all art must begin somewhere. Tradition also resides in the eye of the beholder, who brings to each new work the experience of other works. And tradition implies community; our perpetually unfinished arguments over the art of the past are the proof of its vitality.

Our sense of what art has been offers our only definition of what art can be, so both are always changing. As T. S. Eliot famously observed eighty years ago, genuinely new art inflects our understanding of the past as it proposes a different future:

The existing order is complete before the new work arrives; for order to persist after the supervention of novelty, the *whole* existing order must be, if ever so slightly, altered; and so the relations, proportions, values of each work of art toward the whole are readjusted. . . . Whoever has approved this idea of order . . . will not find it preposterous that the past should be altered by the present as much as the present is directed by the past.[1]

This book is an experiment in mapping the changing order of tradition. The text identifies some key landmarks, but the map itself is composed of works of art. The focal point is the work of the great American photographer Walker Evans, who was born in 1903 and did most of his best work in the 1930s. The book also reproduces a modest number of earlier works by other artists, chosen to represent fruitful precedents, and a larger number of later works, which together trace paths of creative tradition extending from Evans's art toward the present. The reproductions are arranged in ten sections or chapters, the first two devoted to American vernacular photography before 1930 and to the work of Eugène Atget, both of which helped Evans to define his sense of photography's possibilities. Each of the remaining eight chapters is organized around a single dimension of Evans's work. Some of

these sections open with a few examples of relevant precedents (mostly but not exclusively photographs). All of them include a group of photographs by Evans followed by a roughly chronological sequence of works by other artists (again, mostly photographs) that elaborate, transform, or otherwise resonate with a particular aspect of Evans's art.

In other words, the first two sections are a prelude. Thereafter the reader is asked to travel the same terrain—roughly from the 1930s to the 1970s, with occasional forays into the 1990s—eight times, each time following a different path. There are two goals: to explore the unfolding of tradition, and to harness tradition as a critical tool for exploring Evans's art.

Eliot's essay expressed an ideal image of a tradition shared by all artists and beholders of a single—European and American—community. Like all books, *Walker Evans & Company* addresses a community, but it acknowledges a less cohesive and more contentious pattern of tradition. It presumes not only that each artist must chart his or her own useful past but that each beholder must do so as well, provisionally drawing together threads that have been separately spun.

<center>* * *</center>

Walker Evans formed a powerful artistic ambition while he was still a teenager. He wanted fiercely to become a writer of fiction, but admired the works of his heroes so deeply that he judged his own efforts to be hopeless. In 1928, at the age of twenty-five, he turned improbably and at first tentatively to photography. By 1931 he had made a number of pictures that would survive among his best, and he had sketched out the entire range of his work. Thereafter he significantly enriched and deepened his artistic vision but did not substantially revise it. Nor was his active career very long: although he continued to photograph intermittently until his death, in 1975, his essential achievement was complete by 1941.

When Evans abandoned literature for photography, he exchanged a crowded creative arena for one relatively unencumbered by recognized achievement. Indeed the idea that a photograph could be a work of art was barely older than Evans himself, and in the United States it owed its fragile currency largely to the determined campaign of one man: Alfred Stieglitz. Stieglitz had not argued that *all* photographs were works of art, for such a claim would have been absurd. By 1900, photographs were both ordinary and ubiquitous—in commerce and journalism, advertising and industry, tourism and science, and in countless family albums. Some photographs even sported modest pretensions as artful illustrations. That was not good enough for Stieglitz, who aimed to erect an uncrossable barrier between photography's prospects as a high art and the undisciplined mass of its practical applications. As his ally Charles Caffin put it in 1901, "There are two distinct roads in photography—the utilitarian and the aesthetic: the goal of the one being a record of facts, and the other an expression of beauty."[2]

In his own work Stieglitz repeatedly blurred the distinction that Caffin drew so clearly, but for the movement that Stieglitz championed, renunciation of fact was indeed indispensable to the pursuit of beauty. The Pictorialist photographers, as they called themselves, purged their pictures of unwanted detail in favor of

1. T. S. Eliot, "Tradition and the Individual Talent," 1919, in *Selected Prose of T. S. Eliot*, ed. Frank Kermode (New York: Harcourt Brace & Company, 1975), pp. 38–39.

2. Charles Caffin, *Photography as a Fine Art*, 1901 (reprint ed. Hastings-on-Hudson, New York: Morgan & Morgan, 1971), p. 9.

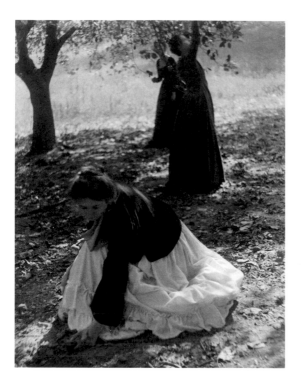

Fig. 1. Clarence H. White. *In the Orchard*. 1902. Platinum print, 9⅜ x 7½ in. (23.7 x 19 cm). The Museum of Modern Art, New York. Gift of Mrs. Clarence H. White

pleasing patterns of light and shadow. And they retreated from the world of industry and commerce that was so thoroughly implicated in "utilitarian" photography, seeking beauty in nature and among the comforting enclosures of bourgeois domesticity (fig. 1). By the 1920s this tradition was sufficiently mature to sustain a stylistic revolution. Crisply focused studies of vegetables and plants by Edward Weston and Paul Strand (fig. 2), and Stieglitz's own newly adventurous work at his Lake George estate, swept away the painterly effects and moody chiaroscuro of the turn of the century, presenting themselves as embodiments of purely photographic vision. But despite its distinctly modernist ambition, the new style preserved the underpinnings of photography's precarious identity as a fine art: a posture of withdrawal from the modern world, an adherence to a handful of privileged themes, a fetish of pictorial perfection, a devotion to beauty.

With the necessary arrogance and protective anonymity of youth, Evans seized upon the idea of photography as art and set about overturning the aesthetic that had been erected in its name. His plain, uninflected style appeared artless next to the polish and panache of the Stieglitz school. His roster of aggressively ordinary subjects—a gas station, a billboard, a shard of junk, an unexceptional citizen on the street—exploded the protected domain of timeless artistic themes. In place of the posture of reverent surrender before an ideal, his photographs addressed the messy contemporary world with restless curiosity.

In all of these respects Evans's work of the 1930s was enormously influential, and it eventually fostered a robust alternative to the Stieglitz school. The new tradition aimed to engage experience rather than to cultivate perfection. Instead of seeking universal ideals, it explored the contingent particulars of modern life. Instead of looking inward, it looked outward.

*　　*　　*

Implicit in the contrast between the work of Stieglitz and the work of Evans was a conflict between two divergent conceptions of the art of photography. For Stieglitz, the artistic photograph was the enemy of the mundane document. For Evans— and for the tradition that followed upon his work—photography's richest potentials as an art lay precisely in its capacity for recording fact, however mundane that fact might be.

Such an expansive definition of Evans's artistic legacy is useful, or justifiable, only if it is paired with an equally expansive definition of his creative inheritance. To celebrate Evans as an influential pioneer is at the same time to recognize him as the fortunate beneficiary of an artistic potential that was latent in photography at its invention. And in both roles he was not alone.

In seeking an alternative to what he regarded as the cloistered pretensions of the Stieglitz school, Evans turned to photography's plainspoken vernacular—a sprawling, unexamined archive that stretched from solemn records of the Civil War to the cheap picture postcards with which every American town had announced its civic pride at the turn of the century (plates 1–12). In between were the unclassified documents of the real estate agent, the engineer, the salesman, the newspaper hack, the small-town photographer, and the tour conductor. What

these pictures lacked in conventional artistic refinement they repaid in abundant example for the unconventional photographer who perceived in them the grammar of a new art.

Ever since the invention of photography, the popular imagination has construed the photograph as a transparent window on the world. But, as just about everyone who has made a snapshot knows, it is difficult to predict—and still more difficult to control—just how the picture will look. By the time Evans arrived on the scene, countless practical professionals and not a few amateurs had wrestled extensively with this challenge. On occasion the victory of a well-made picture had contained the unexpected reward of transcendent clarity. On occasion an apparent defeat had disclosed the surprise of visual poetry where no one would have thought to look for it. At least so it could seem to an eye that, despite ingrained cultural habit and the fulminations of Stieglitz, regarded photography's appetite for fact as an artistic opportunity.

Evans's appreciation of unvarnished photographic description meshed perfectly with his taste for the unpretentious functional artifacts he often photographed. In both cases, the vernacular appealed to him in part because it was the anonymous expression of a collective culture. At the same time, by casting an artist's eye on photography's vernacular tradition, Evans implicitly prepared himself to recognize within it the work of an artist—a practical photographer who had capitalized upon his unexpected victories and instructive defeats to create an indisputably personal outlook and style. One such photographer was the Frenchman Eugène Atget, who in the four decades before his death in 1927 had extensively photographed the city of Paris. In function his work was no different from countless photographic documents produced by dozens of other professionals. Evans was among the first of a rapidly growing number of artists to perceive that nonetheless Atget's photographs—not just one or a few but the whole large body of them—expressed the unique, articulate voice of a disciplined sensibility (plates 13–26).

It was partly thanks to Atget's example that Evans discovered and progressively exploited the rich artistic potential of descriptive photography. It was partly through Evans's eyes that subsequent photographers and the rest of us discovered and progressively appreciated Atget's creative achievement. These twin discoveries—one prospective, one retrospective—unfolded from a single point that marks an explosive encounter between two mature traditions, which gave birth to a third.

On the one hand was the accumulated practice of applied photography, a tradition of picture-making that was no less mature because it had been overlooked by the keepers of high art. Atget's vision in all its originality and depth was an expression of that maturity—of the tradition's capacity to nourish a remarkable talent. On the other hand was the tradition of avant-garde experiment, which had sustained an anxious, nimble quest for new forms and strategies and conceptions of art equal to the challenges and tribulations of modern experience. In Europe the maturity of the avant-garde—and the destructive folly of the Great War, which had filled many young artists with disgust for all authority and convention—had created an atmosphere in which photography could seem appealing precisely because it was unsullied by the high aspirations of old art.

Fig. 2. Paul Strand. *Leaves II*. 1929. Gelatin silver print, 9% x 7% in. (24.3 x 19.3 cm). The Museum of Modern Art, New York. Gift of Georgia O'Keeffe

As these two traditions collided in the two decades after the war, they generated the beginnings of a new tradition that would embrace descriptive photography as an uncharted artistic adventure. In the years around 1930, André Kertész, Henri Cartier-Bresson, Brassaï, Bill Brandt, and others created original and distinctive bodies of imagery, which collectively posited a conception of photographic art that was simultaneously at work in the experiments of Walker Evans. The literal terms of that art were utterly simple: the photographer chooses something to look at and a particular point in time and space from which to observe it. In practice the operation turned out to be inexhaustibly complex, because, in the resulting photograph, neither term can be defined independently of the other; what is seen and how it is seen are inescapably reciprocal. In the new art, a photographer's image of the world and his or her personal outlook were destined to evolve in tandem.

* * *

In 1971 Evans recalled, "I think I operated in reaction to mediocrity and phoniness. . . . In round terms, I was damn well going to be an artist and I wasn't going to be a businessman. . . . My photography was a semi-conscious reaction against right-thinking and optimism; it was an attack on the establishment."[3] Although Evans did his best work in the 1930s, in the midst of the Great Depression, his personal convictions and artistic outlook were formed in the 1920s, in the midst of unprecedented affluence and untrammeled materialism. "The business of America is business," proclaimed President Calvin Coolidge in 1925.[4] Born to an advertising man and raised in the secure comfort of a Chicago suburb, Evans knew that America intimately and wanted no part of it: "It was very hard to stay outside of the great sweep of material prosperity, which of course fell on its nose in the '30s. . . . It was a hateful society . . . and all authority was almost insulting to a sensitive citizen. . . . You either got into that parade or you got a bum treatment."[5] Evans got out of the parade early, leaving well-heeled Williams College, in Massachusetts, after one year to lead the bohemian life of a would-be writer in New York. In April 1926, with his father's blessing and financial support, he achieved the bohemian's dream of fleeing to Paris. There he acquired, or confirmed, a deep allegiance to European modernism, an attachment that would survive his return to New York a year later and his subsequent decision to give up his literary ambitions. Thus it is no surprise that, when he found his footing as an artist in the late 1920s and early 1930s, his photography found its nearest echoes in the work of young Europeans such as Cartier-Bresson and Brassaï (names he had not yet heard) rather than in the American work he knew and decisively rejected—the high romanticism of Stieglitz and the glittering commercialism of Stieglitz's former acolyte Edward Steichen, who reigned as chief photographer for *Vanity Fair.*

If Evans's tale of struggle against conformity is thoroughly familiar, it is because he was following a pattern first established a century earlier in the city to which he had fled. The avant-garde tradition, with its stress on personal independence, creative dissent, and perpetual invention, had arisen within and against the modern bourgeoisie, that nervous child of industrial and political revolution, and guardian of commerce and conventional morality. For an American nonconformist of the

Fig. 5. Walker Evans. Untitled. c. 1928. Gelatin silver print, 1⁹⁄₁₆ x 2½ in. (4 x 6.3 cm). The Museum of Modern Art, New York. Gift of Dr. Iago Galdston

Fig. 6. Walker Evans. Untitled. c. 1928. Gelatin silver print, 2½ x 1¹¹⁄₁₆ in. (6.3 x 4.2 cm). The Museum of Modern Art, New York. Gift of Dr. Iago Galdston

3. Walker Evans, quoted in Leslie Katz, "Interview with Walker Evans," *Art in America* 59 no. 2 (March–April 1971): 84. This and other published interviews and lectures from the last years of Evans's life are very illuminating. Beyond drawing a handful of quotations from them, I have relied upon them generally for my sense of Evans's views about his own work and other matters. See the Bibliography, pp. 269–70.

4. Calvin Coolidge, quoted in Luc Sante, "A Nation of Pictures," in Peter Galassi, *American Photography 1890–1965 from The Museum of Modern Art, New York*, exh. cat. (New York: The Museum of Modern Art, 1995), p. 48.

5. Evans, "Walker Evans on Himself," ed. Lincoln Caplan, *The New Republic* 175 no. 20 (November 12, 1976): 26.

6. The word "incandescent" is Evans's: "Any man of my age was drawn like a magnet to Paris because that was the incandescent center, the place to be." In "Walker Evans, Visiting Artist: A Transcript of His Discussion with the Students of the University of Michigan," 1971, in Beaumont Newhall, ed., *Photography: Essays & Images* (New York: The Museum of Modern Art, 1980), p. 315.

7. See Katz, "Interview with Walker Evans," p. 84.

1920s, especially one with ambitions as a writer, Paris remained the "incandescent center" of that tradition.[6]

Although Evans admired the work of Marcel Proust, André Gide, and James Joyce (not to mention Eliot, D. H. Lawrence, Virginia Woolf, Ernest Hemingway, and others), he felt closest of all to the nineteenth-century lions of French modernism: Gustave Flaubert and especially Charles Baudelaire. He liked to say that the cool, impersonal style of his mature photography was modeled on Flaubert's clinical method, in which the artist's control is everywhere felt and nowhere perceived. He named Baudelaire as his spiritual guide without ever saying just what he meant—perhaps, among other things, that Baudelaire had made urgent engagement with modern life the calling of the modern artist; perhaps also that the engagement could never achieve comforting completeness, that modern art, like modern life, was destined to remain troubled and uncertain.[7]

Evans's transatlantic inclinations shaped his earliest photographic experiments—essays in a fresh, distinctly European style of mobile viewpoints and angled perspectives, which celebrated photography as a vehicle of modern energy and freedom, and which yielded lively graphic images with a Cubist flavor (e.g., figs. 3–6). Although Evans rapidly outgrew this phase and soon adopted vernacular photography as his principal model, the pictorial vocabularies and aesthetic strategies of European modernism continued to reverberate throughout his mature work. Among these were a mode of observing the social theater of the street, enabled by the agility of hand-held cameras (e.g., plates 121–31); a sense of the image as a shallow field of collagelike patterns (e.g., plates 36, 45, 156, 202, 280); and a taste for the uncanny and bizarre, schooled in Surrealism (e.g., plates 200, 258).

Invigorated by radical inventions in the plastic arts, and seared by the upheavals of war and revolution, advanced European culture of the 1920s had embraced photography as an antidote to refinement and pretension, as the mechanical avatar of modernity, as a fresh field of experiment, and as an anarchic vernacular rooted in the world outside the studio. The open-ended spirit of Europe's overlapping and competing photographic aesthetics, in which the most rarefied formal experiment could be rich in social implication and the most mundane discard of the printed press could be an object of mystery, was the very opposite of Stieglitz's ivory-tower idealism. In this undisciplined atmosphere, the Pandora's box of photography was all the more tempting because no one could be certain just what it contained. The Surrealists, for example, applauded Atget as a passive vessel of the collective unconscious. But once they had brought his work to the attention of advanced culture, others were free to make of it what they would. The American photographer Berenice Abbott owed her acquaintance with Atget to her apprenticeship to Man Ray, the doyen of photographic Surrealism. After rescuing the contents of Atget's studio and returning to the United States, however, she construed his panorama of Paris very differently from the Surrealists, adopting it as the model for her own exploration of the changing fabric of New York. It was upon visiting Abbott in November 1929 that Evans became alert to the implications of Atget's art for his own.

Fig. 7. Eugène Atget. *Austrian Embassy, 57 rue de Varenne.*
1905. Albumen silver print from a glass negative, 6⅞ x 8⅜ in.
(17.5 x 21.4 cm). The Museum of Modern Art, New York.
Abbott-Levy Collection. Partial gift of Shirley C. Burden

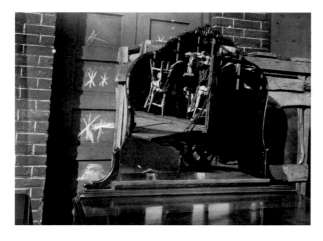

Fig. 8. Walker Evans. *Street Scene, Brooklyn.* c. 1931. Gelatin
silver print, printed c. 1970, 4¹¹⁄₁₆ x 6⁵⁄₁₆ in. (11.9 x 16.9 cm).
The Museum of Modern Art, New York. David H. McAlpin Fund

In late 1931, in a review of recent photography books, Evans cited the work of
Atget, together with the portraits of the German photographer August Sander, as
examples of a "valid flowering" of photography that had recently supplanted the
"peculiar dishonesty" of the aesthetic movement of the turn of the century:
"Suddenly there is a difference between the quaint evocation of the past and a win-
dow looking straight down a stack of decades." For Evans, Sander's book *Antlitz
der Zeit* (*Face of Our Time*),[8] an outline of German society composed of portraits
of representative types, was "a case of the camera looking in the right direction
among people. This is one of the futures of photography foretold by Atget. It is a
photographic editing of society, a clinical process: even enough of a cultural neces-
sity to make one wonder why other so-called advanced countries of the world have
not also been examined and recorded."[9] Among those "so-called advanced coun-
tries" was the United States, and by the time Evans's review appeared he had been
pursuing his own clinical editing of American society for some two years.

This does not mean that he had abandoned art for sociology; it means that he
had begun his mature work as an artist. Atget's example had helped Evans to rec-
ognize that photographic fact could address social reality; it had also helped him to
recognize that photographic perception could embody a personal vision. The
workings of the second lesson are evident in the relationship between one of Atget's
ancien régime interiors (fig. 7) and one of Evans's boldest early experiments (fig. 8).
Here Atget was teaching Evans not so much what to look at as how to see—how to
imagine and master the surprising ways that the world, through photography, may
transform itself into a picture.

Compared to Atget's graceful if mysterious interior, Evans's photograph is a
jarring Cubist collage, and the difference is telling. The distinctness of Atget's vision
had emerged from within his professional competence as a craftsman who satisfied
a broad market for pictures of Paris. Although Evans sometimes took on photo-
graphic commissions to make ends meet, he well knew that the only client his art
must satisfy was himself. Thus he was free to adopt the clinician's pitiless scrutiny
of society, and the whole vocabulary of descriptive photography, in the service of
the inexplicable dictates of his flickering intuitions. The prospect excited Evans so
much that in 1930 he told his friend Lincoln Kirstein that he sometimes thought
he would go mad.[10] The intensity of vision that he sought and repeatedly found
had been described (although without the least thought of photography) by his
hero Baudelaire: "In certain almost supernatural states of being, the depth of life
reveals itself in its entirety in the sight before one's eyes, however ordinary it may
be. The latter becomes the symbol of the former."[11]

* * *

Kirstein put the matter concisely: "Evans' eye is sympathetic to a very special aspect
of a very general material." The "very general material" was American civilization
present and past—any tangible evidence that might bear on the question of who
Americans were and had been. The "very special aspect" is far less easy to summa-
rize because it did not exist in advance of the photographs, even in the mind of
Evans himself. It emerged cumulatively as Evans worked intuitively, finding "the

wavelength of his vision," as Kirstein suggested, by discovering "the images which attract and repel it."[12]

In Evans's America the industrial revolution remains incomplete; his pictures seem to measure the distance between unfolding modernity and the unfinished past. Factories and steel mills appear improbably amid fields and farmhouses. Mass advertising coexists with the folk art of hand-painted signs. A humble row of wooden houses, designed without benefit of architects, has not yet been razed for development (plate 155). A rocking chair lovingly crafted from unmilled saplings sits below an ebullient Santa Claus selling Coca-Cola (plate 201). Through the tall trunks of trees planted to grace the main street of a nineteenth-century town, Evans surveys a veritable assembly line of automobiles, newly gleaming in the rain (plate 87).

In another photograph the cars, so recently new, form a hillside of junk (plate 90). Unfinished as it may be, technological civilization has already left behind a grim record of waste and decay. The picture abruptly deflates the futurist optimism of photography's prevailing image of modernity, which favored the skyscraper and the machine as symbols of progress. Once Evans set aside his early Cubist exercises, the skyscraper disappeared altogether from his work, and we search in vain for an iconic machine, polished and pristine. Instead of picturing an ideal modernity as if from on high, Evans examined the everyday present from the viewpoint of the man in the street.

The man in the street might be going to or coming from a hard day's work in a factory filled with machines or an office filled with telephones. Outside the factory and the office, the face of modern life was the culture of the automobile and the motion picture; after the advent of the railroads in the nineteenth century, and before cheap air travel and television, it was above all through cars and movies that ordinary citizens received the spread of technology. Although both had only recently achieved their universal currency, Evans did not present them as modern wonders, nor celebrate them as popular symbols of freedom and adventure. In his pictures they are taken for granted as part of the fabric of everyday life—typical, inevitable, often somewhat used and worn.

Following his nose rather than the Chamber of Commerce guidebook, Evans noticed things—and people. He noticed a military dandy at a patriotic parade, his mustachioed lip on the verge of a sneer (plate 128). He noticed an aspiring flapper in a chic hat and fashionable fur collar (plate 261). A similar collar is worn more impressively by a young black woman, who regards the white photographer without curiosity (plate 125). Evans may not have been the first American photographer to acknowledge the presence of blacks in American life, but he was the first to take notice of racism as a significant fact of American society. In another picture he confronts the remains of a minstrel-show poster, its buoyant racism rendered all the more hideous by decay (plate 200). It is a ready-made Surrealist collage, a caustic jolt that strikes not at the untended emotions of the unconscious but at the iniquity of unexamined prejudice.

Weather has also worked the surface of a black church in South Carolina (plate 41), but here the peeling paint is a testament to the persevering spirit of the

8. August Sander, *Antlitz der Zeit: Sechzig Aufnahmen deutscher Menschen des 20. Jahrhunderts*, with an introduction by Alfred Döblin (Munich: Transmane Verlag and Kurt Wolff Verlag, 1929; reprint ed. Munich: Schirmer/Mosel, 1976).

9. Evans, "The Reappearance of Photography," *Hound & Horn* 5 no. 1 (October–December 1931): 126, 128.

10. See John Szarkowski, "Introduction," in *Walker Evans*, exh. cat. (New York: The Museum of Modern Art, 1971), p. 13.

11. Baudelaire, "Fusées," in *Oeuvres complètes*, eds. Y.-G. le Dantec and Claude Pichois (Paris: Gallimard, 1961), p. 1,257. My translation from the French; the original reads, "Dans certains états de l'âme presque surnaturels, la profondeur de la vie se révèle tout entière dans le spectacle, si ordinaire qu'il soit, qu'on a sous les yeux. Il en devient le symbole."

12. Lincoln Kirstein, "Photographs of America: Walker Evans," in Evans, *American Photographs*, 1938 (reprint ed. New York: The Museum of Modern Art, 1988), p. 194.

people who crafted such a noble monument from so little. Or so it may seem. In fact, Evans approaches the decaying show bill and the weathered facade with the same blunt frontality. The forthright address of his photography may be interpreted as an uncompromising indictment of an ugly fact or as an admiring regard for a beautiful thing. But his gaze is equally admiring when it looks upon the abandoned grandeur of a Louisiana plantation—a beautiful thing built upon the injustice of slavery (plate 42). The originality of Evans's "clinical editing of society" involved a convergence of critical intelligence and passionate feeling. His skeptical mind rejected conventional taxonomies of American identity; to construct his own, he photographed only what moved him. It might inspire him to wonderment; it might fill him with anger and disgust; it might provoke his sense of humor or his sense of irony, or both. If it left him bored or indifferent, he ignored it. Once his volatile intuition had selected the significant thing, however, he recorded it with the studied indifference of an archaeologist, stripping the image of any pictorial rhetoric that would instruct the viewer how to feel.

Of course, as Evans himself repeatedly insisted, his posture of impersonal neutrality is itself a form of rhetoric, and the austere frontality of his photographs is a style like any other. Modeled upon the clarity of functional photography, Evans's aesthetic aspired to the spare unpretentious honesty that he perceived in the clapboard houses and handmade signs that he often photographed. These artifacts of an indigenous American vernacular lacked both the cultivated flourishes of European design and the polished regularity of mass commerce. To Evans, their imperfections were cherished expressions of a collective identity composed of resolutely self-reliant individuals.

Evans's strain of retrospective admiration for Puritan fortitude is easily misread as a stoic answer to the hardscrabble 1930s. While he soberly recognized the trials of deprivation, and suffered them himself, he also welcomed the Depression as a rebuke to the false materialism of the 1920s. Recalling the stock market crash of 1929, he later remarked, "That awful society well deserved it. I used to jump for joy when I read of some of those stock brokers jumping out of windows!"[13] To Evans, part of the appeal of the vernacular past was its value as an authentic counterweight to dishonest profligacy. This was as much, perhaps more, an artistic attitude as a moral one. Toward the end of his life he explained to a group of students, "Prosperity is my aesthetic enemy!"[14]

Collected in isolation, some of Evans's photographs may suggest a comforting retreat into a Yankee myth unsullied by comfort or pretension. But taken as a whole his image of American history is inhospitable to nostalgia. Consider, for example, the photograph he titled *Stamped Tin Relic* (plate 45): its Ionic capital is not a durable ornament carved in stone but a cookie-cutter image in cheap sheet metal, manufactured, sold, installed, enjoyed, and discarded by people who had never visited Greece. It is a fraudulent imitation of European refinement, crushed by wasteful indifference. Yet it is also an emblem of the spirit of American independence, which owed its democratic idealism in no small degree to its image of the ancient Greek republic. That shard of stamped tin, no less than the plain clapboard house, is an exemplary fragment of the American vernacular.

European culture had its vernacular too: Atget's farmhouses and wooden carts were no less essential to French identity than the refined architecture of Versailles. The difference was that, for Americans, the dominant models of refinement were European—that is, foreign—so the ambitions of American culture were fraught with contradiction. Moreover, as John Kouwenhoven first observed in an essay written about a decade after Evans began to make photographs, the birth of America's agrarian mythology was inseparable from the birth of its technological tinkering, for the political revolution that had created the nation had coincided with the industrial revolution.[15] The same Yankee ingenuity that had settled the frontier had also invented the automobile—and machines for stamping Greek designs in tin. All of this is made manifest in Evans's early photograph (the date is 1929, before the onset of the Depression). He brought the contradictions up-to-date by discovering the fractured planes of European Cubism in a shard of Americana, but the picture's fundamental ironies were not imposed by avant-garde wit; they were embedded in American reality. Evans's originality was to recognize them.

<p style="text-align:center">* * *</p>

The perspective of history and the sting of irony both arise from comparison. The principle of comparison, often at work in Evans's individual photographs, is also fundamental to his art as a whole, in which an isolated perception fully discloses its metaphoric potential only when brought into play with others.

That is one way to characterize an idea that came to play a central role in modern photography—a sense that the full power of the art resides not in individual pictures, no matter how fine, but in an open-ended accumulation that progressively defines both a subject and a way of looking at it. This definition of photography's potential challenges the photographer to develop a consistent outlook through a sum of discrete observations, constantly susceptible to revision; and it challenges the viewer to discover that outlook by assessing the ways in which the photographs confirm, question, or otherwise inflect each other.

Especially in the era before photographs began to appear regularly on the walls of museums and galleries, the covers of a book were an ideal enclosure for such an aggregation of pictures. Layout and sequence, and the presence or absence of text, became further tools for shaping a coherent vision—for fixing fluid associations in a durable form. Evans at once announced and beautifully realized the opportunity in the book *American Photographs,* which he prepared to accompany an exhibition of his work at The Museum of Modern Art in 1938.

Photographs had enjoyed a rich career in books since the 1840s, being frequently pasted onto the page even before they could be reproduced in ink along with the text. There were few precedents, however, for a book of photographs whose sole purpose was to set forth the vision of an artist. One such precedent was Sander's *Antlitz der Zeit,* whose spare layout, with a single picture on the right side of each two-page spread, may well have influenced the design of *American Photographs.* Sander conceived *Antlitz der Zeit* in part as a sketch for a more ambitious mapping of German society, and the sequence of the book loosely expresses the structure of this larger work-in-progress. It begins with the peasants, whom

13. Evans, "Walker Evans on Himself," p. 26.

14. Evans, quoted in Jerry L. Thompson, *The Last Years of Walker Evans: A First-Hand Account* (New York: Thames and Hudson, 1997), p. 27.

15. John Kouwenhoven, "Art in America," 1941, in Kouwenhoven, *Made in America: The Arts in Modern Civilization* (Garden City, N.Y.: Doubleday, 1948), pp. 1–14.

Fig. 9. August Sander. *Manufacturer*. 1928.
Gelatin silver print, 11⅜ x 9⅟₁₆ in. (28.8 x
23.1 cm). The Museum of Modern Art, New
York. Gift of the photographer

Fig. 10. August Sander. *Industrialist*. 1928.
Gelatin silver print, 11⅜ x 8¹¹⁄₁₆ in. (28.8 x 22
cm). The Museum of Modern Art, New York.
Gift of the photographer

Sander regarded as the roots of German civilization (plate 33); surveys the scope of the social hierarchy; and concludes with the unemployed of the modern city (plate 117).

Numbers 45 and 46 of Sander's sixty plates are titled respectively *Der Industrielle* and *Grossindustrieller*, or *Manufacturer* and *Industrialist*, or more colloquially *Businessman* and, putting the former in his place, *Big Businessman* (figs. 9 and 10). Every detail of these pictures—the decor of each man's office, his clothing, and above all his bearing, his manner of presenting himself to the camera; even the distance and angle of Sander's approach—conspires to persuade us that we see an individual who in every sense embodies his designated role. Thus the second picture completes the first, by sharpening our attention to the precise perception set forth in each.

In *American Photographs* this method is deployed deliberately and elastically, with a much broader range of effect than in *Antlitz der Zeit*, for here it is carried out over extended sequences that bleed into, echo, and qualify one another. Evans's book is first of all a book of photographs and nothing but photographs; even the titles and dates are relegated to the end of each of its two parts, and Kirstein's brilliant afterword is commentary only, not an integral part of the work. The first two plates salute the cheap portraiture of driver's licenses, high school yearbooks, and family albums—symbols, perhaps, of a democratic culture (plates 204 and 205 in the present volume). In the third plate Evans presents a street portrait of his own, as if to imply that his art is modeled on the familiar vernacular form. At the same time, this opening sequence subtly suggests that Evans's pictures themselves are not mere slices of reality; they, too, are signs and symbols. Plates 7 through 10 of *American Photographs* (figs. 11–14) introduce car culture and recapitulate the theme of picture-making, insinuating that life may imitate art as readily as art imitates life. The automobile reappears as the key protagonist in plates 24 through 27, the last two of which—views of the main streets of small towns—announce the theme of community. Evan's plate 28, a third main-street view, is dominated by a monument to the doughboys of World War I (fig. 15). But the reader who interprets this picture as a comforting symbol of noble sacrifice and national solidarity is brought up short by the following plate (fig. 16), which represents a Confederate general whose dramatic call to battle may be read simultaneously as an anguished cry of defeat. As the sequence then unfolds (figs. 17–21), the motif of uniformed authority is further elaborated through three more plates until we are confronted with the dark face of a Havana dockworker, a figure unlikely ever to be granted the power of a uniform. This personification of racial disenfranchisement is followed by the shock of the decaying minstrel-show poster.

These brief remarks barely suggest the relentless, animated exchanges that electrify the plates of *American Photographs*. In the afterword Kirstein speculates on Evans's potential as a filmmaker, alluding to the example of Sergei Eisenstein. The sequencing of the book may be compared to—and indeed may have been consciously inspired by—Eisenstein's principle of cinematic montage, in which one shot has the capacity to alter dramatically the sense of another. Yet there remains a crucial difference: effectively though Evans propels the viewer through a highly charged

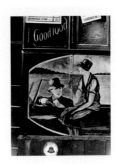

Figs. 11–14. Walker Evans. *American
Photographs*. 1938. Part 1, plates 7–10

16. Wright Morris, *The Inhabitants* (New York: Charles
Scribner's Sons, 1946); Paul Strand and Nancy
Newhall, *Time in New England* (New York: Oxford
University Press, 1950; reprint ed. Millerton, N.Y.:
Aperture, 1980).

17. The book was first published as Robert Frank, *Les
Américains*, with texts selected and introduced by
Alain Bosquet (Paris: Robert Delpire, 1958). It then
appeared in English as *The Americans*, without the
texts of the French edition but with an introduction
by Jack Kerouac (New York: Grove Press, 1959).

18. See Evans's remark in Paul Cummings, *Artists in Their
Own Words* (New York: St. Martin's Press, 1979), p. 88:
"I remember [Strand's] famous *Blind Woman* excited
me very much. I felt that was the thing to do. That
really charged me. . . . It was strong and real, it seemed
to me. And a little bit shocking—brutal."

continuity, each photograph nonetheless retains its stubborn identity as a mute record and obdurate symbol, forever prepared to offer itself again to fresh inquiry.

Evans's intuitive pursuit of a series of pictures, in which each next one has the potential to reconfigure the provisional constellation formed by the preceding ones, contributed to the development of a self-conscious practice that would be codified in the 1950s under the phrase "a body of work." Evans's deliberate poetics of editing and sequencing in *American Photographs* helped to establish the photographer's book as an indivisible unit of artistic expression. His influence took time to unfold, however. In the United States, the most ambitious photographic books of the following decade—*The Inhabitants*, by Wright Morris (1946), and *Time in New England*, by Paul Strand and Nancy Newhall (1950)[16]—focused on the problem of integrating text and photographs without subordinating one to the other. The full force of Evans's example would not be seized until the publication of Robert Frank's *The Americans* in 1959.[17] Frank's cinematic sequencing is more elliptical and, despite the high passion of his book, less tendentious than Evans's. But in common with themselves and with very few other books, each work projects a fiercely independent artistic vision through an irreducible whole composed solely of photographs in a particular order and no other.

The two-decade hiatus that separates *American Photographs* from *The Americans* is telling. Although Evans had discovered the perfect vehicle for his aesthetic, the audience that received it was looking in another direction. His book elicited both praise and derision, and soon disappeared from view. Certain that it knew what photography was for, American culture of the 1930s confidently substituted its simple, comforting meanings for the complex, unsettled ones that Evans had so deliberately set forth. It would be a long time before the artists of Frank's generation would begin to recover and reinterpret them.

* * *

Evans once claimed that in all the issues of Stieglitz's luxurious magazine *Camera Work* he found only one photograph to admire: Strand's riveting *Blind* of 1916 (plate 120).[18] Perhaps the remark is best understood as an acknowledgment of Strand's early work as a whole, which had proceeded rapidly to pictures such as *Truckman's House, New York*, of 1920 (plate 190)—a sharp piece of observation that in its formal compression and gritty subject matter resembles nothing so much as Evans's first mature pictures of a decade later. Thereafter, however, Strand had

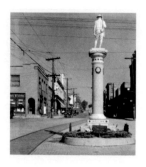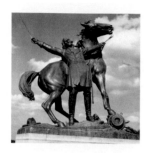

Figs. 15–21 (this page and opposite). Walker Evans. *American Photographs*. 1938. Part 1, plates 28–34

retreated equally rapidly into the idealism of the Stieglitz aesthetic. Apart from his bold debut, advanced American photography offered few clues to Evans as he trained his camera on the conflicted realities of contemporary America.

The opposite was true of American literature and American painting. By 1930, creative struggle with themes of American identity was well established, impressively diverse, and full of momentum. The point may be illustrated by an abbreviated roster ordered by date of birth: Walt Whitman (1819), Mark Twain (1835), Winslow Homer (1836), Thomas Eakins (1844), Edith Wharton (1862), Robert Henri (1865), George Luks (1867), William Glackens (1870), Theodore Dreiser (1871), John Sloan (1871), Willa Cather (1873), Robert Frost (1874), Sherwood Anderson (1876), Upton Sinclair (1878), George Bellows (1882), Edward Hopper (1882), Charles Sheeler (1883), William Carlos Williams (1883), Sinclair Lewis (1885), Thomas Hart Benton (1889), Stuart Davis (1892), Charles Burchfield (1893), John Dos Passos (1896), F. Scott Fitzgerald (1896), William Faulkner (1897), Hart Crane (1899), and Ernest Hemingway (1899).

Thus, when Evans (1903) took up photography as a means of exploring America, he enjoyed both the relative rarity of commanding precedents in the medium he had chosen and an abundance of instructive examples in literature and painting. Consider, for instance, the following passage from Twain's *Life on the Mississippi* of 1874:

Every town and village along that vast stretch of double river-frontage [between Baton Rouge and St. Louis] had a best dwelling . . . big, square, two-story "frame" house, painted white and porticoed like a Grecian temple—with this difference, that the imposing fluted columns and Corinthian capitals were a pathetic sham, being made of white pine, and painted. . . . On the end of the wooden mantel, over the fireplace, a large basket of peaches and other fruits, natural size, all done in plaster, rudely, or in wax, painted to resemble the originals—which they don't.[19]

Or consider this, from an essay on Burchfield written by Hopper in 1928:

By sympathy with the particular he has made it epic and universal. No mood has been so mean as to seem unworthy of interpretation; the look of an asphalt road as it lies in the broiling sun at noon, cars and locomotives lying in God-forsaken railway yards, the steaming summer rain that can fill us with such hopeless boredom, the blank concrete walls and steel constructions of modern industry, midsummer streets with

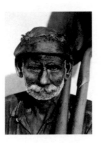

the acid green of closecut lawns, the dusty Fords and gilded movies—all the sweltering tawdry life of the American small town, and behind all, the sad desolation of our suburban landscape.[20]

Evans also shared with contemporary American writers and painters—especially those who, like him, took America as their subject—the challenge of a cultural climate in which social issues impinged upon the arts with unusual force. In the hardest years of the Depression, few artists in any medium felt wholly immune from pressing social debates and competing claims of national identity. The turmoil of Europe, where opposing ideologies were embodied in belligerent dictatorships, further raised the stakes and simultaneously heightened old longings for a distinctly American culture. Even the most earnestly personal voice was liable to be heard as a plea for one side of a contentious collective argument.

Moreover, while the public (including most of the cultural elite) was ill prepared to accept photography as an art, it increasingly embraced photography as a medium perfectly suited to inform or persuade. By the 1920s and 1930s photography was flooding the pages of newspapers and magazines. (The *New York Daily News* began publishing in 1919, *Time* magazine in 1923, *Life* in 1936.) When Evans's work started to receive notice and to exert influence, it did so not in the context of the protected artistic sphere that Stieglitz had struggled and largely failed to establish, but through photography's rising prominence in the field of mass communication. The result was a deep and lasting misunderstanding of his art.

The misunderstanding was nourished in no small degree by Evans's involvement with the Resettlement Administration, a government agency created at the height of the Depression, in 1935. Two years later it acquired its more familiar name—the Farm Security Administration, or FSA. The mission of the FSA was to improve the dire circumstances of the rural population, especially in the South, which had been visited with natural as well as economic disaster. The agency's large bureaucracy included a small photographic unit, administered by Roy Stryker, whose function was to persuade the public of the urgent need for these good works. It served that function by dispatching its staff photographers to document rural conditions, assembling their pictures in a Washington archive, and distributing those pictures with appropriate captions to newspapers, magazines, and book publishers. In short, the FSA was a propaganda picture agency, which owed its existence to photography's newfound currency in the printed press.

Evans was the model of the prickly independent artist for whom art and politics were like oil and water. But he had to eat, and throughout the 1930s he managed to survive, at times just barely, by undertaking a variety of professional assignments. Some of these contributed marginally to the development of his personal work; others produced only cash. After a trial stint in the summer of 1935, he joined Stryker's unit full-time that October.

It was the best job Evans ever had. The FSA provided him with equipment and materials, a car, and, for the first time in his photographic career, a regular paycheck over an extended period of time. And it sent him into parts of the country— West Virginia, Pennsylvania, Mississippi, Alabama, Louisiana—that he had already

19. Mark Twain, *Life on the Mississippi*, 1874 (New York: P. F. Collier & Son, 1917), pp. 317–18.

20. Edward Hopper, quoted in Brian O'Doherty, *American Masters: The Voice and the Myth* (New York: Random House, 1973), p. 20.

identified as fruitful hunting ground for his art. To Stryker, Evans was a talented if obstreperous photographer whose style of detailed observation was well suited to the FSA mission. To Evans, the FSA was a godsend—"a subsidized freedom to do my stuff! . . . That whole hot year I was tremendously productive."[21] "I was cheating, in a way," he later recalled. "I was looking upon this as a great opportunity for myself and I was exploiting the United States government, rather than having them exploit me. . . . If I was asked to do some bureaucratic, stupid thing, I just wouldn't do it. I'm sorry to say that Mr. Stryker was representing the government of bureaucracy and, therefore, naturally I antagonized him, poor fellow. I gave him a hard time, and he was very nice about it."[22] The mutually antagonistic relationship was mutually rewarding, however, and employer and employee managed to maintain it until March 1937, when Stryker, faced with a budget cut, fired Evans.

By 1935 Evans was in command of a mature aesthetic. Deployed in the service of its creator's acutely personal sensibility, it was a bold creative experiment. Defined in gross terms as impersonal scrutiny of ordinary social reality, however, it was a perfect model for the house style of a government information-agency. Russell Lee (plates 51, 160, 161, 165), John Vachon (plates 50, 134), Marion Post Wolcott (plates 91, 93, 135), and other young members of Stryker's team rapidly assimilated Evans's dry, factual style and applied it to the subjects he had made typical—storefronts and other commonplace structures, sidewalk gatherings, humble dwellings pictured inside and out. Particularly reminiscent of Evans's quick sketches of citizens on the street were the photographs of his friend Ben Shahn (plates 132, 133).

On its face, this matter-of-fact vein of FSA imagery has little obvious propaganda value. Some of the pictures of people in fact seem to lean in the opposite direction, taking aim at authority and pretension rather than eliciting sympathy for the underdog (e.g., plates 133, 136). But in the context of the Depression, an extensive government-sponsored record of rural and small-town life was in itself a form of propaganda. Especially after the pictures had been captioned in Washington, they conveyed to the newspaper-reading population a patriotic appeal for national solidarity with the countryside's beleaguered citizens.

Beginning in the mid-nineteenth century, American writers and painters and printmakers had developed an articulate mythology of native grit, rural self-reliance, and homemade virtue, which in the 1920s and 1930s dovetailed neatly with a new appreciation of American folk art. Evans's eye for the vernacular contributed to a durable photographic form of that mythology, which equated the authentic with the ordinary and tended to locate the essential battleground of American identity in the patterns of rural life. In the 1940s, notably in Morris's Midwestern work (plates 52, 162, 164) and in Strand's New England photographs (plates 48, 49), the tradition expanded its geographical range and began to detach itself from its Depression associations—a process that would continue to unfold for decades (plates 53, 56, 57).

Within the vocabulary of FSA photography, Evans's style of disinterested observation coexisted and commingled with a very different style that was decisively shaped by Dorothea Lange. Every bit as much an artist as Evans, Lange too had

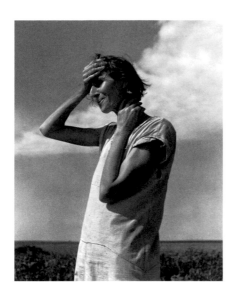

Fig. 22. Dorothea Lange. *Woman of the High Plains, Texas Panhandle*. 1938. Gelatin silver print, 12⅞ x 10⅛ in. (32 x 25.8 cm). The Museum of Modern Art, New York. Purchase

found her voice before joining the FSA, and she too bristled at many of Stryker's directives. But like Stryker and unlike Evans she was a fervent believer in social reform, and much of her best work is openly rhetorical—a cry of distress and a call to action (fig. 22). Evans's work, conversely, although rooted in youthful disgust at an unjust and complacent society, had matured into an art that passionately engaged social and moral questions and with equal passion declined to answer them. Indeed, the impersonal facade of his style may be interpreted as a defense against easy answers. But answers were what the Depression required, and the FSA and its photographic unit had been created to provide them. The public could not be expected to interpret one government photographer's work differently from another's, and Lange's powerful vision of photography as an instrument of social reform easily prevailed. Evans's work was widely perceived not as the challenging vision of an independent artist but as part of a collective answer to a collective problem.

A similar fate awaited the work that Evans made in Alabama in the summer of 1936, when the FSA gave him leave to collaborate with his friend James Agee on a story for *Fortune* magazine about three families of near-destitute tenant farmers. Rejected by *Fortune*, the story evolved with painful slowness into *Let Us Now Praise Famous Men*, a book containing a lengthy text by Agee and a slim portfolio of photographs by Evans (among them plates 36, 38–40, and 158). Published in 1941, as the travails of the Depression were giving way to the urgencies of World War II, *Let Us Now Praise Famous Men* met with indifference. Reissued in 1960, however, the book became a talisman of the Depression for people who had not experienced it.

Agee and Evans admired and respected each other, but they agreed that their collaboration would function best if each worked independently of the other. The strategy yielded two very different works of art, drawn from a single subject and juxtaposed within a single book. Agee's long piece of impassioned prose is as elaborate and self-involved as Evans's terse collection of photographs is austere and reserved. The 1960s culture in which the book found its audience was as politically charged as the 1930s climate in which FSA photography made its mark, and in each case a hortatory voice—of Lange, of Agee—overwhelmed Evans's taciturn reticence.

Like every other American who lived through the 1930s, Evans had no choice but to face the Depression. He had embarked on his artistic journey before the hard times settled in, and he pursued it thereafter as best he could. By strange fortune his best chance came in the form of a government job, which he construed fruitfully but against any reasonable expectation as a subsidy for his art. In a brief preface to *American Photographs* Evans asserted that the photographs "are presented without sponsorship or connection with the policies, aesthetic or political, of any of the institutions, publications or government agencies for which some of the work has been done." But few wanted to listen. By enabling Evans to do a healthy share of his best work, by opening a conduit of influence to several talented but unformed photographers in Stryker's unit, and by bringing his work and theirs to public attention, the FSA injected a key strain of his art into the mainstream of American culture. But this triumph, if it was one, came at a high price. In the popular imagination and in the history books, Evans's personal creative struggle to come to

21. Evans, quoted in Cummings, *Artists in Their Own Words*, p. 91.

22. Evans, in "Walker Evans, Visiting Artist," pp. 315–17.

terms with American history and identity was registered as a contribution to the collective struggle to survive the Depression. His highly original aesthetic of descriptive photography was received as a universal language of visual anthropology. And his ironic distance from group action was assimilated within the rhetoric of social reform.

*　　　*　　　*

An improbable exception to this overwhelming general trend offered itself in Weston's response to Evans's work. In the course of the 1930s, Weston progressively expanded both the scope of his frame, once tightly constricted, and the range of his subjects, once dominated by specimens of nature. Thus by 1937 he could choose to photograph, instead of a weathered rock at his feet, the equally beautiful arc of a hill in the middle distance, seen across a road through fence posts and telephone poles (plate 96). This was not Depression realism but an impressive broadening of a mature artist's work, all the more impressive because it involved the alien example of a younger artist's vision. In September 1938, Weston wrote to Beaumont Newhall at The Museum of Modern Art, requesting a copy of *American Photographs*. "He is certainly one of our finest," Weston noted. "When I see a photograph reproduced that I like, I usually find it is by Walker Evans."[23] Through Weston's open curiosity, a passage had been breached between the modernist tradition that descended from Stieglitz and the younger tradition that would grow from Evans. A decade later another such passage opened in the work of the young Harry Callahan, who had been initiated in advanced photography by Ansel Adams (a protégé of both Stieglitz and Weston), and whose penchant for extreme formal purity coexisted with a passion for concrete experience. From Evans's style of frontal address Callahan abstracted an aesthetic of taut planar patterns, infinitely variable in their geometric details (plates 286, 287).

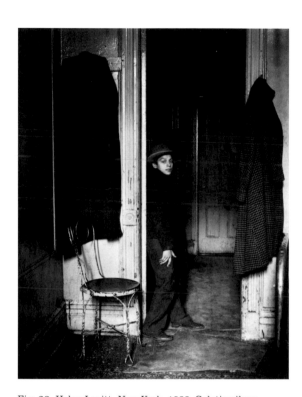

Fig. 23. Helen Levitt. *New York*. 1938. Gelatin silver print, printed c. 1981, 14¾ x 11½ in. (37.5 x 29.2 cm). The Museum of Modern Art, New York. Gift of William H. Levitt

Between 1938 and 1941, Evans quietly pursued a new project that, had it been executed three decades later, might have been welcomed as a contribution to the branch of Conceptual art that explored photography as a form of automatic, serial record-making. Armed with a camera hidden beneath his topcoat and a shutter release that snaked unseen through his sleeve into his hand, Evans descended regularly into the New York City subway to photograph one by one (and occasionally two by two) the citizens who sat opposite him (plates 303–13). His first mature photographs, some dated 1928 or 1929, had been pictures of city types observed in the anonymous arena of the street (plates 124, 125, 261), but the conception of the subway portraits was new. For one thing, they were in fact portraits—penetrating sketches of individual identities, revealed in the release of the underground journey. At the same time, since most of the photographer's options were eliminated—choice of angle, distance of view, variety of context, niceties of framing—the extended series evoked the impersonal enumerations of a census report.[24]

But Evans would not publish or exhibit the series for many years.[25] In the meantime he and his work slipped into near oblivion. Ironically, he disappeared into the recesses of Henry Luce's Time, Inc., first as a stand-in movie and book critic at *Time* magazine during the war, then for a twenty-year stretch as a staff

23. Edward Weston, letter to Beaumont Newhall, September 23, 1938, in the files of the Department of Photography, The Museum of Modern Art, New York.

24. In a draft introduction to the series, Evans wrote, "This collection is at least an impure chance-average lottery selection of its subjects—human beings in a certain established time and place. The locale was picked for practical reasons only, for rigidity of technical working conditions. Actually the ultimate purity of this method of photography—the record method—has not been achieved here, but it is presented as an unfulfilled aim: I would like to be able to state flatly that sixty-two people came unconsciously into range before an impersonal fixed recording machine during a certain time period, and that *all of these individuals who came into the frame were photographed, and photographed without any human selection for the moment of lens exposure. I do claim that this series of pictures is the nearest to such a pure record that the tools and supplies and the practical intelligence at my disposal could accomplish.*" In John T. Hill and Thompson, eds., *Walker Evans at Work* (New York: Harper & Row, 1982), p. 160.

25. A selection of the pictures was published as Evans, "Rapid Transit: Eight Photographs," *The Cambridge Review* 5 (March 1956): 16–25. The project did not appear in book form until 1966, as Evans, *Many Are Called*, with an introduction by James Agee (Boston: Houghton Mifflin). In the fall of that year, forty of the pictures were presented in an exhibition titled *Walker Evans' Subway* at The Museum of Modern Art, New York.

26. See Edward Steichen, *The Family of Man* (New York: published for The Museum of Modern Art by Simon and Schuster in collaboration with the Maco Magazine Corporation, 1955).

27. Helen Levitt and Evans met in 1937 or 1938 and became friends, shared a darkroom, and even worked together. It is reasonable to suppose that, in an environment where serious photography was poorly understood and rarely applauded, Evans's example encouraged and helped to guide the younger photographer. In short, Levitt's work is an obvious candidate for inclusion in *Walker Evans & Company*. Her principal artistic mentor, however, was not Evans but Henri Cartier-Bresson, whom she had encountered earlier, in 1935; and while her observations of ordinary people on the street are stylistically related to some of Evans's hand-camera pictures, the open warmth of her sympathy for her subjects diverges sharply from the coldness of Evans's clinical eye. Figure 23, which echoes Evans's reserve, is for that reason uncharacteristic of Levitt's art.

photographer and soon also a photography editor at *Fortune*, which functions he performed in desultory fashion until 1964, when he left to teach at Yale University. The irony resides in the fulsome postwar success of the picture magazines, especially those published by Luce, which blessed photography with unprecedented power and glamour by subordinating the independence of artists such as Evans to the homogenized language of mass communication. The editorial aesthetic achieved its apotheosis in 1955, in Steichen's exhibition and book *The Family of Man*, which orchestrated the voices of 273 photographers into a single harmonious chorus.[26]

The prevailing ethos of magazine photojournalism crowned the belated triumph of the hand-held camera in America. Although from the outset of his career Evans had shared the European enthusiasm for hand-held cameras, and his first successful pictures had been made with them, his most characteristic work, no less than the work of Stieglitz and Strand and Weston, was identified with the formality of the eight-by-ten-inch view camera. Even on the level of craft, then, the rise of the magazine era seemed to consign Evans's achievement to the completed past. Yet it was precisely during this period of incipient American globetrotting and self-congratulatory humanism, in which the country's power and prosperity recovered and then overwhelmed the previous highs of the 1920s, that Evans's richest creative influence began to unfold.

Starting out in the late 1920s, Evans had been obliged to piece together a useful artistic past from a variety of uncertain clues. Atget's precedent was clear, but his identity as an artist was uncertain—and Evans had never met him. Ralph Steiner taught view-camera technique to Evans, and his inventive work of the late 1920s (plates 30, 80, 188, 255, 256) pointed toward Evans's path. There were other friends, other clues. Nevertheless, Evans enjoyed no sympathetic mentor, no example of the photographer he might become. For the American mavericks of the 1950s and 1960s, on the other hand, who worked for pay in the magazine world but defined their artistic ambitions in defiant opposition to it, Evans would become just such an example.

For Frank (who met Evans in 1953), then Lee Friedlander (about 1957), and then Diane Arbus (about 1960), Evans was the author of a body of work whose poetic force, worldly curiosity, and distinctive voice exemplified photography as a deadly serious art. He was also a friend, supporter, critic, and abiding mystery. Partly through Evans's relationships with these photographers, his achievement became a touchstone for a creative explosion that soon energized a diversity of sensibilities and experiments far removed from his own.

In fact (as always) the story is not quite that simple. Beginning in the late 1930s a number of young photographers, including Louis Faurer (plate 262), Rudy Burckhardt (plates 94, 95, 219), and Helen Levitt (fig. 23),[27] responded to Evans's work in personal artistic terms unconstrained by the public image of the FSA. But while these disparate responses gradually gathered force, they did not yet constitute the muscular new tradition whose bold prospects were announced with Frank's publication of *The Americans*.

When Frank arrived in New York, from Switzerland, in 1947, photography was already an art for him. Making his living in his adopted country by shooting fashion photographs, he kept his heart for the street, where he exercised a divine natural

talent in the murky, melancholic mode that then prevailed in Europe. By 1955, when he set out to explore the expanse of America with the support of a Guggenheim grant that he had won with Evans's help, he had left that romantic style behind.

Deep affinities lie beneath the stylistic divide that separates Evans's sunstruck facades and austere neutrality from Frank's grainy glimpses and urgent emotion. Frank's "very special aspect" of a "very general material" occasionally repeats and always parallels Evans's essential America of individual citizens elected as representative types, pictured together with the relentlessly ordinary trappings of their vernacular environment. The cars and gas stations are there; the movies; the houses and storefronts and lunch counters; a jolly Santa Claus to cheer the consumer; a cross to mark a grave. Frank transforms the raw vernacular with the same swift certainty as Evans; again and again he abruptly condenses incidental fact into indelible symbol.

Evans's iconography surely helped Frank to know where to look, but by 1955, automobiles and gas stations had become awfully difficult to ignore. Far more valuable to Frank and the other young photographers was the whole of Evans's example as an artist in photography, an example that was all the more distinctive against the background of the magazine mentality. Evans's choices of subject matter had demonstrated not only that certain things were unavoidable in modern America but that all things could be the stuff of art. Just which things were relevant and what they might mean could not be prescribed in advance by social theory, and certainly not by a magazine editor. They had to be discovered through personal experience, and through the idiosyncratic working habits that enable independent photographers to draw experience into their art. The new whole that might be constructed from an accumulation of private observations was the least predictable of all. It decidedly would not resemble "those goddamned stories with a beginning and an end"—Frank's derisive epithet for the narrative niceties of the photo-essay form that prevailed in the magazines.[28] All of this he set forth in his application to the Guggenheim Foundation: "The project I have in mind is one that will shape itself as it proceeds, and it is essentially elastic. . . . 'The photographing of America' is a large order—read at all literally, the phrase would be an absurdity. . . . I speak of things that are there, anywhere and everywhere—easily found, not easily selected and interpreted."[29]

There was one more essential aspect of Evans's precedent, which Frank politely omitted from his application but fiercely incorporated into his work. Introducing a portfolio of pictures from Frank's cross-country journey in the 1958 *U.S. Camera Annual*, Evans wrote, "Irony and detachment: these are part of the equipment of the critic. Robert Frank, though far, far removed from the arid pretensions of the average sociologist, can say much to the social critic who has not waylaid his imagination among his footnotes and references. Now the United States, be it said, will welcome criticism, and use it."[30] Evans's "now" might have been a rhetorical device, or it might have meant that *now*, in this present prosperity, as distinct from the heedless 1920s of his youth, America might learn something from an artist's dissenting voice. Evans's posture of dissent—from authority and comfort, from

group patriotism and enforced optimism, from conventional morality and conventional expectation—lay at the core of his artistic legacy.

Among the conventional expectations that Evans rejected most strongly was the idea that personal dissent must inevitably lead to the collective dissent of politics. His critical view of the social order was fundamental to his art, and indisputably contained a political dimension. But it did not entail an endorsement of particular political solutions, which Evans regarded as another variety of group mentality.[31] The purpose here is not to assess Evans's own political—or, rather, resolutely apolitical—outlook but to stress the significance for his successors of his passionate definition of artistic independence. His work implicitly argued that the American artist had no choice but to confront the social reality of America without flinching—hence the need for a plentiful reserve of irony—and without accepting unexamined anyone else's views on the matter. America was a perpetually unfinished and imperfect reality, and so was the personal outlook of the artist. Through the artist's work, each of these realities would define itself in terms of the other.

If there is any truth in these speculations, then it may help to explain the welcome variety of sensibilities and styles that Evans's example helped to foster. A degree of ironic detachment from American mythology is common to them all, but none of them construes that imperative in the same way as any other. If Frank is the angry young man, whose love of life is offended by a society that appears determined to waste its freedom, Friedlander is the hipster flaneur, whose bag of attitudes includes puzzlement, knowing wit, open delight, wry irony, Cubist gamesmanship, and dumb amazement in ceaselessly varied configurations. Arbus placed the social world offstage, the better to solicit attention to the vulnerable individuals—that is, all of us—who must suffer and negotiate its machinations. For Garry Winogrand, those machinations were an inexhaustibly fascinating spectacle; Winogrand began a long way from Evans, and ended still farther away, but he recalled that he had first recognized that intelligence could be at work in a photograph in 1955, when his friend Dan Weiner showed him a copy of *American Photographs*.[32] In style, in sensibility, in the picture each draws of America, Friedlander and Arbus and Winogrand are as different from each other as all are from Evans (and from Frank, whose work they also knew). But all three share with Evans a definition of photography fiercely opposed to the neat packages and unassailable sentiments of the magazine aesthetic—or of the FSA. As John Szarkowski wrote in the text for a 1967 exhibition that brought the three together as exemplars of a new spirit in American photography, "Their aim has been not to reform life but to know it. Their work betrays a sympathy—almost an affection—for the imperfections and frailties of society. They like the real world, in spite of its terrors, as the source of all wonder and fascination and value, and find it no less precious for being irrational."[33]

Szarkowski called the exhibition *New Documents*, aiming to distinguish the personal artistic endeavors of the three photographers from the image of documentary truth and social utility that had accrued to descriptive photography as it had been deployed by the FSA and in the magazines. The point applied equally well to the work of Evans. The new generation had found his precedent rewarding

28. Frank, quoted in Tod Papageorge, *Walker Evans and Robert Frank: An Essay on Influence*, exh. cat. (New Haven: Yale University Art Gallery, 1981), p. 3.

29. The entire text of Frank's Guggenheim application appears in Anne Wilkes Tucker and Philip Brookman, eds., *Robert Frank: New York to Nova Scotia*, exh. cat. (Houston: The Museum of Fine Arts, 1986), p. 20.

30. The entire text appears in ibid., p. 30.

31. In 1974, Evans stated, "I cared to have certain things read into my work, but I really don't intend to have my ideas and my work and my vision used as political action. ¶ Since you raised the question of whether I'm a politically-minded artist or not, the answer is no, I'm not." From Evans, "The Thing Itself Is Such a Secret and So Unapproachable," *Yale Alumni Magazine* 37 no. 5 (February 1974): 12–15. The interview is reprinted in *Image* 17 no. 4 (December 1974): 12–18.
 Elsewhere Evans explained, "I photograph what's in front of me and what attracts me. Half the time I can't say why. I have been politicized by other people, not by myself." In "Walker Evans, Visiting Artist," p. 317.

32. See John Szarkowski, *Winogrand: Figments from the Real World*, exh. cat. (New York: The Museum of Modern Art, 1988), p. 18.

33. Szarkowski, unpublished wall text for the exhibition *New Documents* (February 28–May 7, 1967); on file in the Department of Photography, The Museum of Modern Art.

precisely for that reason; their work in turn helped to lift from Evans's art the unwelcome burden of the FSA mantle.

Even at its most influential, of course, Evans's work was only one element in a broadening field of precedent. Arbus owed more directly to Sander, Brassaï, and her teacher Lisette Model than she owed indirectly to Evans. By fostering creative experiment, Evans's example further complicated the picture: as they were finding their feet, in the early 1960s, Friedlander and Winogrand surely learned more from *The Americans* than from *American Photographs*; and there is little doubt that both spent a great deal more time photographing than they did looking at books. Nevertheless, as photographic innovation fanned out in the 1960s and 1970s, it drew new lines of perspective from which to look back on Evans's art. For Robert Adams and William Eggleston, America was not the whole stretch east of the Mississippi, as it had been for Evans, nor was it anything one might encounter along the entire highway system, as it had been for Frank. It was a particular region (Adams) or an insistently self-contained community (Eggleston) to which the photographer inalienably belonged. The two artists have construed that sense of belonging very differently, but both have sought to explore and define it through an accumulation of precisely framed observations. Whether looking around the corner or under the bed, they have regarded the stuff of the lived environment with eyes attuned to its symbolic potential. Both have extended the Evans tradition not only in a general sense but by rediscovering and distilling the power of certain motifs that first appeared in his work, thus redirecting us to his photographs with newly opened eyes.

* * *

Evans's distinctly American art has naturally enjoyed its widest influence in America. Outside this country, the evidence assembled here suggests, it has resonated most actively in postwar Germany. Bernd and Hilla Becher (plate 293) share with Evans only his attachment to the past—in their instinct for locating the origins of modernity in the unconscious monuments of the industrial revolution— and the astringent rectitude of his regard. Their student Thomas Struth has pursued a broader definition of history capable of encompassing the ironies of the present, including its failed emulations of the past (plates 70–73). Andreas Gursky, another Becher student, has reinvigorated both Evans's frontal style and his aesthetic of terrified rapture in the face of the distinctively modern (postmodern?) artifact (plate 301). Most relevant of all in the present context is the work of Michael Schmidt, whose engagement with postwar Germany is full of parallels to the critical posture of Evans's inquiry into prewar America.

Like Adams and Eggleston, Schmidt at first—that is, in the 1970s—focused on his immediate environment: the working-class neighborhoods of his native Berlin, a city that perhaps more than any other wears modern history on its face and so invites sober scrutiny in the mode of Atget or Evans (plate 67). Trained as a policeman, Schmidt found his way in photography instinctively, with some help from such contemporaries as Gabriele and Helmut Nothhelfer (plate 141). In 1976 he founded a photography workshop in the district of Kreuzberg, which among

other things fostered transatlantic exchange by inviting to Berlin such young Americans as Adams, Eggleston, and Stephen Shore.

Born in 1945 in what soon would become East Berlin, Schmidt eventually ended up in West Berlin. By 1989, when the wall between the two abruptly collapsed, his work had evolved considerably, and he soon set himself the ambitious task of making a work of art that would measure the challenge of reunification. The result was a project of 1991–94 titled *U-ni-ty*—in German the word divides itself more aptly in two: *Ein-heit*—of which an extract is reproduced here (plate 254).[34]

The "very general material" of *U-ni-ty* is German history from the Nazi seizure of power in 1933 through the half-century of conflicting ideology that divided the country after 1945. Schmidt's "very special aspect" comprises clipped glimpses of visual fact: portraits, interiors, facades, and monuments, and often details of photographs or other illustrations from old and current magazines, newspapers, history books, political pamphlets, and the like. The urgency of these symbolic fragments obliges the viewer to discover that his or her singular identity is enmeshed in the collective patterns of history, culture, and ideology. Is this man a Nazi agent or a Bonn politician? Does that image belong to the West or to the East? What is your Germany? The answers are destined to vary.

In cultural and political terms, Schmidt's powerful project suggests that genuine German unity can be achieved only through a recognition of its current hyphenated reality. In artistic terms, his work illuminates Evans's example by showing so plainly that the symbolic charge of photographic fact is perpetually open to interpretation, its meanings unfixed, so that in completing them the viewer must engage the critical challenge initiated by the photographer.

* * *

It is easy to say that photography, in all of its practical and popular applications, has played a central role in modern visual culture. It is not much harder to say that photography as a medium of high art has produced robust traditions of its own. But it is quite a bit harder to say precisely how photography in either guise has interacted with other visual mediums—with the younger medium of film (with which it shares a technology but not the obdurate identity of the still image) or with the much older medium of painting (with which it shares little beyond that identity). The artistic exchanges between and among these and other mediums have been active and all but constant, but they are different in character from exchanges within a single medium. The physical givens of each medium, its traditions of craft and imagery, and its communities of artists and audiences have all tended to reconfirm its singularity.

The dominant histories of modern art have been written virtually without reference to the work of Walker Evans (or of any other photographer), because they are histories of painting and, to a lesser degree, of sculpture and drawing and printmaking. These histories generally ignore photographers for the very good reason that painters generally have done so. No modern painter has been unaware of photography, of course, and some have been very interested in it. Some doubtless have been impressed by the artistic achievements of individual photographers.

34. The entire work, composed of 163 photographs, was published as Michael Schmidt, *Ein-heit* (Zurich: Scalo, 1996), a book that also served as the catalogue of an exhibition jointly organized by the Sprengel Museum, Hannover, and The Museum of Modern Art, New York. Except for the Acknowledgments, the book has no text. Through its New York office, Scalo also published the book under the English title *U-ni-ty*.

But, in competing with the past as they aimed at the future, painters naturally have kept their eyes largely on the work of other painters. Thus any attempt to include both painting and photography within a broader picture of tradition is destined to fantasy or failure if it is founded on the familiar model of influence.

The vigorous movement that coalesced in the early 1960s under the banner of Pop art is a case in point. Although a little digging will turn up evidence that many of the Pop artists and their successors were aware of Evans's work,[35] a thorough review will prove that Evans's work played a decidedly marginal role in the new art. That is no reason to conclude, however, that nothing can be learned by comparing the two. Pop's irreverent departure from the autographic grandeur of Abstract Expressionism, for example, repeated a familiar modernist gambit of challenging an achieved aesthetic by appealing to the common and the colloquial. Evans had done just that when he turned away from the romantic idealism of Stieglitz toward the messy realities of the contemporary scene. Faced with an art that had invested abstract forms created in the studio with the significance of timeless universals, the Pop artists looked out the window and walked out the door.

When they did so, they encountered some of the things that Hopper and Stuart Davis had painted and quite a few of the kinds of things that Evans had photographed: car culture; the signs, symbols, words, and pictures of commerce; the movies and other vehicles of popular romance, such as the comics; junk, and things on their way to becoming junk; and photographs themselves. Times had changed, to put it mildly—the roads were bigger and faster, and the machines of commerce had become slicker and more efficient—but the differences only reinforce an obvious yet telling lesson: if an iconography first outlined in the down-and-out 1930s could reappear in the prosperous 1960s, then Evans's art was not a time-bound picture of the Depression but an image of modern America writ large.

Most Pop painting presented itself as brash and new, and against the brooding background of Abstract Expressionism it certainly seemed so at the time. Among newcomers in the 1960s, only the architect Robert Venturi shared Evans's vision of the American vernacular as an extended historical continuum stretching deep into the past (plate 166). Gradually, however, observers recognized that although the Pop strategy was indeed new, much of its raw material was not. The design of the Campbell's soup cans that Andy Warhol copied had not changed for more than half a century (plate 223).[36]

However alien the imagery of popular culture may at first have seemed to the precincts of high art, it was anything but alien to the daily lives of both the artists and the audience. The longevity of Campbell's soup and Coca-Cola was an essential aspect of their meaning, because through it these products and their imagery had become part of American identity—not only the collective identity of sociology but also the private identity of every adult who as a child had sat at the kitchen table or at the soda counter of the local five-and-dime. Critics who celebrated or denounced Pop art as a satirical survey of an impersonal society overlooked this aspect of the new art, in which collective history and private identity were hard to separate. Like Evans, whose collection of turn-of-the-century postcards documented both the rise of modern America and the scenes of his youth, the Pop

artists looked back to see how the past had delivered them into the present. As it happened, they looked back upon a youth that the adult Evans and his contemporaries in the FSA had photographed. Roy Lichtenstein was born in 1923; Warhol in 1928; James Rosenquist in 1933.

Robert Rauschenberg, who was born in 1925, and whose work helped to initiate Pop but retained a degree of independence from the movement, is closest to Evans in his fondness for things that are worn and used and so evoke the passage of time. Like Evans, he is a collector of shards of historical evidence, and his busy present is crowded with reminders of the recent past. Unlike works by Allan D'Arcangelo (plate 106) or Edward Ruscha (plate 107) that suggest a spanking-new road culture, Rauschenberg's *First Landing Jump* (1961) treats the highway as a human place because people have been there and have left behind the marks of their strivings (plate 101). For both Rauschenberg and Evans, the entrapments of nostalgia were worth risking if the detritus of the past could help them to negotiate the unfolding present. The 1930s and the 1960s each delivered a storm of social and political turmoil that the settled comfort of the prior decade could not have predicted. "America—love it or leave it," proclaimed the slogan of conservative reaction to the '60s culture of protest. Three decades earlier Evans had proved that an artist could both love and hate America—and stay.

In broad terms, the Pop project and its obstreperous aftermath may be interpreted as renewals of that engagement in a hyped-up key tuned to the times. The Pop admixture of irony and affection, clinical disinterest and open enthusiasm, biting satire and buoyant good humor, has so thoroughly colored contemporary sensibility that it is easy to forget how much of modernism's creative energy had in earlier decades issued from decisive passions for or against—for the creation of a better future and against the repressions of the past, for political engagement and against retiring complacency, for the idealism of high art and against the banal escapism of kitsch. The souls of Whitman and Twain deserve to enjoy a knowing chuckle at this point, for these and many other American writers of the premodern era had long ago initiated an exploration of the challenging contradictions of national identity. But in the realm of still pictures, Evans's stubborn example of skeptical engagement with the enthralling spectacle of American capitalism increasingly appears both prescient and lasting.

Setting aside all of the above, it may be worthwhile to reconsider Evans's art through the lens of Pop's methodologies of transporting the vernacular given into the vocabulary of high art. The characteristic creations of Pop involved reproducing or copying a flat image, or transposing one to another, and much of the energy and lasting creative influence of these works derived from the wit and imagination with which they demonstrated that the business of transposition was every bit as complicated in practice and allusion as it was straightforward in principle. Even in its most elemental form—when Rauschenberg, for example, obviated the need to represent a tire by dragging it whole into his work (plate 101)—transposition raised implications that were anything but simple, for the tire thus also appeared as an image of itself. But the matter became deliciously convoluted when an image that described a thing was itself pictured again in a new form, which at once

35. See, for example, Jean-François Chevrier, "Dual Reading," in Chevrier, Allan Sekula, and Benjamin H. D. Buchloh, *Walker Evans & Dan Graham*, exh. cat. (Rotterdam: Witte de With, 1992), p. 17.

36. See Kirk Varnedoe and Adam Gopnik, *High & Low: Modern Art and Popular Culture*, exh. cat (New York: The Museum of Modern Art, 1991), p. 327.

resembled and differed from the original, which itself was likely to have been some sort of copy.

Photography lay at the heart of these convolutions. In some cases—in Rauschenberg's lithographs and Warhol's silkscreens, for example (plates 231, 270)—photography was the medium of both the raw material and its replication. In other cases—in Warhol's soup cans or Lichtenstein's comics, for example (plates 223, 267)—there was no photographic image, but the process of photography was involved nonetheless, for it had long been the indispensable lubricant of the graphic arts, enabling the ease of enlargement, reduction, recombination, and reproduction that made modern graphics modern. When the former billboard-painter Rosenquist made paintings of billboard imagery in a style adapted from billboard technique (plate 229), photography was nowhere present but everywhere implied—as the originator of the underlying image and as the agent of its gigantic transformation.

All of this may invite us to reconsider the presumed purity of Evans's photography, beginning with the apparent neutrality of his frontal address—the perfect mechanism of a self-effacing copy. In quite literal terms, his *Torn Movie Poster* (1930; plate 258) is a photograph of a photomechanical reproduction of a hand-painted image reproducing a still photograph derived from a movie. His photograph of the display window of a provincial portrait-photographer (1936; plate 205) involves fewer generations of imagery (although the display does include multiple copies of many of the portraits), but Evans was fully aware of the comic irony of the operation: "It's uproariously funny, and very touching and very sad and very human. Documentary, very real, very complex. All these people had posed in front of the local studio camera, and I bring my camera, and they all pose again for me."[37]

Of course the endpoint of Evans's image transformations was always the black and white photograph, while the finished Pop product was a good deal more varied and almost always a great deal more tangible. But across this distinction lies an amusing parallel of reversal: in the 1930s, Evans celebrated the folk art of hand-painted signs, which were then giving way to mass-produced imagery, by transposing the signs into the featureless vocabulary of industrially produced photographic paper. Three decades later, the Pop artists celebrated the mechanical vocabularies of photography and mass-produced graphic design by transposing them into the tactile realm of paint on canvas.

Photography had previously made cameo appearances in the high drama of painting's history, but Pop art imported it en masse, and there it has remained ever since. That statement requires qualification, however, for the Pop aesthetic approached photography in a particular way: it understood photography as a huge uncatalogued image bank, inexhaustibly rich in its worldly associations, not least of which was the familiar worldly feel of photographic imagery itself. Still more enthusiastically, Pop itself deployed photography as a fluid process for replicating, combining, absorbing, and transforming the given material of the collective photographic archive. In the process the photographic image increasingly merged with other varieties of pictorial sign, all the while retaining its distinctive flavor, no matter how diluted or degraded, as a trace of the real.

As these two definitions of photography—as a resource of imagery and as a process of replication—flourished in the realm of painting, they detached themselves from photography's third identity, as an art of precise observation. All three definitions had creatively overlapped within Evans's work. But the dominance of the first two within Pop and its aftermath had the effect of discouraging curiosity about the third. Thus in the eyes of those artists who might otherwise have been most sympathetic to Evans's explorations of photography as cultural fiction and self-reflexive process, his art continued to lie dormant in the unexamined tradition of descriptive photography.

According to some of what we read, Pop art was succeeded rapidly by Minimal art, performance art, Conceptual art, and so on and so forth until the whole impatient history of modernism collapsed, circa 1980, into the knowing skepticism of postmodernism. In a less dramatic version of the same story, neither the modernist imperative of ceaseless renewal nor its consequently well-stocked arsenal of forms and strategies has been superseded. Instead of evolving along a more or less linear path on which the advent of the new entails the shedding of the old, however, the bulging accumulation of modernisms currently mingle, overlap, circle back, and collide with each other at a crowded junction that has produced, as ambitious art always does, both the brilliant and the boring. Perhaps the biggest piece of real news is that irony is not what it used to be. Once it became a convention, it lost most of its power to deflate the complacency of convention.

Certainly the legacy of Pop is still very much alive, and with it Pop's definition of photography as resource and process. Both dimensions of that definition are at work, for example, in Felix Gonzalez-Torres's *Untitled (Death by Gun)* of 1990 (plates 252, 253), based on a *Time* magazine layout detailing (with photographic portraits of most of the victims) the gunshot deaths of 460 Americans in the course of one week in May 1989. Using the same medium of photolithography that had produced the magazine, Gonzalez-Torres redeployed the twenty-five-page layout on a single sheet, to be printed in countless multiples, displayed in a stack on the floor, and constantly replenished as its audience, by invitation, took sheets away to keep. It is tempting and perhaps rewarding to think of *Death by Gun* as a contemporary reinterpretation of Evans's deadpan *Penny Picture Display, Savannah* (plate 205), with the small-town community updated as a community of violent death and the handmade photographic print replaced by mass reproduction. The thought is misleading, however, if it is ascribed to Gonzalez-Torres: a sophisticated and well-informed artist, he probably knew Evans's work, but Warhol's recycled images of death and disaster surely came more readily to his mind. Within Gonzalez-Torres's artistic constellation, the worldly engagements of Pop were far more immediate than the work of Evans; so, too, was the legacy of Conceptual art.

As Evans had done before them, the leaders of the Conceptual movement of the 1960s applied philosophical disinterest and pictorial plainness like disinfectants to the body of art. Nothing could be plainer than a black and white photograph, and it was through the cleansing Conceptual impulse that an ambitious tradition rooted in the history of painting began to employ photography not merely as a resource of existing imagery and as a process of replication but—well, to make

37. Evans, quoted in Katz, "Interview with Walker Evans," p. 83.

photographs. From the mid-1960s onward, the most ordinary photograph could serve as the vehicle of the most cultivated artistic ambition—could do so, in fact, only if it seemed utterly ordinary, only if it presented itself as the embodiment of an artistic idea uncompromised by any known brand of pictorial refinement. This Conceptual aesthetic of anti-aesthetics became a fertile point of exchange for experiments variously associated with the Pop, Minimal, and performance movements. In the present context, for example, Sol LeWitt's *Brick Wall* of 1977 (plate 295) is both Conceptual and Minimal; Ruscha's *Every Building on the Sunset Strip* of 1966 (plate 292) is Pop and Conceptual. Ruscha's book so exemplifies the tried-and-true strategy of renewing modernism by reaching outside the boundaries of art that beside it Evans's sober reserve can seem positively artful, which of course it was. Todd Webb's Sixth Avenue panel of 1948 (plate 285) anticipated Ruscha's strategy, in which the image is shaped to fit the subject and the point of view shifts at regular intervals so as to maintain a steady frontal gaze upon the street facade. But the care with which Webb executed the strategy only underscores the fine artlessness of Ruscha's approach. We are obliged to look all the way back to the turn of the century to find such a perfectly flat-footed photographic document (plate 6).

Perhaps the most imaginative and perfectly realized work of art to emerge from this broad vein of photographic experiment was Cindy Sherman's series of Untitled Film Stills, whose roots include the Pop, Conceptual, and performance traditions. Executed between 1977 and 1980, the series comprises sixty-nine photographs in each of which the artist has pictured herself as an imaginary film actress playing an imaginary role (plates 271–73).

For all practical purposes, Sherman's black and white Stills look just like the promotional stills distributed by Hollywood studios to movie theaters and the press, or on occasion like the stage-managed "candid" shots of fan magazines. Each picture elicits an unmistakable twinge of recognition. What we have recognized, however, is not a particular star in a particular film but a generic identity, which Sherman has ingeniously abstracted from any number of movies. Together the Stills comprise a spirited survey of the fictions of femininity that took hold in America in the 1950s and 1960s—the period of Sherman's youth, and the crucible of our contemporary culture. Once again, the artist has looked back, as if to study the origins of the present.

Sherman owed less than nothing to Evans, in the crucial sense that her indifference to photography's accomplishments as a descriptive art was no less fundamental to her invention than was her allegiance to the post-Conceptual experimental outlook that flouted the authority of traditional mediums. And yet there are instructive parallels between her deft appropriation of a banal pictorial vocabulary lying hidden in the open and Evans's delirious recognition, half a century earlier, that photography's plainspoken documents were full of potential for an as yet unformed art.

In each of the Stills the heroine is pictured alone, the better to receive the emotions we project upon her. Or, rather, she prompts us to recall and rekindle the emotions we have invested in all of her predecessors and prototypes. As our eyes rush to meet the heroine we feel we must know, we watch ourselves in the process.

The originality and effectiveness of Sherman's strategy lay in its simplicity: instead of treating the pop-culture image as raw material (as Rauschenberg and Warhol had done), she adopted its vocabulary whole and uninflected. Speaking in the generic language of the movie still, she returned her private picture of the collective image bank to public circulation, closing the loop and drawing us into it. Here it is essential that Sherman played her roles absolutely straight. A knowing or ironic wink at the audience would have broken the spell of recognition that makes her fictional world our own.

The novelist Knut Hamsun once defined truth as "disinterested subjectivity"[38]—a phrase that perfectly summarizes Sherman's poise. In the Stills she speaks not in the hortatory voice of a critic who stands outside in judgment but with the candor of a participant, and so she makes participants of us all. Hamsun's phrase applies equally well to Evans's art. Sherman and Evans, so different in so many ways, share more than a taste for the vernacular. For through the vernacular each achieved an exemplary detachment—a way of engaging our curiosities and our passions without telling us what to think and feel.

According to the familiar pathways of influence, Evans and Sherman belong to divergent traditions—the one devoted to photography as an art of observation, the other for which photography is a repository of the already observed. It is only by following those pathways that we are able to grasp the distinctness and originality of each artist's work. But our experience of their work can invite us to cross those pathways and thus to sketch a more fluid image of tradition. It may be useful, for example, to compare Evans's *Girl in Fulton Street, New York* (1929; plate 261) to Sherman's *Untitled Film Still #21* (1978; plate 273). The former is a precisely calculated slice of life, the latter a perfectly calibrated fiction. But the subject in both is the same: the psychology of an attractive young woman alone in the big city, clothed in the armor of fashion. Both pictures, in other words, frame the question of identity in social terms. Having thus framed the question, both artists leave us to ponder it. Like the figures in the pictures—and like the introspective usher in Hopper's *New York Movie* (1939; plate 263)—we ponder the question amid others but nonetheless alone, confronting a world not of our making that is nonetheless ours.

<p style="text-align:center">* * *</p>

For some, it may be more useful to look at the photography of Evans through the lens of Sherman's work rather than the other way around, since the frankness of her fictions may illuminate the artfulness of his observations. For others, the challenging depth of Evans's image of America may help free Sherman's invention from the narrowing zeal of the flood of interpretation that quickly surrounded it. In both cases, the work of one artist may help us to see more clearly, in the very different work of another, something new that was there all along. In any case, it is worth drawing the connection only if it is rewarding in this way. Any one such link, like the whole constellation of relationships that together draw our picture of tradition, is provisional—perpetually in need of revision, as indeed tradition has always seemed to artists.

38. The entire sentence reads, "Truth is neither two-sided nor objective; truth is precisely disinterested subjectivity." It appears in the preface to Knut Hamsun, *The Cultural Life of Modern America*, 1889, ed. and trans. Barbara Gordon Morgridge (Cambridge, Mass.: Harvard University Press, 1969), p. 3.

L. S. Glover. *In the Heart of the Copper Country, Calumet, Michigan.* 1905. Detail of plate 5

1. Lincoln Kirstein, "Photography in the United States," in Holger Cahill and Alfred H. Barr, Jr., eds., *Art in America in Modern Times* (New York: Reynal & Hitchcock, 1934), p. 86.

By explicitly defining photographic art in opposition to the sprawling mass of ordinary, practical photography, Alfred Stieglitz paradoxically endowed the latter with an embryonic identity it had not possessed. Evans and his successors completed the process by recognizing a coherent aesthetic in the same pile of mundane photographs that everyone knew and used, filed, or discarded as the daily occasion required. Thanks in part to Evans, we now have a name for this material; we call it "vernacular," meaning functional or ordinary rather than refined or exotic.

In principle, the vernacular is the collective expression of anonymous craftsmen, but Evans did know and revere the name of one photographer. Paradoxically, this was Mathew B. Brady, whom Evans and his contemporaries credited with an extensive photographic record of the Civil War—a body of imagery that in fact had been produced by a dozen or more photographers. The cultural significance of that record was all the greater because there were no photographs of the other great conflict fought on American soil, the Revolution of 1776. Thus in the 1920s and 1930s, as the Civil War slipped from living memory into the recorded past, through the Brady archive the medium of photography achieved new stature as a witness to history.

Where others perceived transparent documents of history, however, Evans and his circle perceived a vision of history embedded in a distinctly photographic aesthetic. "Brady's plates," wrote Lincoln Kirstein, "have the esthetic overtone of naked, almost airless, factual truth, the distinction of suspended actuality, of objective immediacy. . . . Brady's work is an example of the camera's classic vision, austere and intense."[1]

The Brady archive proved that photography could make the past vividly present, as long as the photographer did not presume to intrude. The same operation was at work in countless other photographs whose subjects were a great deal less momentous than the battlefields of the Civil War; the unvarnished factuality of functional photography was a universal pictorial vocabulary, through which the most mundane object could be transformed into historical evidence. Thus for Evans vernacular photography was at least three things in one: a stylistic model of impersonal clarity; a window on the past; and a resource of the ordinary, in which an unpretentious style and unpretentious subjects together spoke in an authentic American voice.

By turning to the vernacular for inspiration, Evans radically expanded the prospects of photography as an art, for himself and for others. He also irreversibly transformed our sense of the photographic past. Ever since, it has been not merely an adjunct to history but a way of seeing, with a history of its own.

1. George N. Barnard. *Nashville from the Capitol.* 1864–65

2. Studio of Mathew B. Brady. *Ruins of the Gallego Flour Mills, Richmond, Virginia.* 1865

3. Edwin Hale Lincoln. *Figurehead of U.S.S. Frigate Niagara.* c. 1900

4. Unknown. *Shaker Building.* c. 1890

5. L. S. Glover. *In the Heart of the Copper Country, Calumet, Michigan.* 1905

6. G. Willard Shear. Two-page spread from *Panorama of the Hudson* (New York: Bryant Literary Union, 1900)

7. Charles H. Currier. *Kitchen in the Vicinity of Boston, Massachusetts.* c. 1900

8. William Preston Mayfield. *Grocery Store.* 1920s or 1930s

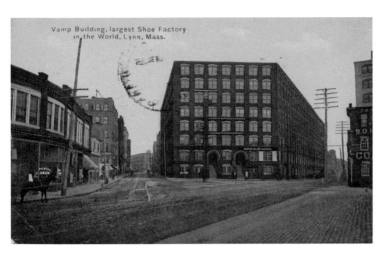

Vamp Building, largest Shoe Factory
in the World, Lynn, Mass.

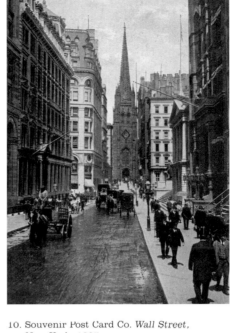

9. Unknown. *Vamp Building, Largest Shoe Factory in the World, Lynn, Massachusetts.* 1912 or before

10. Souvenir Post Card Co. *Wall Street, New York.* 1895

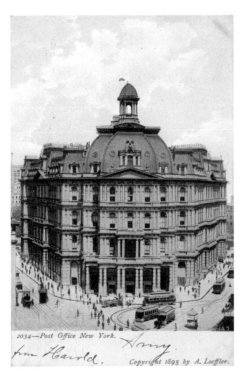

2034—Post Office New York.
from Harold.
Copyright 1895 by A. Loeffler.

11. Souvenir Post Card Co. *Post Office, New York.* 1895

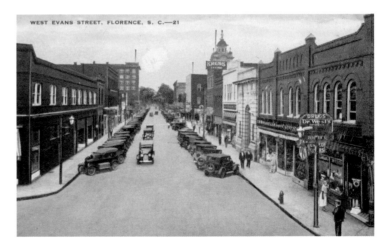

WEST EVANS STREET, FLORENCE, S. C.—21

12. Unknown. *West Evans Street, Florence, South Carolina.* c. 1910

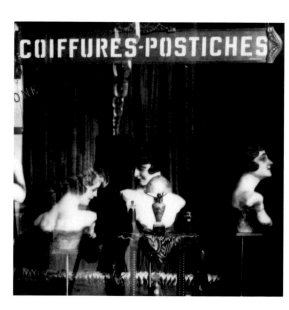

Eugène Atget. *Hairdresser, Palais Royal, Paris.* 1926–27.
Detail of plate 25

The modern French romance with the noble French past was born in the early nineteenth century, not long before the medium of photography. By the early twentieth century, especially in Paris, photographing the material expression of the past was a thriving business. Dozens if not hundreds of photographers ceaselessly surveyed the city's monuments and parks, its historic buildings and beautiful details, its hidden treasures and humble corners. From the 1890s until his death, in 1927, at the age of seventy, Eugène Atget was one of them.

In 1920, Atget's name was unknown to anyone outside his clientele of antiquarians, librarians, publishers, craftsmen, illustrators, and a few painters, who bought his photographs as documents of old Paris or as models for their own work. By the early 1930s, his achievement, although still known in a fragmentary way, was widely appreciated by sophisticated artists and photographers on both sides of the Atlantic. The catalyst of this improbable transformation was an eager curiosity about photography that arose in European avant-garde circles in the 1920s. Man Ray, who lived only a few doors away from Atget, had been the first to celebrate the old photographer's work as a kind of naïve Surrealism, all the more provocative because its uncanny effects were presumed to be unintentional. Man Ray's apprentice Berenice Abbott, who with the financial aid of the young American art-dealer Julien Levy purchased the contents of Atget's studio upon his death, was largely responsible for the preservation and dissemination of his work over the next four decades. Although Evans had spent a year in Paris in 1926–27, he first became alert to Atget's achievement when he visited Abbott in her New York studio in November 1929, just as he was finding his footing as an artist.

Atget pictured Paris as the living embodiment of history, and he pictured history as an unbroken continuity stretching from the distant past of peasants and kings to the bustling present of fashion and commerce. Evans was among the first to recognize that the photographer's image of French culture was also "the projection of Atget's person"[1]—that even if Atget's role as a professional photographer lay outside the realm of art as it was then defined, the work he made in the service of that role manifested the coherent imagination of a creative artist.

The fluidity and ease of Atget's style—as if the world had been organized to reward his gaze, wherever he might wish to look—are much closer to Lee Friedlander's mature aesthetic than to the compressed, immobile frontality of Evans's pictures. (Indeed, parsing the intertwined influences of Atget's and Evans's work on later photographers would be an engaging project in itself.) As Evans himself acknowledged, however, his work and Atget's have a great deal in common: a view of human endeavor in which the common is as significant as the grand; an understanding of photography as a cumulative medium, in which successive observations elaborate upon the ones that have come before; and above all, a recognition that clarity of perception can yield compelling mystery rather than banal objectivity.

The degree to which Atget's example actively inspired Evans's art or, significantly but less decisively, confirmed an intuition that Evans had already formed is both difficult to judge and less important to consider than the two-way street of photographic tradition that was created by the encounter. As Evans and his successors pursued the art of descriptive photography in part by learning from Atget's example, they simultaneously taught others to recognize Atget as an artist.[2] That recognition was not a familiar matter of rediscovering a neglected old master. It was part of a great cultural sea change in which the rise of a self-conscious artistic tradition enabled—and was enabled by—the exploration of artistic achievement within a tradition that had developed outside the ken of art. The name we now have for that fruitful conundrum is "the history of photography."

1. Evans, "The Reappearance of Photography," *Hound & Horn* 5 no. 1 (October–December 1931): 126.

2. See John Szarkowski, "Understandings of Atget," in Szarkowski and Maria Morris Hambourg, *The Work of Atget*, vol. 4, *Modern Times* (New York: The Museum of Modern Art, 1985), pp. 9–33.

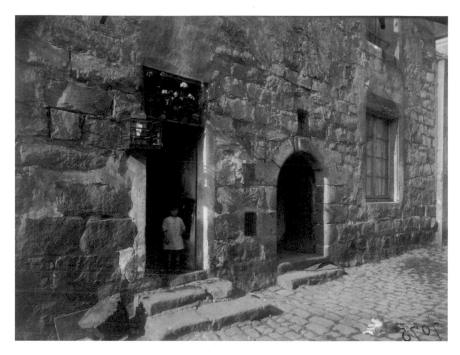

13. Eugène Atget. *Old Farmhouse, Gif.* 1924

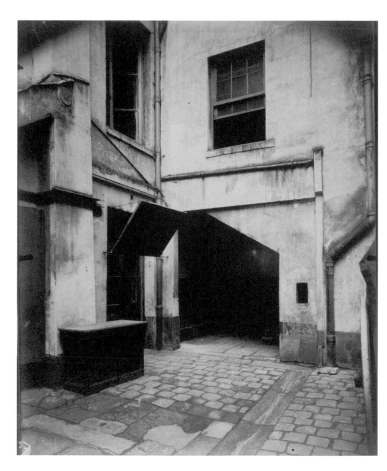

14. Eugène Atget. *Old Courtyard, 22 rue Saint-Sauveur, Paris.* 1914

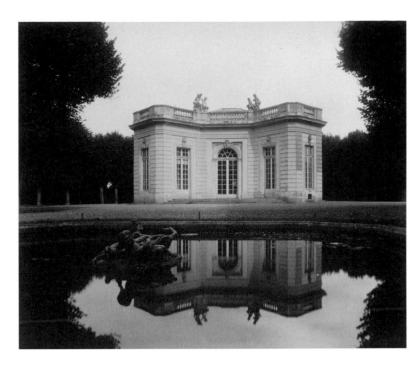

15. Eugène Atget. *Pavillon Français, Petit Trianon, Versailles.* 1923–24

16. Eugène Atget. *Door, 6 rue Saint-Florentin, Paris.* 1912

17. Eugène Atget. *A Corner of the quai de la Tournelle, Fifth Arrondissement, Paris.* 1910–11

18. Eugène Atget. *Canal, Saint-Denis.* 1925–27

19. Eugène Atget. *Courtyard, 7 rue de Valence, Paris.* 1922

20. Eugène Atget. *Working Class Apartment, rue de Romainville, Paris.* 1910

21. Eugène Atget. *Apartment of Mr. C., Interior Decorator, rue du Montparnasse, Paris.* 1910

22. Eugène Atget. *Prostitute Taking Her Shift in front of Her Door, rue Asselin, La Villette, Nineteenth Arrondissement, Paris.* 1921

23. Eugène Atget. *Rue Saint-Vincent, Montmartre, Paris.* 1922

24. Eugène Atget. *Fête du Trône, Paris.* 1925

25. Eugène Atget. *Hairdresser, Palais Royal,*
Paris. 1926–27

26. Eugène Atget. *Automobile Showroom,*
avenue de la Grande Armée, Paris. 1924–25

Walker Evans. *Stamped Tin Relic*. 1929. Detail of plate 45

The only rock that Evans ever photographed had been quarried and shaped for building. Trees do appear in his pictures, but the vast majority of them had long since been lumbered, milled, carpentered, and nailed. His subject was not nature but civilization—the human circumstance of the present understood as a collective inheritance from the past.

Through Evans's eyes, we look upon the past to ask what meaning it holds for the present. What we encounter is a legacy of the ordinary, as if history's essential lessons lay not in memories of great men or exceptional events but in the relics of everyday life. Evans's distinct, one might say democratic, emphasis on the common and typical is further sharpened by his penchant for the humble and unaffected—an implicit rebuke to the prosperity and pretension that he saw in the dominant American culture of the 1920s, and which so estranged him from it.

The Depression complicated the reception of Evans's historical iconography because it tended to transform the ordinary and worn from talismans of an honest

past into symbols of an impoverished present. But even at the height of the Depression, as Evans worked with James Agee on the project that would become *Let Us Now Praise Famous Men*, he regarded the poor farming families in Alabama not as victims to be pitied but as exemplars to be emulated:

I felt pretty much at home there; perhaps not so much as Agee did, because he came from Tennessee stock, with a rural background. I don't know much about my forebears, but there was a combination of old Massachusetts and, I guess, Virginia gone west into a place like Missouri. I think that some of them must have been dirt farmers even. They had an attachment to the land. I was divorced from that by then. I was a suburban-city son of a Chicago businessman, so I didn't really know a hell of a lot about what was there. But I had an almost blood relation to what was going on in those people, and an understanding and love for that kind of old, hard-working, rural, southern human being. They appeal to me enormously from the heart and the brain.[1]

If this betrays a hint of romantic nostalgia for an imaginary past, the unsentimental bluntness of the photographs quickly clears the air (plates 38–40). Evans's evident sympathy for what he regarded as an authentic, down-to-earth past did not blind him to America's lasting conflicts and contradictions, including the legacy of slavery in the rural South he otherwise admired.

The aim in this chapter of isolating the historical dimension of Evans's photography is to stress its significance in all of his work—and in the tradition that followed after him. Recognizing that dimension is a step toward appreciating the demands that photographs in the descriptive tradition make of their audience. To interpret such a photograph is to consider the collective aspirations and often painful fates that together have shaped what we see—and so to call upon knowledge we may not possess. An American, for example, might need to learn a few things in order to make sense of Thomas Struth's views of the cities of his native Germany (plates 70–73), or of David Goldblatt's social history of his native South Africa through photographs of its buildings (plates 74–78). But then an American of the present might need to learn a few things in order to decipher Evans's photographs of the 1930s.

Here is a brief extract from Goldblatt's long and illuminating commentary on his 1964 photograph *Café-de-Move-On, Braamfontein, Johannesburg* (plate 74):

In the early 1960s cafés-de-move-on or coffee-carts were the dominant source of food for Johannesburg's African workers during the working day.... Built from the cast-offs of White Johannesburg, a cart would be large enough to allow the owner—invariably an African woman—to stand and cook inside on a paraffin burner while serving customers through a hatch. Once parked on the chosen spot carts were seldom moved. In 1962 there were some 2000 of them in Johannesburg. Within three years there was none: the authorities had won a twenty-year war against the coffee-carts, the "aunties" were put out of business and their carts were destroyed.... In 1985, when the apartheid apparatus began to disintegrate, Africans and others trading in all sorts of commodities started trickling back onto the streets. At first they were arrested, but soon their tide became unstoppable.[2]

1. Evans, quoted in Bill Ferris, *Images of the South: Visits with Eudora Welty and Walker Evans*, Southern Folklore Reports no. 1 (Memphis, Tenn.: Center for Southern Folklore, 1977), p. 31.

2. David Goldblatt, *South Africa: The Structure of Things Then*, with an essay by Neville Dubow (New York: The Monacelli Press, 1998), pp. 178–79.

27. Charles Sheeler. *White Barn, Bucks County, Pennsylvania.* 1914–17

28. Arthur G. Dove. *Grandmother.* 1925

29. Edward Hopper. *House by the Railroad.* 1925

30. Ralph Steiner. *American Rural Baroque.*
c. 1928

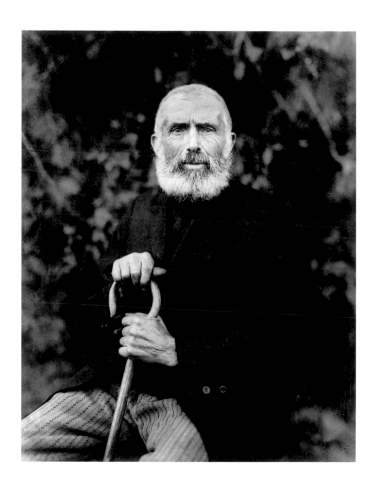 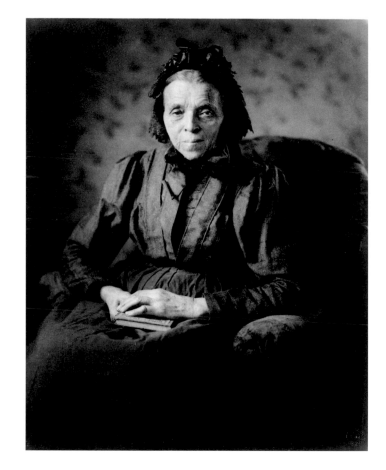

31. August Sander. *The Earthbound Farmer.* 1910 32. August Sander. *Peasant Woman.* 1914

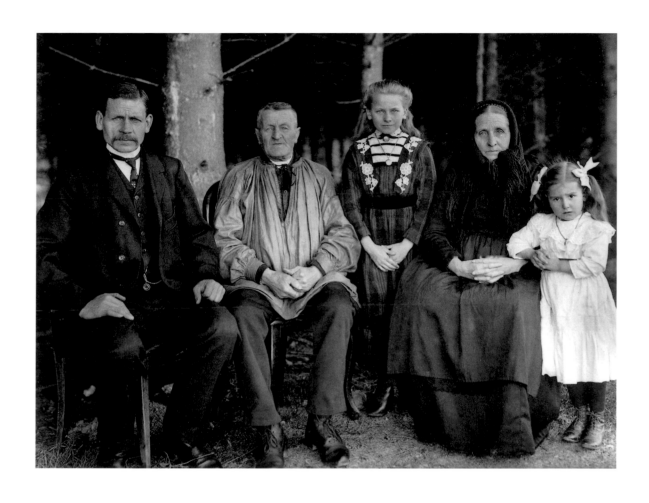

33. August Sander. *Farming Generations*. 1912

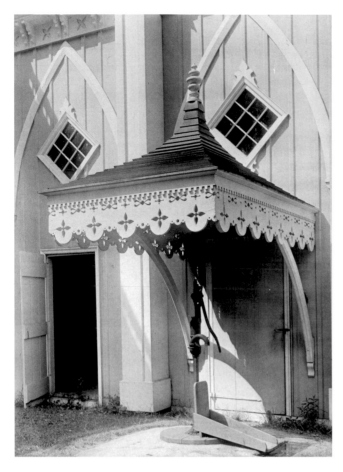

34. Walker Evans. *Maine Pump.* 1933

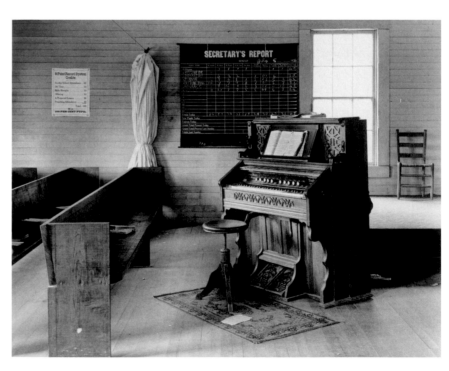

35. Walker Evans. *Church Organ and Pews, Alabama.* 1936

36. Walker Evans. *Kitchen Wall, Alabama Farmstead.* 1936

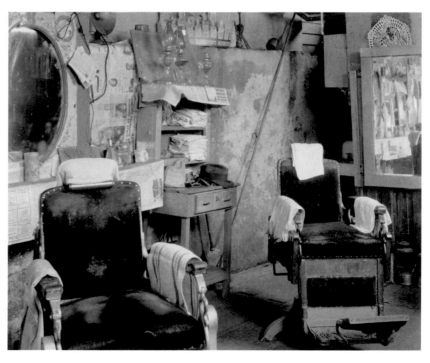

37. Walker Evans. *Negro Barber Shop Interior, Atlanta.* 1936

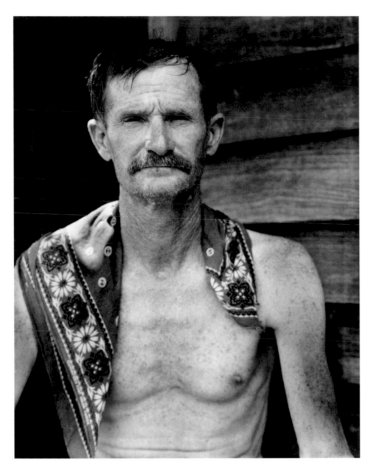

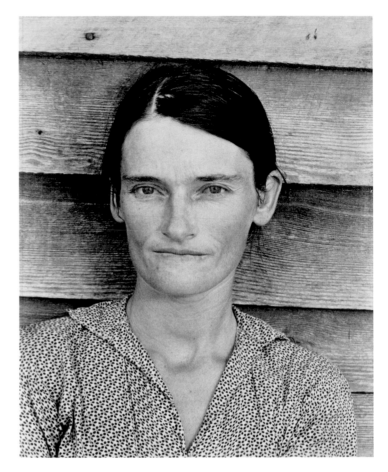

38. Walker Evans. *Sharecropper, Hale County, Alabama.* 1936

39. Walker Evans. *Alabama Cotton Tenant Farmer Wife.* 1936

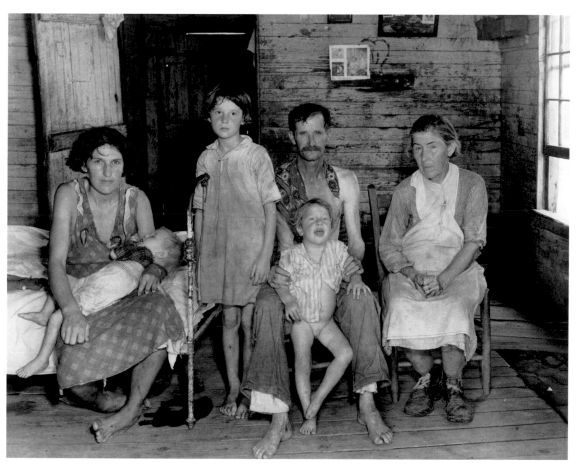

40. Walker Evans. *Sharecropper's Family, Hale County, Alabama.* 1936

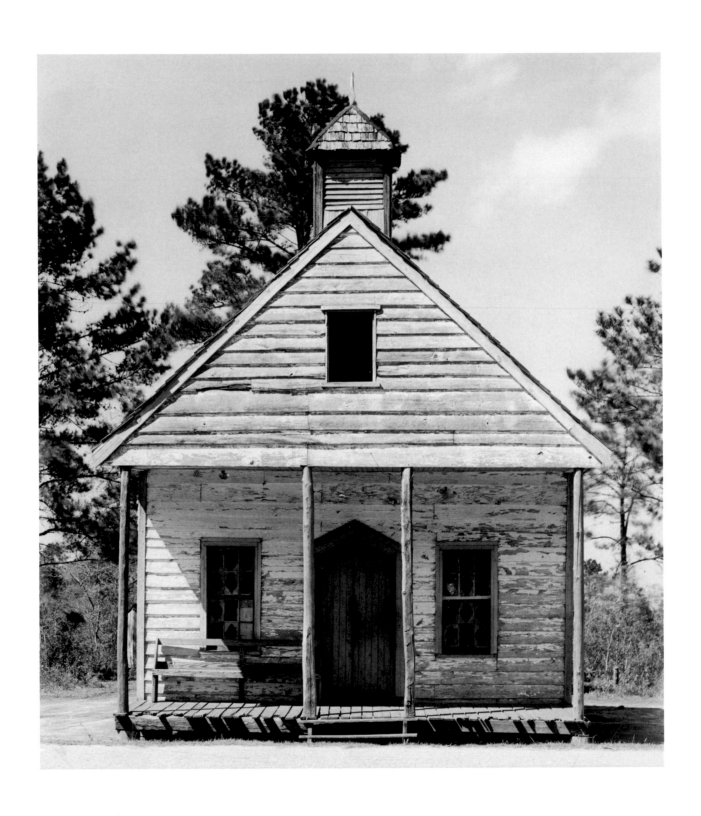

41. Walker Evans. *Wooden Church, South Carolina.* 1936

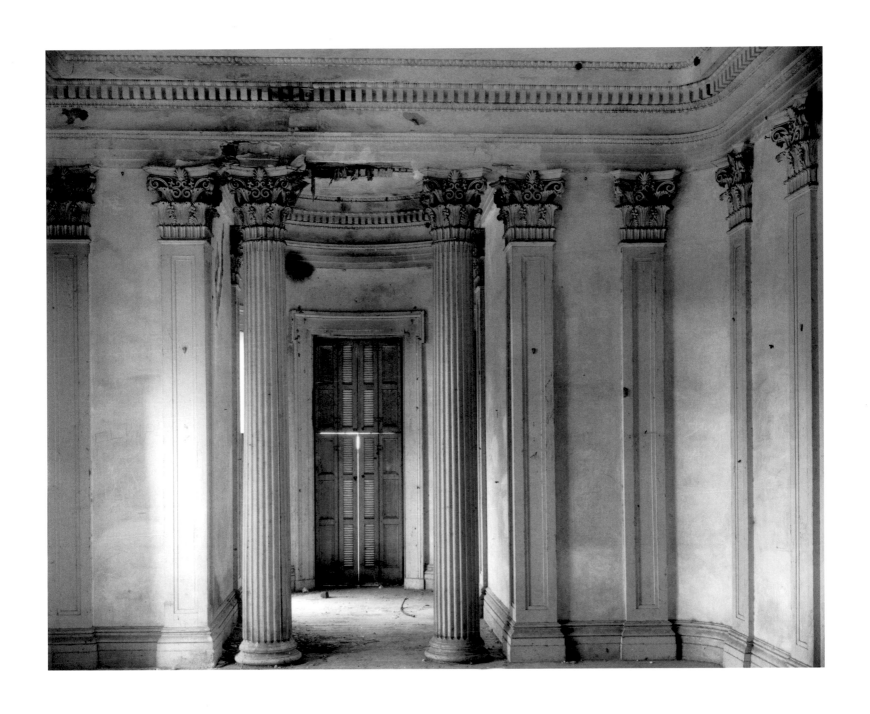

42. Walker Evans. *Breakfast Room at Belle Grove Plantation, White Chapel, Louisiana.* 1935

43. Walker Evans. *Main Street of Pennsylvania Town.* 1935

44. Walker Evans. *Battlefield Monument, Vicksburg, Mississippi.* 1936

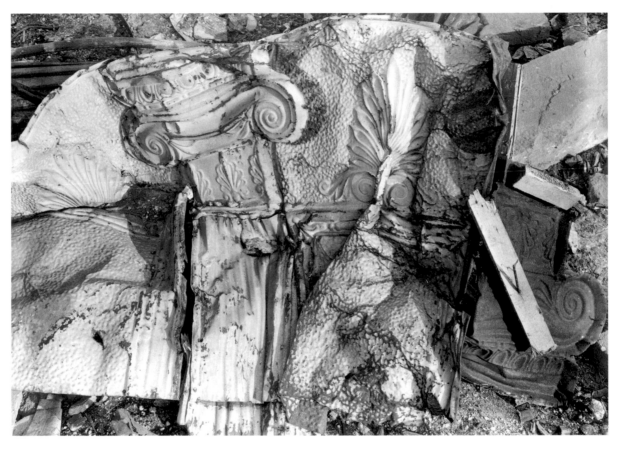

45. Walker Evans. *Stamped Tin Relic*. 1929

46. Edward Weston. *Belle Grove Plantation House, Louisiana.* 1941

47. Edward Weston. *Church Door, Hornitos.* 1940

[68]

48. Paul Strand. *Mr. Bennett, Vermont.* 1944

49. Paul Strand. *Church.* 1944

50. John Vachon. *Main Street of Starkweather, North Dakota.* 1940

51. Russell Lee. *Old Lamps in House of Jim Hardin, Two Bit near Deadwood, South Dakota.* 1937

52. Wright Morris. *Barber Shop Utensils and Cabinet, Cahow's Barber Shop.* 1942

53. George A. Tice. *South Main Street, Hannibal, Missouri.* 1985

54. Berenice Abbott. *Doorway, 204 West 13th Street, Manhattan.* 1937

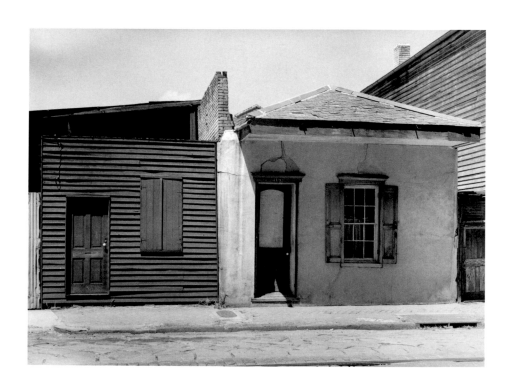

55. Clarence John Laughlin. *Black and White (No.1).*
1938–40

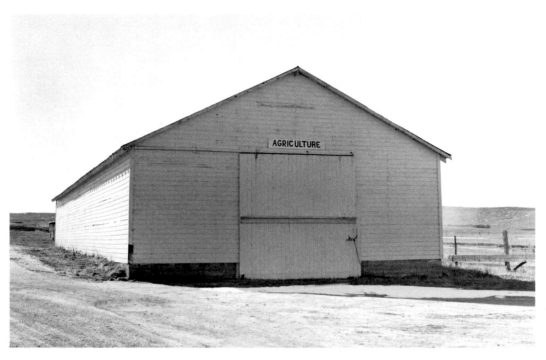

56. Robert Adams. *El Paso County Fairgrounds, Calhan, Colorado.* 1968

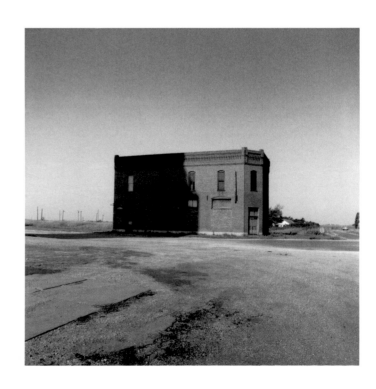

57. Frank Gohlke. *Brick Building in the Shadow of a Grain Elevator, Cashion, Oklahoma.* 1973–74

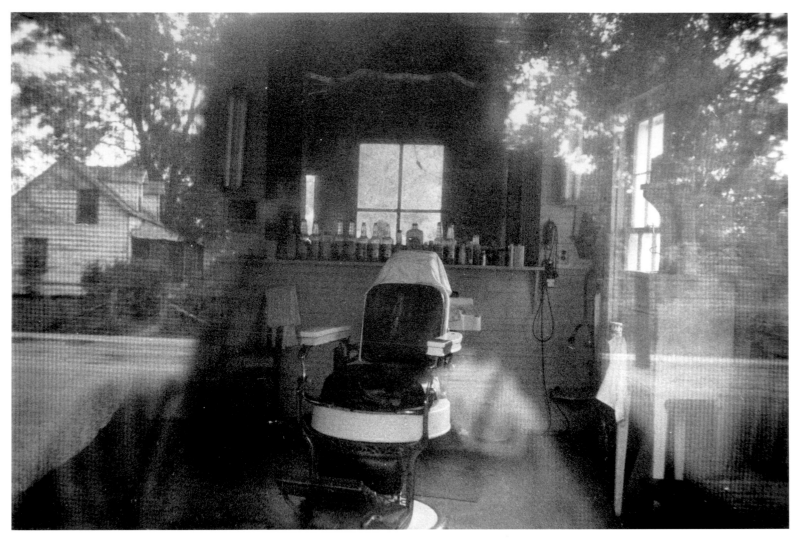

58. Robert Frank. *Barber Shop through Screen Door, McClellanville, South Carolina.* 1955

60. Lee Friedlander. *Baltimore*. 1962

59. William Eggleston. *Nashville*. 1971

61. Richard Benson. *Cannon, Vicksburg.* 1986

62. William Christenberry. *Red Building in Forest, Hale County, Alabama*. 1983

63. Berenice Abbott. *Father Duffy, Times Square*. 1936

64. Lee Friedlander. *Bellows Falls, Vermont*. 1971

65. Lee Friedlander. *Mount Rushmore, South Dakota*. 1969

66. Chauncey Hare. *Escalon Hotel before
 Demolishment, San Joaquin Valley,
 California.* 1968

67. Michael Schmidt. *Chausseestrasse, West Berlin.* 1976–77

68. Laurenz Berges. *Perleberg*. 1992

69. Adam Bartos. *East Wall of General Assembly Room, United Nations, New York*. 1990

70. Thomas Struth. *Fischersand, Erfurt.* 1991

71. Thomas Struth. *Sommerstrasse, Düsseldorf.* 1980

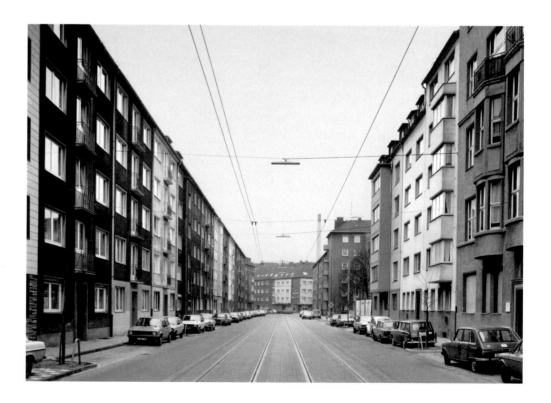

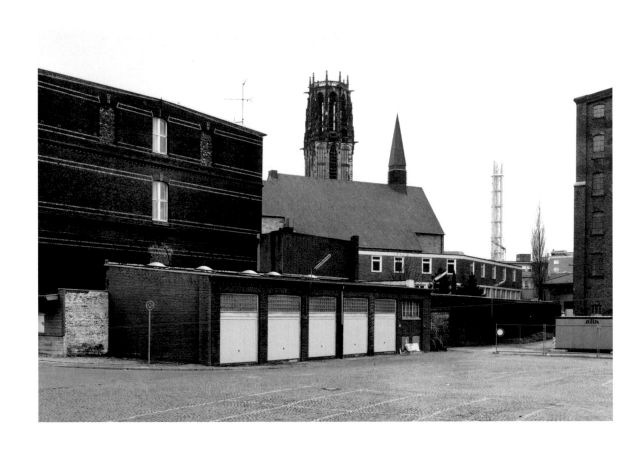

72. Thomas Struth. *View of Sankt Salvator, Düsseldorf.* 1985

73. Thomas Struth. *Hörder Brückenstrasse, Dortmund.* 1986

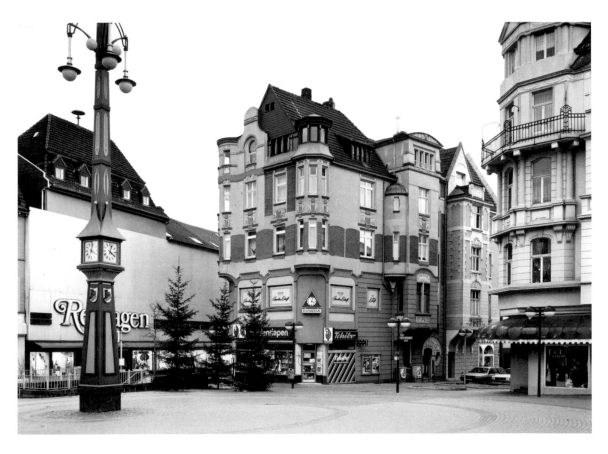

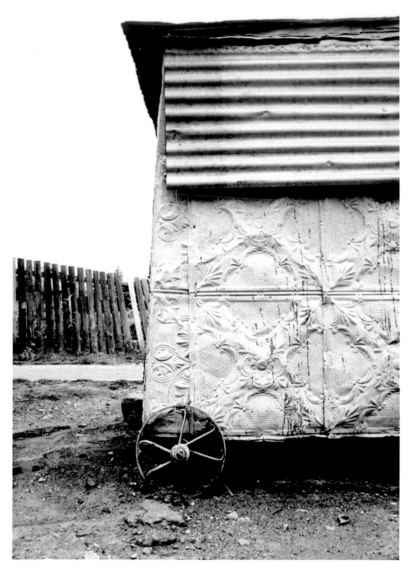

74. David Goldblatt. *Café-de-Move-On, Braamfontein, Johannesburg.* 1964

75. David Goldblatt. *Stairway, Meerlust Wine Farm near Stellenbosch.* 1990

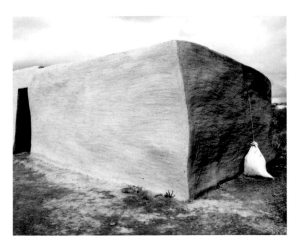

76. David Goldblatt. *House near Phuthaditjhaba, Qwa Qwa.* 1989

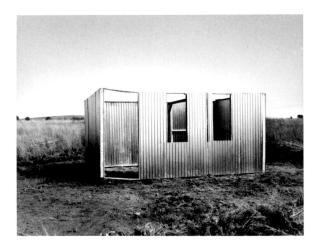

77. David Goldblatt. *A New Shack under Construction, Lenasia Extension 9, Lenasia, Transvaal.* 1990

78. David Goldblatt. *Garage Wall of a House in Verwoerdburg, Transvaal.* 1986

Evans was, and is, interested in what any present time will look like as the past.

—Walker Evans, 1961[1]

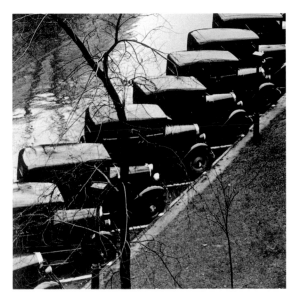

Walker Evans. *Main Street, Saratoga Springs, New York.* 1931. Detail of plate 87

Presumably Evans meant that he aimed to approach the present not with the bias of an interested party but with the dispassion of a historian or, better yet, an archaeologist. Of course this was an aesthetic ambition. But, for the artist no less than for the historian, it is a good deal more challenging to draw a persuasive picture of the present than of the past, for the simple reason that so few others have yet made the attempt.

We enjoy no privileged access to history that would permit us to judge Evans's ambition objectively; his work is as much a part of the past as a record of it. But we do know something about what to Evans was the unseen future, and it has amply confirmed the salience of his archaeological instincts.

In 1928, the year that Evans began making photographs, the Ford Motor Company discontinued production of the Model T. Over fifteen million of these cars, manufactured over a period of twenty years, had transformed the landscape of America and the lives of Americans. Like Thomas Edison's electric light bulb (1879) and George Eastman's Kodak (1888), Henry Ford's automobile had succeeded because the efficiencies of mass production made a useful thing inexpensively available to a mass public. Through the Model T, standardization brought a new chance of mobility and adventure into individual lives, and the paradox of modern America was born.

In Evans's photographs, hulking factories are often pictured as Satanic intrusions—ugly symbols of modern industry, an alien presence in the land (plates 83, 86). But the cars that were made in those factories by and for people played a much wider range of roles. The Model T parked in front of an old clapboard farmhouse is an intruder, perhaps, but it is also a stripped-down piece of practical American vernacular, whose profile Evans draws with the same foursquare respect that he accords to the facade of the house (plate 84). And, although the century or more that separates the house and the car is the picture's main event, the car itself is no longer new. It, too, has earned a place in our history.

What now seems most salient in Evans's image of the automobile is the degree to which it takes car culture for granted. In the art that would follow, car culture would become a symbol of both personal freedom and assembly-line anonymity, both high spirits and lonely pathos. It could become all this because it had become an inescapable part of being American; but it was already that for Evans, although it was then only a generation old. Especially when measured against modernism's mania for machines, Evans's familiarity with cars was prescient indeed.

1. Evans, quoted in John T. Hill and Jerry L. Thompson, eds., *Walker Evans at Work* (New York: Harper & Row, 1982), p. 151.

79. Edward Hopper. *Box Factory, Gloucester.* 1928

80. Ralph Steiner. *Saratoga Springs.* c. 1929

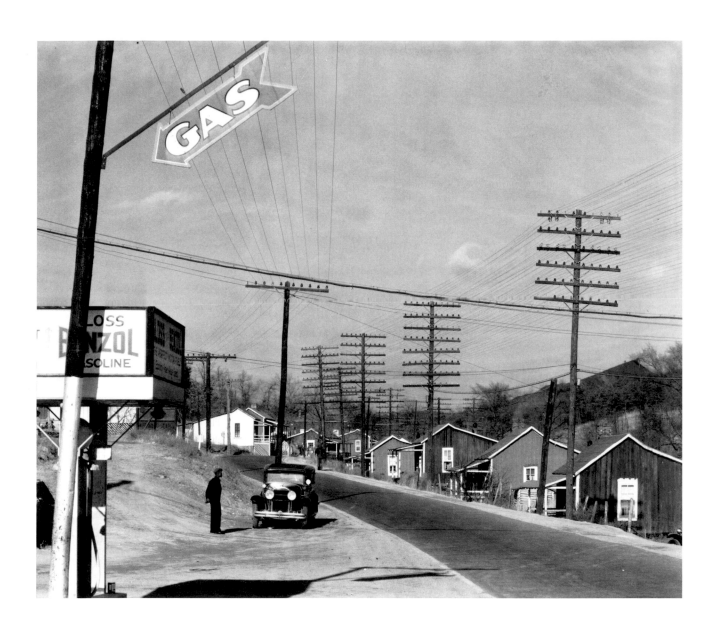

81. Walker Evans. *Roadside View, Alabama Coal Area Company Town.* 1936

82. Walker Evans. *Part of Morgantown, West Virginia.* 1935

83. Walker Evans. *Louisiana Factory and Houses.* 1935

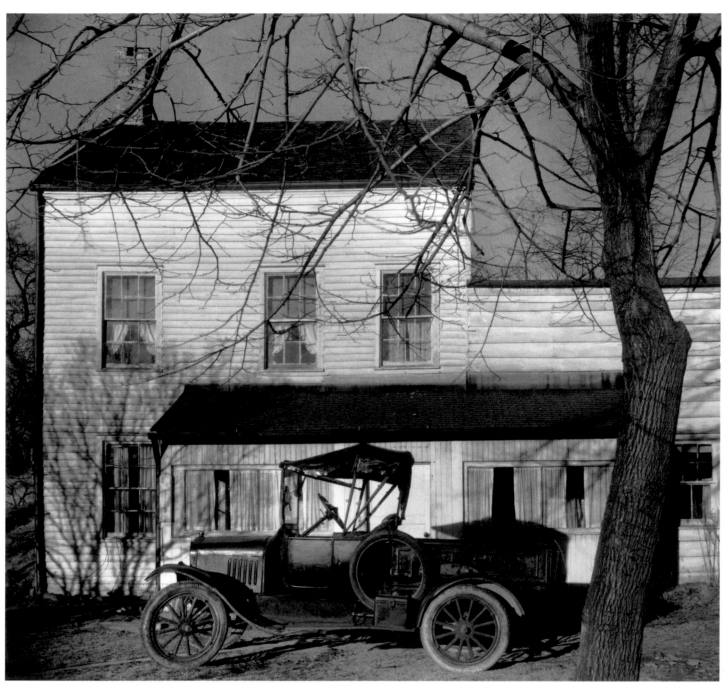

84. Walker Evans. *Farmhouse in Westchester County, New York*. 1931

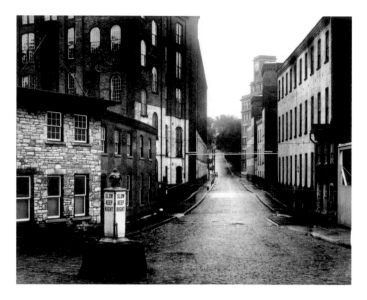

85. Walker Evans. *Factory Street in Amsterdam, New York*. 1930

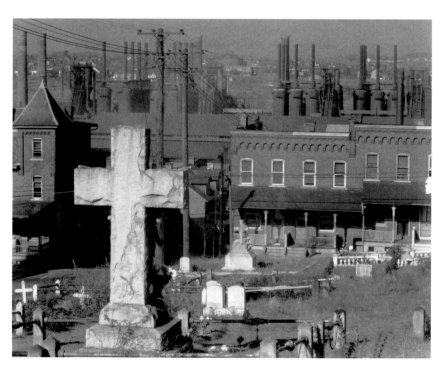

86. Walker Evans. *Bethlehem, Pennsylvania*. 1935

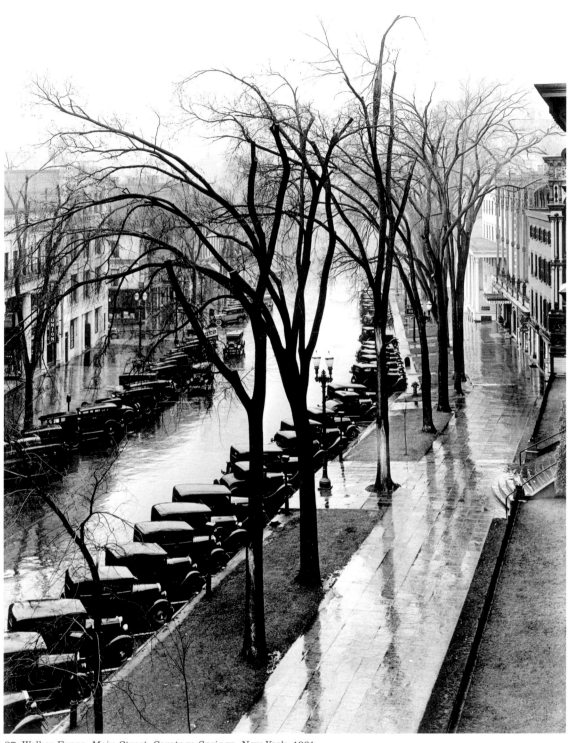

87. Walker Evans. *Main Street, Saratoga Springs, New York.* 1931

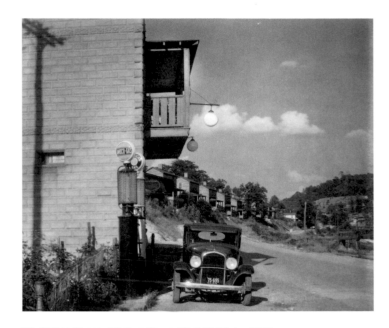

88. Walker Evans. *Mining Town, West Virginia.* 1936

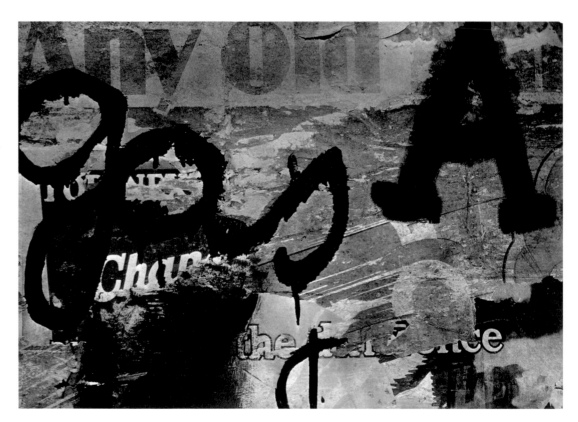

89. Walker Evans. *Roadside Gas Sign.* 1929

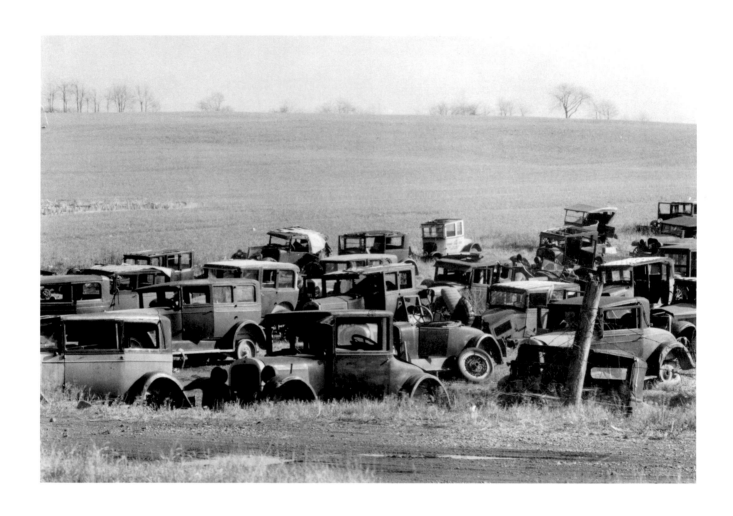

90. Walker Evans. *Joe's Auto Graveyard, Pennsylvania.* 1936

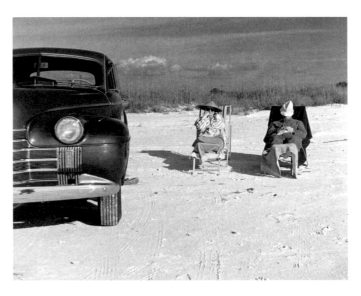

91. Marion Post Wolcott. *Winter Tourists.* 1940

92. Wright Morris. *Mailboxes, Western Nebraska.* 1947

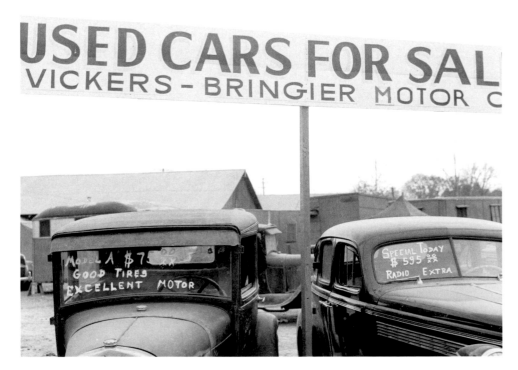

93. Marion Post Wolcott. *Service Station, Used Cars for Sale. Alexandria, Louisiana.* 1940

94. Rudy Burckhardt. *Queens.* 1942–43

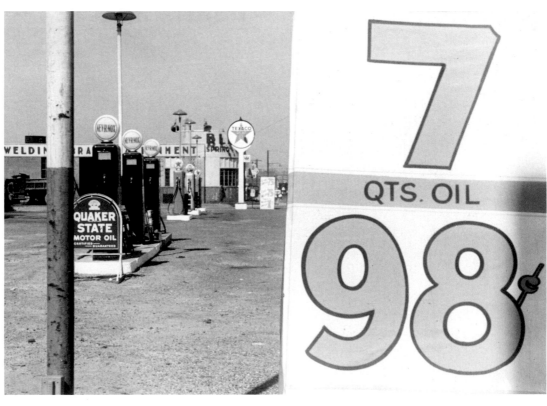

95. Rudy Burckhardt. Untitled. From the album *An Afternoon in Astoria.* 1940

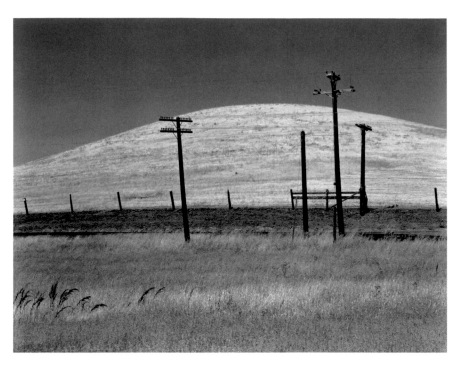

96. Edward Weston. *Hills and Poles, Solano County.* 1937

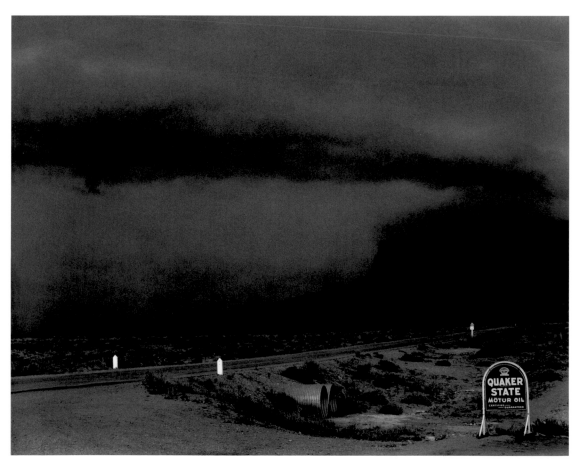

97. Edward Weston. *Quaker State Oil, Arizona.* 1941

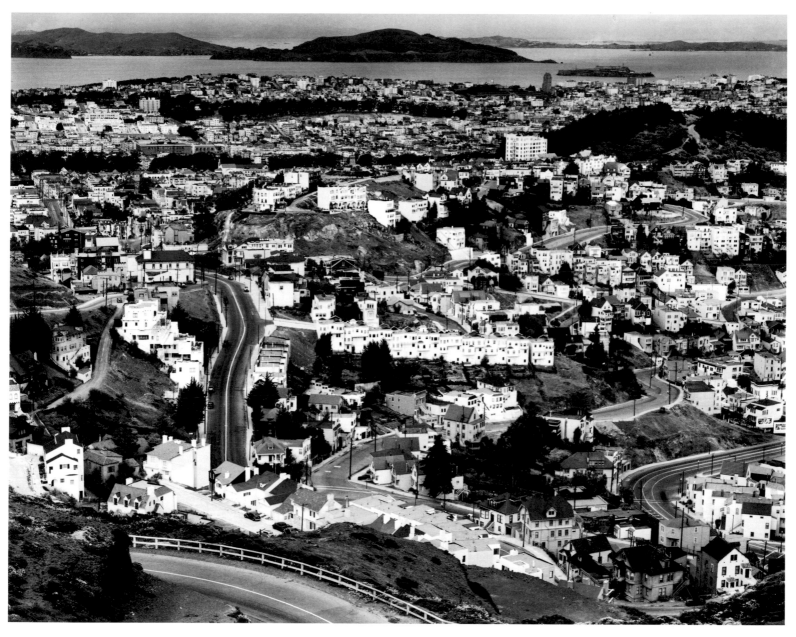

98. Brett Weston. *View of San Francisco Towards Telegraph Hill.* 1939

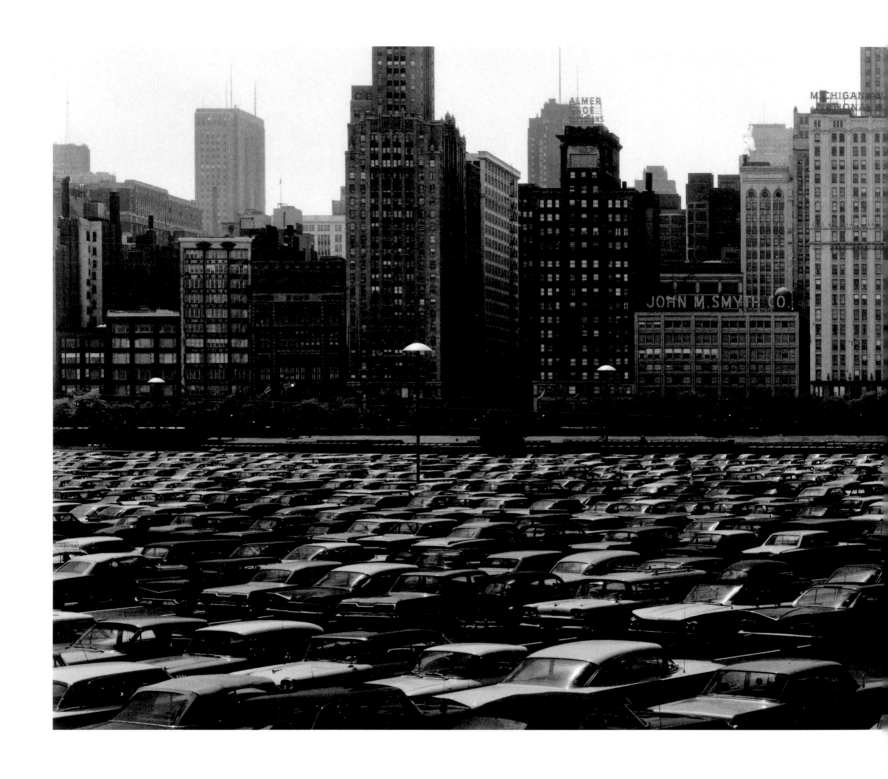

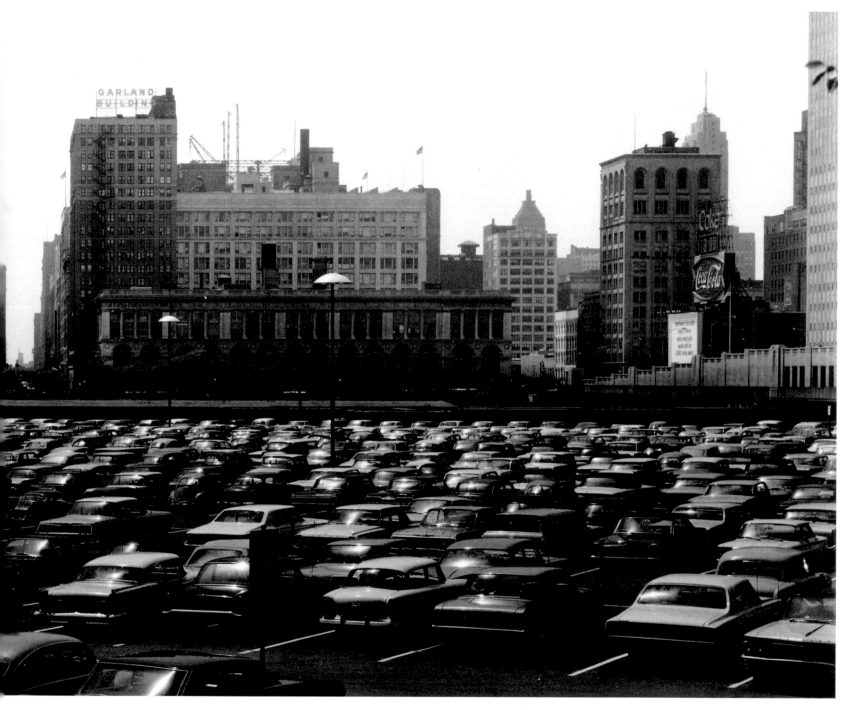

99. Art Sinsabaugh. *Chicago Landscape #85.* 1964

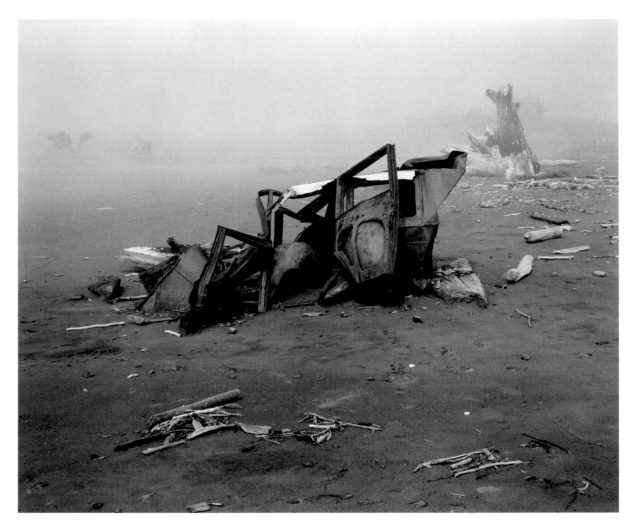

100. Edward Weston. *Wrecked Car, Crescent Beach*. 1939

101 (opposite). Robert Rauschenberg. *First Landing Jump*. 1961

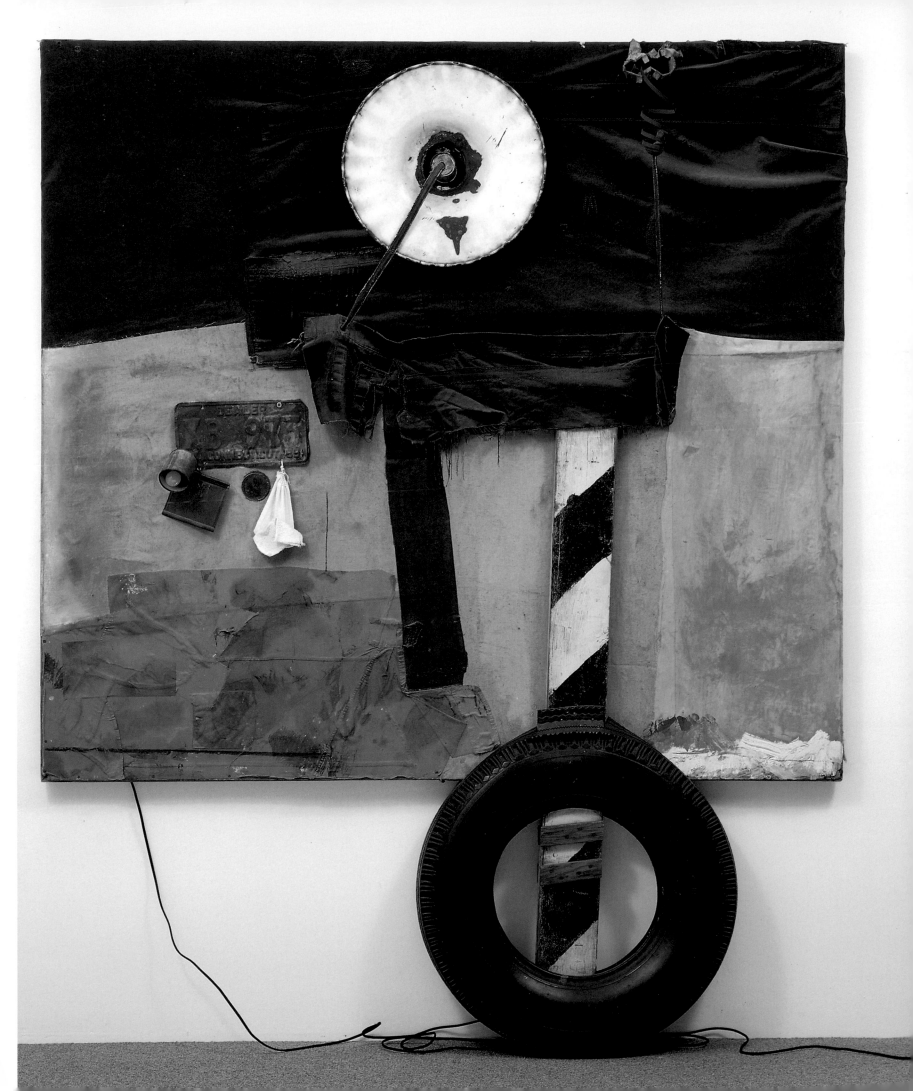

102. Robert Frank. *Covered Car, Long Beach, California*. 1955–56

103. Lee Friedlander. *New York City.* 1963

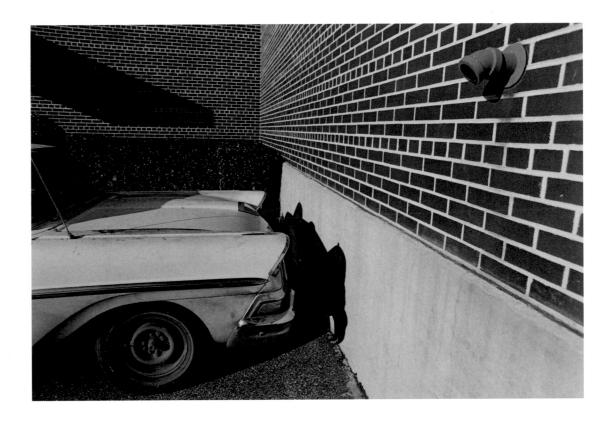

104. William Eggleston. *Memphis.* 1971

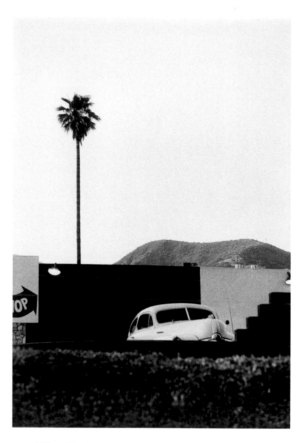

105. Elliott Erwitt. *Hollywood.* 1959

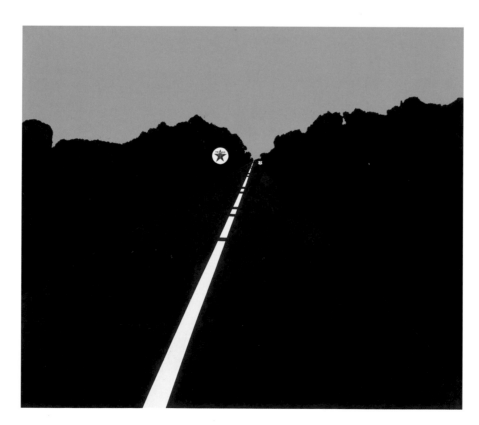

106. Allan D'Arcangelo. *U.S. Highway 1, Number 5.* 1962

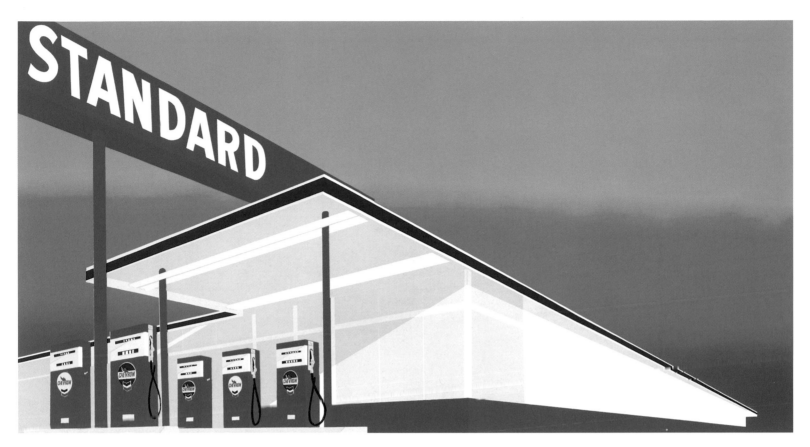

107. Edward Ruscha. *Standard Station*. 1966

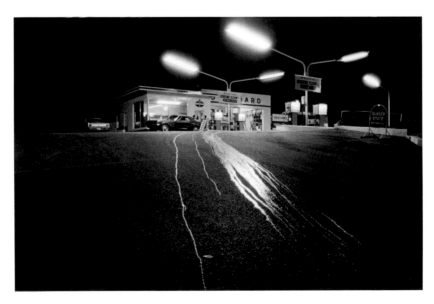

108. Tod Papageorge. *Kansas*. 1969

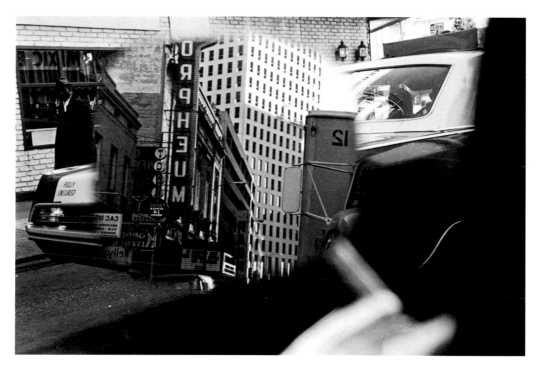

109. Lee Friedlander. *New Orleans*. 1969

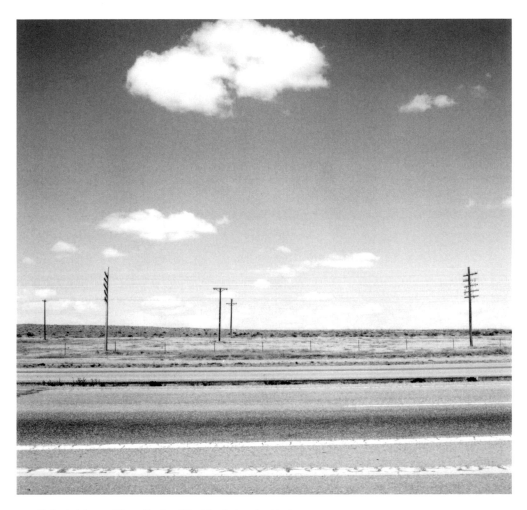

110. Robert Adams. *Eden, North of Pueblo, Colorado.* 1970

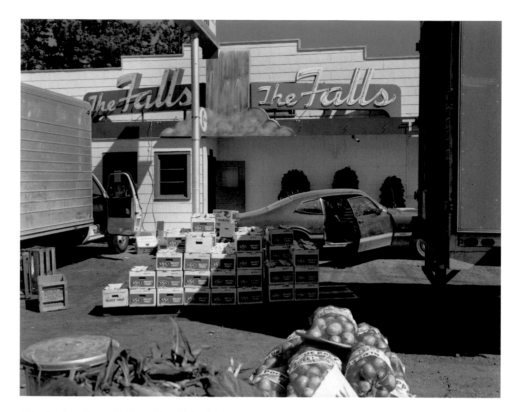

111. Stephen Shore. *U.S. 10, Post Falls, Idaho.* 1974

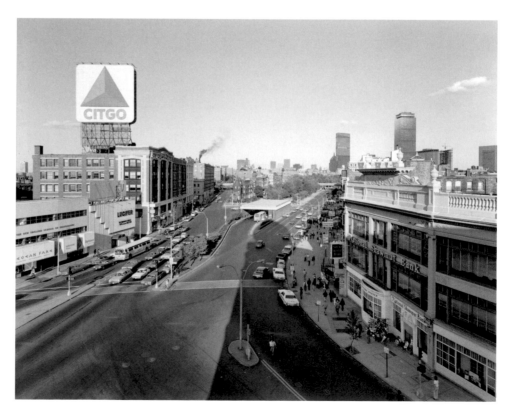

112. Nicholas Nixon. *View of Kenmore Square, Boston.* 1974

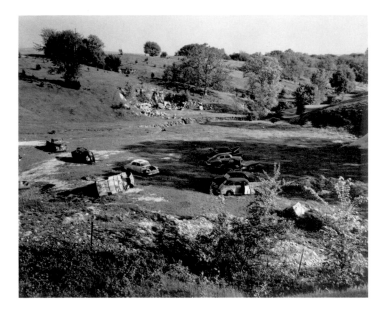

113. Paul Vanderbilt. *Vicinity of Beetown, Wisconsin.* 1962

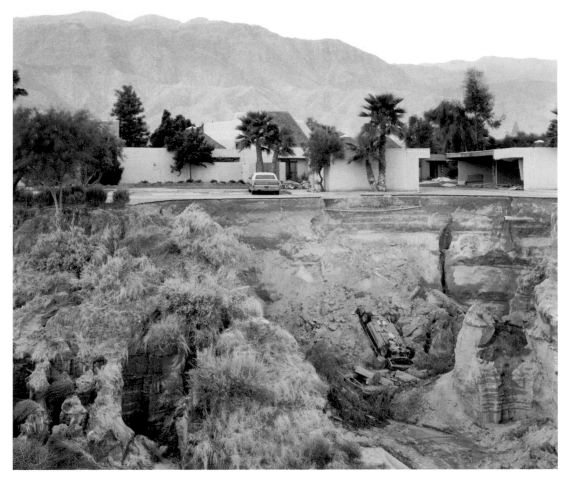

114. Joel Sternfeld. *After a Flash Flood, Rancho Mirage, California.* 1979

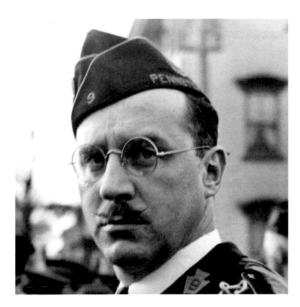

Walker Evans. *American Legionnaire*. 1936. Detail of plate 128

Honoré Daumier trained his razor wit on the entire panorama of nineteenth-century French society from the peasantry to the aristocracy, but his favorite target was the bourgeoisie. For worse and for better the bourgeois was the essential figure of modernity, and while his habits often seemed painfully provincial, he was in essence an inhabitant of the city.

In the medieval village each person was known to all, and his or her place in the social hierarchy was irrevocably fixed. In the streets of the modern city we are strangers to each other, and we judge each other's social identities by noticing one another's clothing, bearing, and gestures, and through the exchange of glances. The modern urban scene is a feast for the eye, and looking is the first and most common form of social intercourse.

Daumier's prints of the 1830s through the 1870s helped to create a lively tradition of acute social observation, which thrived at the heart of early modernism. Toward the end of the nineteenth century, as the momentum of the avant-garde shifted from observation toward formal experiment, the vitality of that tradition waned. Perhaps its last great expression in the old mediums of painting and printmaking was the acid eye that German artists such as Otto Dix and George Grosz fixed upon the rotten bourgeoisie in the wake of the Great War (plates 115, 116).

Photography soon picked up the thread, largely thanks to the advent of the hand-held camera, which roughly coincided with the waning of hand-drawn observation. The small camera's portability and instantaneity of exposure all but erased the difference between a quick glance and its permanent pictorial expression. Although the device began to reach a vast amateur market in the 1890s, its career as a tool of the modern artist awaited the irreverent climate of photographic experiment that swept Europe in the 1920s and 1930s. Beginning in 1928, Evans was among the first Americans to exploit its capacities, and his streetwise sketches significantly enlarged the scope of his otherwise largely unpeopled art.

Like his view-camera photographs and August Sander's portraits, Evans's small-camera pictures of people are all but devoid of narrative incident. In this respect, his work would seem to have contributed little to the vibrant postwar strain of American photography that culminated in the 1960s and 1970s and celebrated the street as an unscripted theater of Rabelaisian behavior. But in fact Evans's style of static scrutiny has enjoyed a lasting resonance. In a great deal of small-camera work to this day, the essential social transaction does not take place among the actors on the street. Rather, it is an encounter between the viewer (now standing in the place of the photographer) and an individual about whom neither viewer nor photographer could know anything except what is seen.

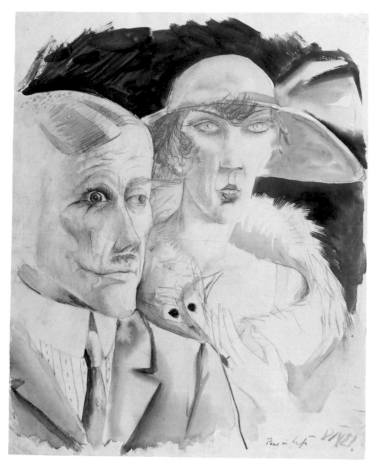

115. Otto Dix. *Café Couple.* 1921

116. George Grosz. *Dr. Huelsenbeck at the End.* 1920.
From the book *Ecce Homo.* 1923

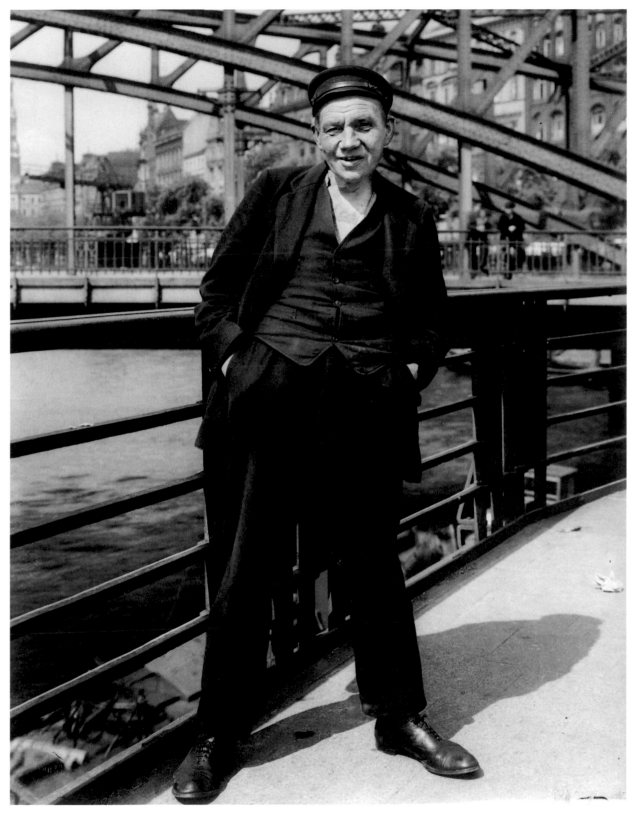

117. August Sander. *Unemployed Sailor*. 1928

118. Edward Hopper. *Girl on a Bridge*. 1923

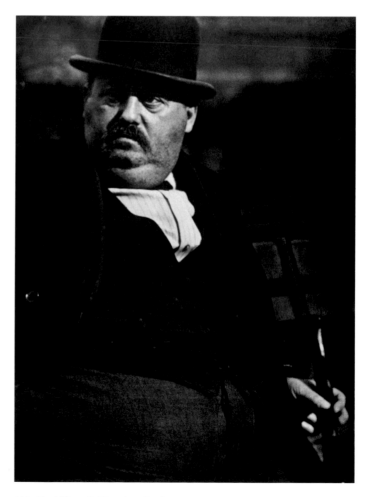

119. Paul Strand. *Man in a Derby*. 1916

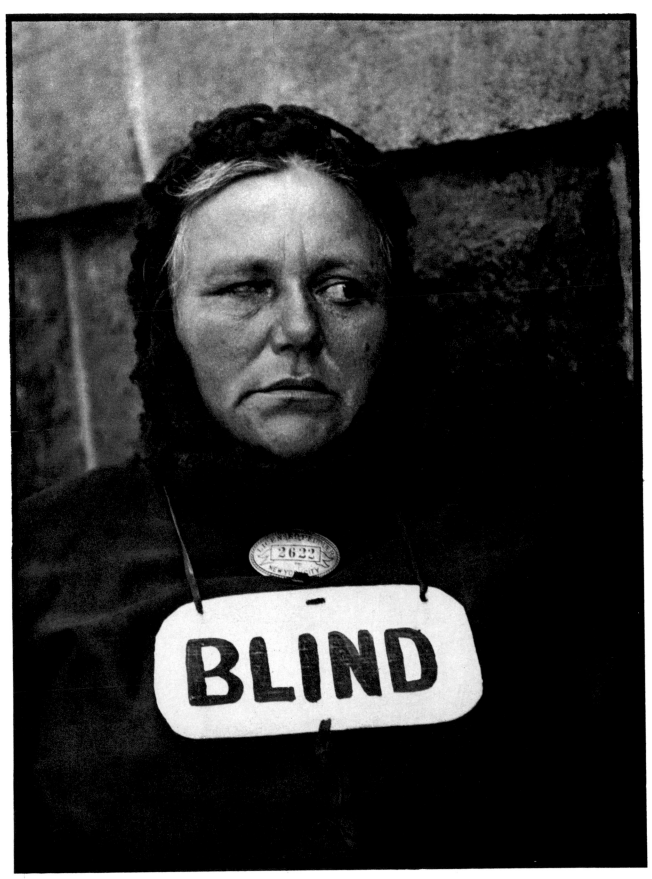

120. Paul Strand. *Blind.* 1916

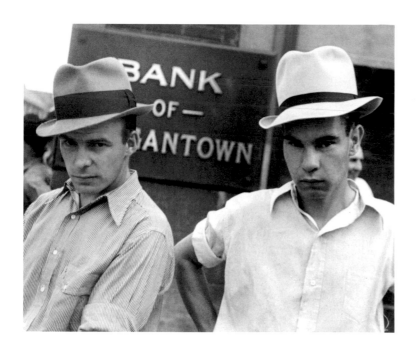

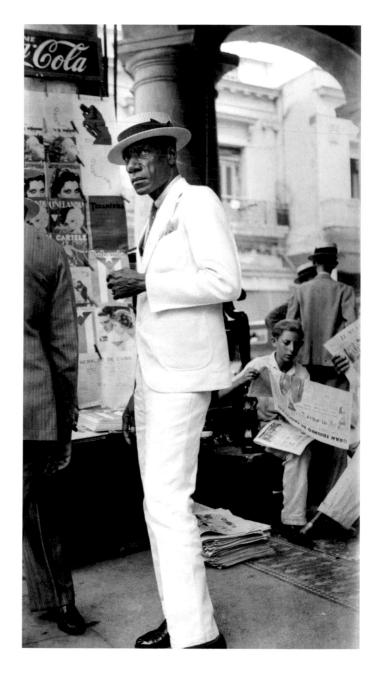

123. Walker Evans. *Posed Portraits, New York.* 1931 124. Walker Evans. *Couple at Coney Island, New York.* 1929

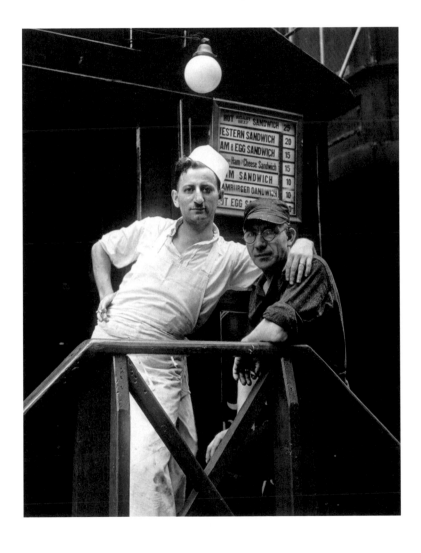

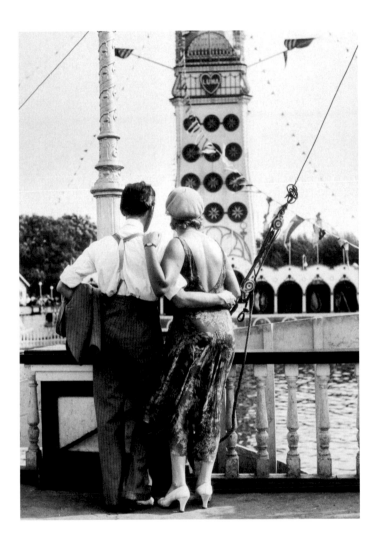

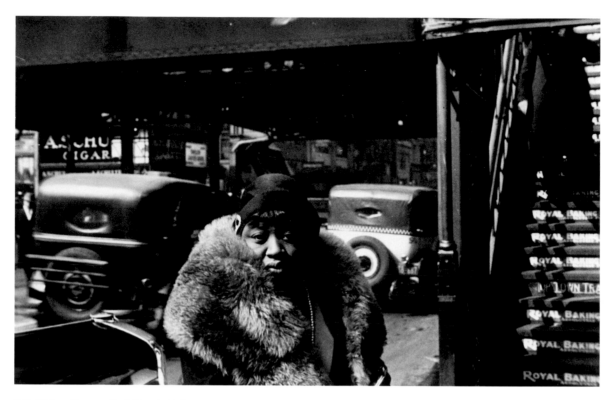

125. Walker Evans. *42nd Street*. 1929

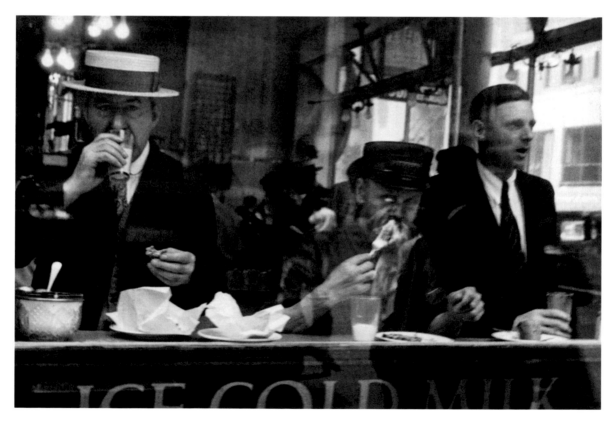

126. Walker Evans. *City Lunch Counter, New York*. 1929

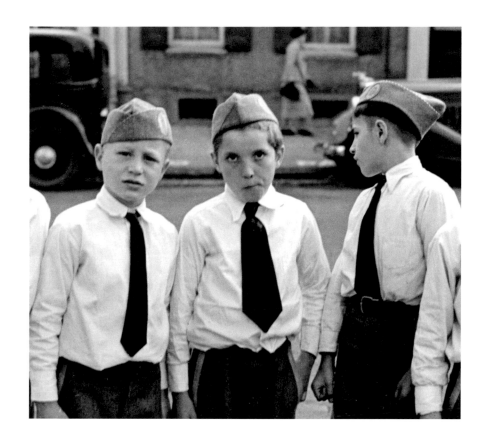

127. Walker Evans. *Sons of the American Legion.* 1936

128. Walker Evans. *American Legionnaire.* 1936

129. Walker Evans. *Resorters at St. Petersburg.* 1941

130. Walker Evans. *Corner of State and Randolph Streets, Chicago.* 1946

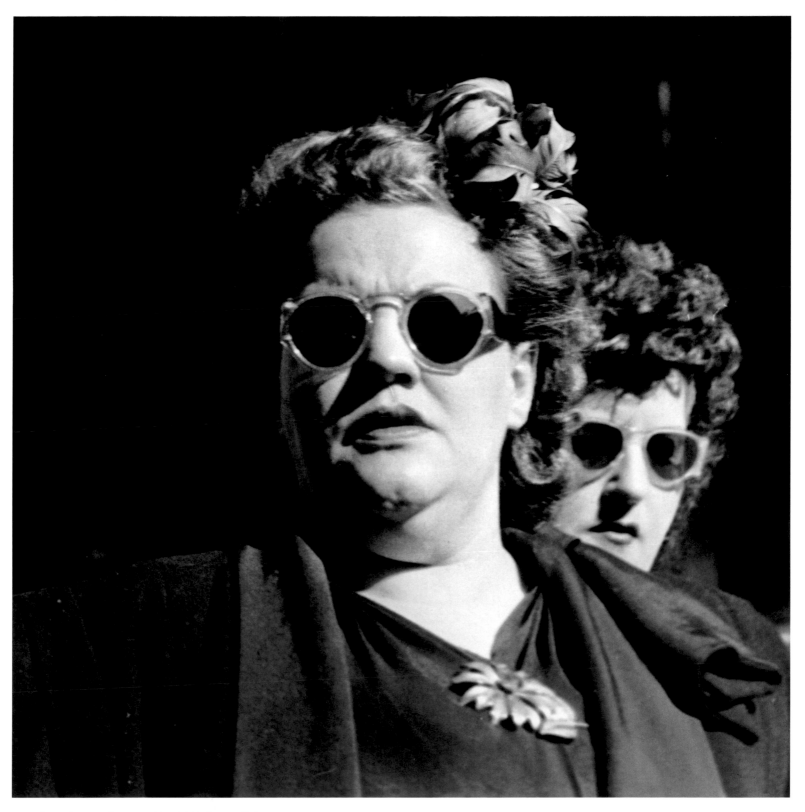

131. Walker Evans. *Shoppers, Randolph Street, Chicago.* 1947

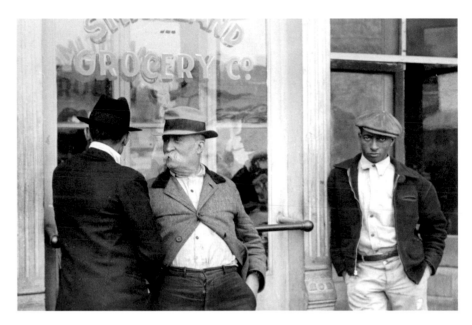

132. Ben Shahn. *Scene at Smithland, Kentucky.* 1935

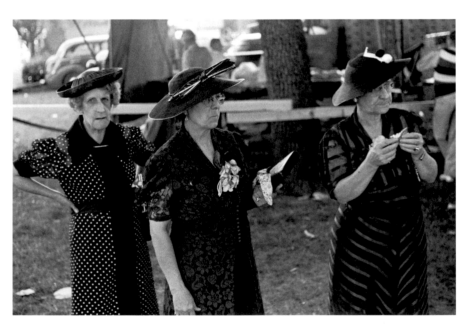

133. Ben Shahn. *Women at Fourth of July Carnival and Fish Fry, Ashville, Ohio.* 1938

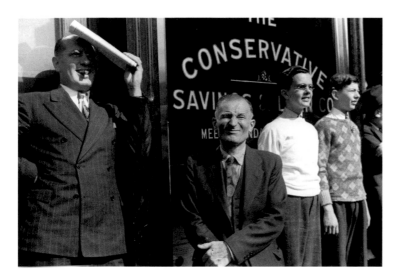

134. John Vachon. *The Flag Is Going By, Sesquicentennial Parade,
 Cincinnati, Ohio.* 1938

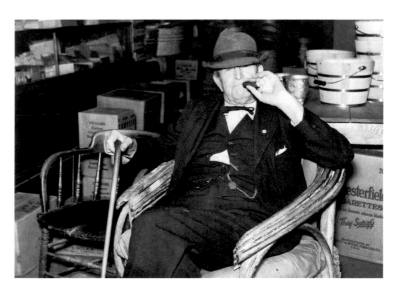

135. Marion Post Wolcott. *Mr. R. B. Whitley Visiting His General Store.* 1939

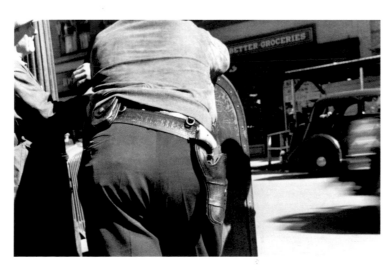

136. Ben Shahn. *Deputy in a West Virginia Mining Town.* 1935

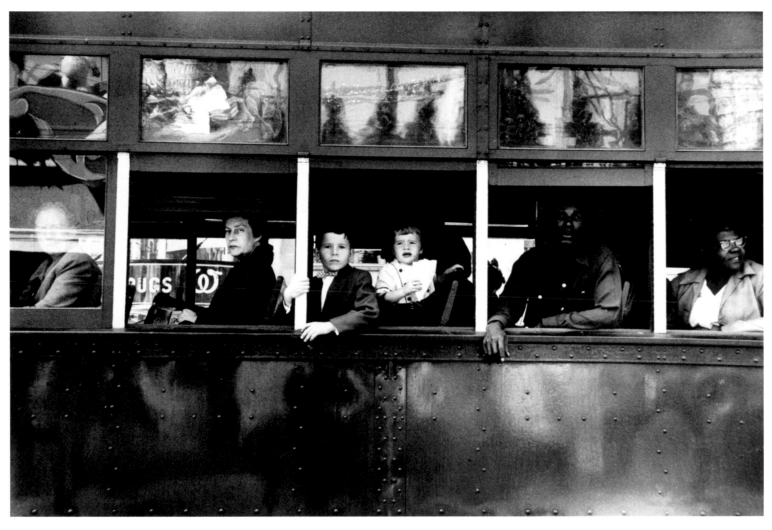

137. Robert Frank. *Trolley, New Orleans.* 1955

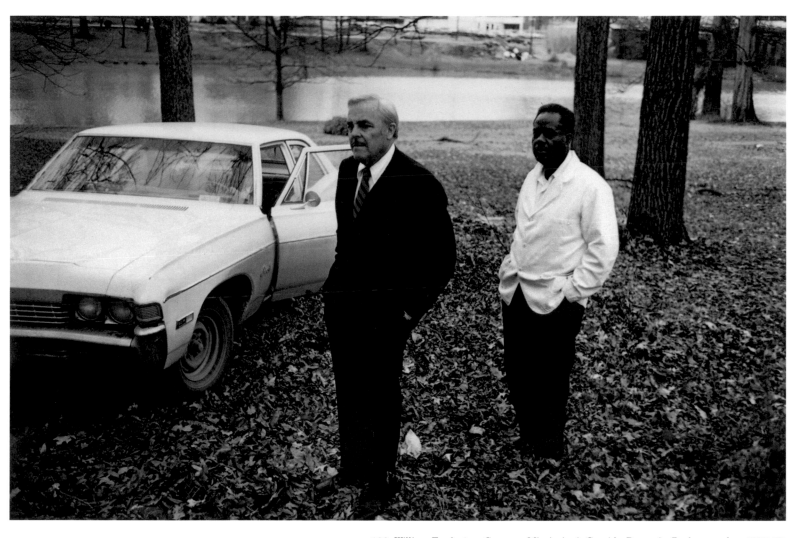

138. William Eggleston. *Sumner, Mississippi, Cassidy Bayou in Background.* c. 1969–70

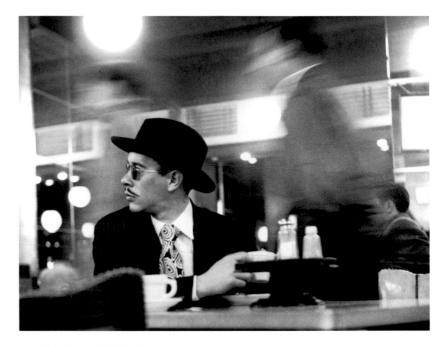

139. Ted Croner. *Untitled*. 1947

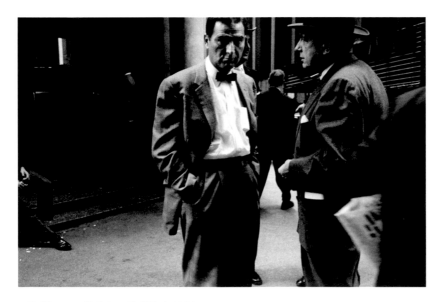

140. Simpson Kalisher. *Untitled*. 1961

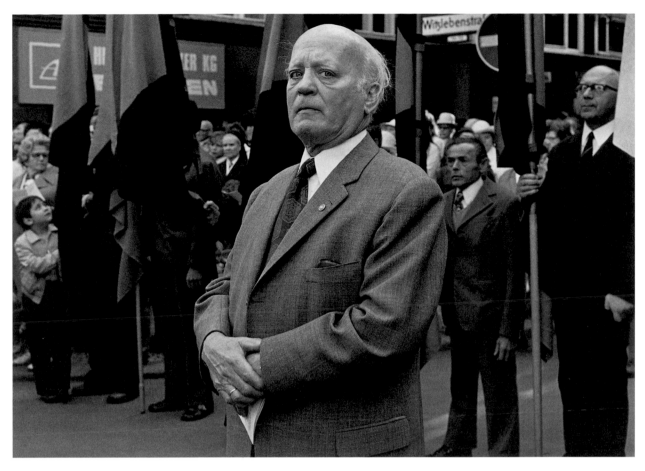

141. Gabriele and Helmut Nothhelfer. *Catholic at Corpus Christi Day, Berlin.* 1974

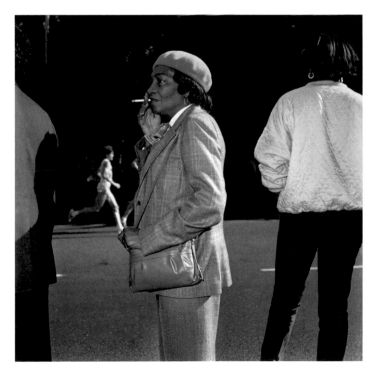

142. Jeffrey Scales. *Woman Smoking, Fifth Avenue.* 1985

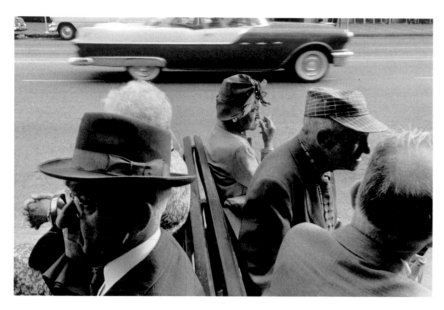

143. Robert Frank. *St. Petersburg, Florida.* 1957

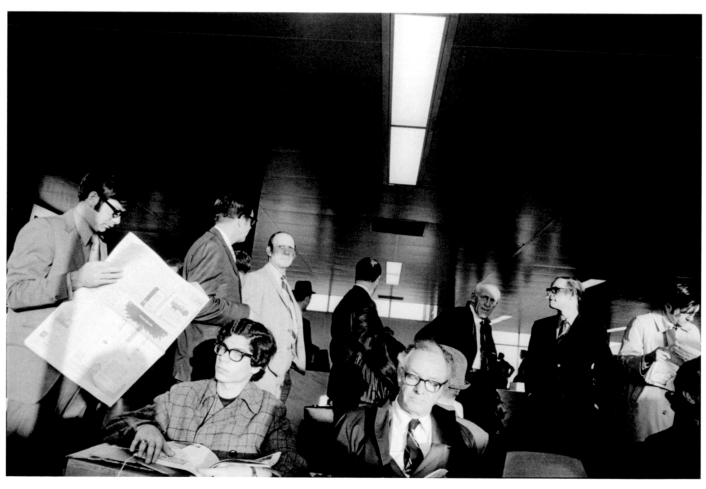

144. Garry Winogrand. *New York City Airport.* c. 1972

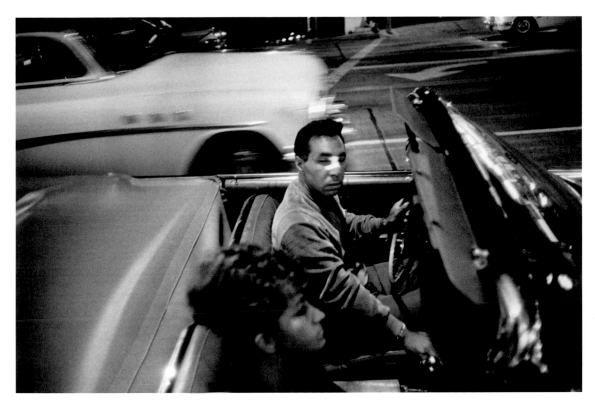

145. Garry Winogrand. *Los Angeles*. 1964

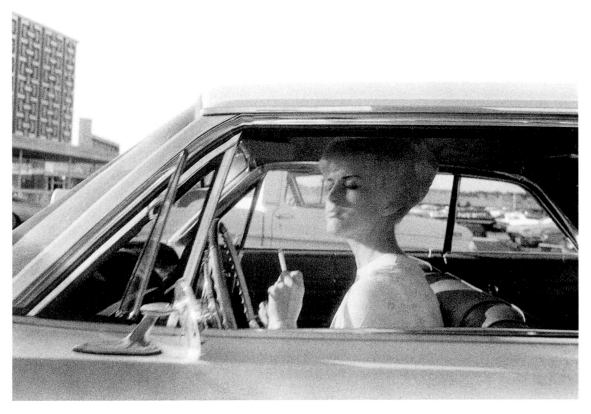

146. William Eggleston. *Untitled*. Late 1960s

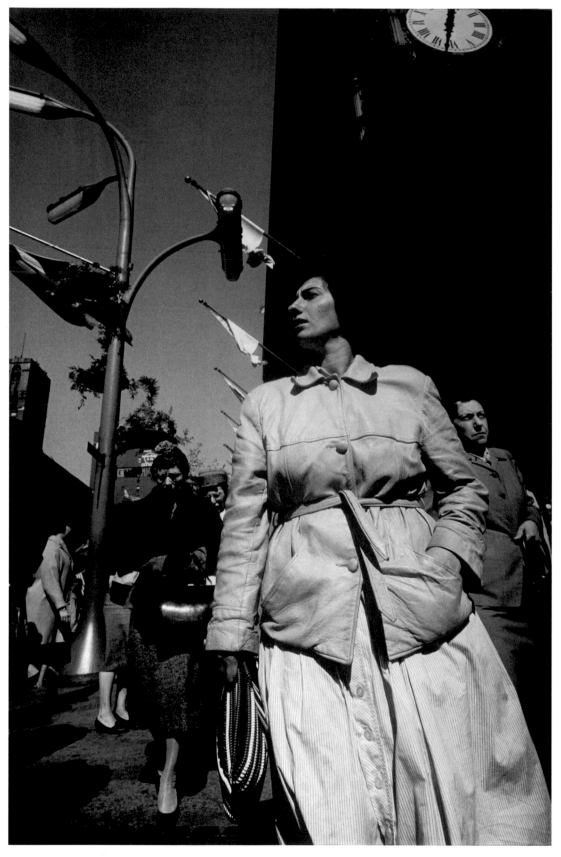

147. Harry Callahan. *Chicago.* 1961

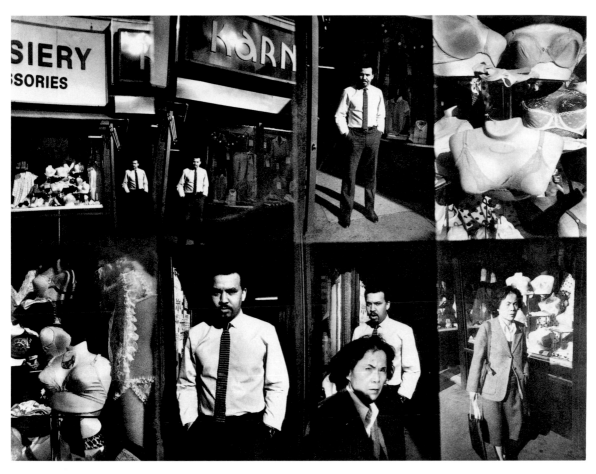

148. Michael Spano. *81st and Broadway.* 1984

149. Dawoud Bey. *A Man Looking at Pants on Fulton Street.* 1989

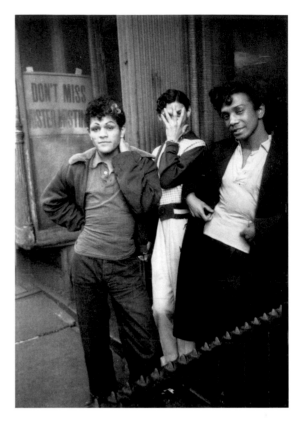

151. Robert Frank. *East Side, New York City*. 1955

150. Joseph Sterling. *Teenagers*. 1960

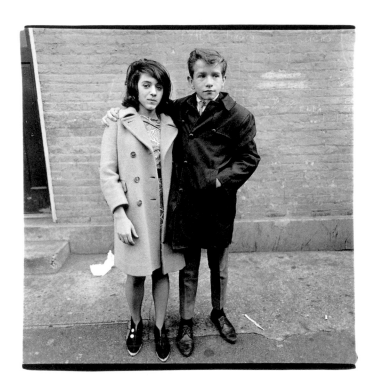

152. Diane Arbus. *Teenage Couple on Hudson Street, New York City.* 1963

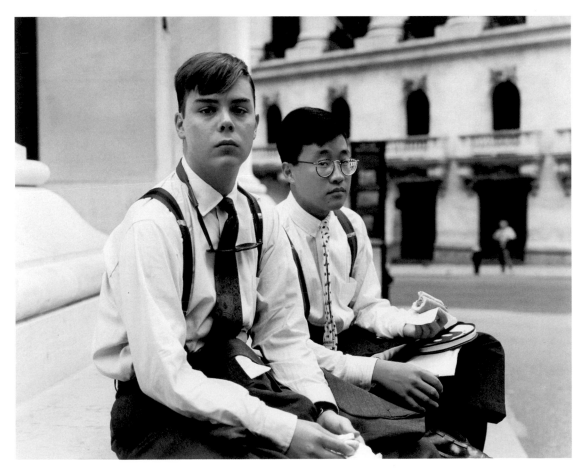

153. Joel Sternfeld. *Summer Interns, Wall Street, New York.* 1987

Walker Evans. *Bed and Stove, Truro, Massachusetts*. 1931. Detail of plate 157

From the outside, Evans photographed banks, schools, churches, stores, factories, gas stations, and houses. From the inside, he mostly photographed houses. The fact is noteworthy, especially since a photographer generally finds it much easier to gain access to public places than to private ones.

Once inside, Evans recorded the scene with the same archaeological precision that he regularly applied to the exterior. His commentary on a Nebraska interior of 1947, by Wright Morris (plate 164), suggests the way he intended his own pictures to be read:

Some of the shoddiness and all the heartbreak of the century seem imprinted in [this] photograph . . . by Wright Morris. Engraved forever are those hideous designs on the chair back; and the peeling plywood of the chair seat, the stains on the floor linoleum, are here placed on permanent record. You know just how that cheap door hardware sounds, and how it is to the touch. You know, too, that there is fly-paper somewhere in the room, just out of sight. This is a perfect example of photography's habit, when guided by a master, of *picking up* searing little spots of realism and of underlining them, quietly, proportionately.[1]

Like Morris (born in 1910 in Nebraska), Evans (born in 1903 in Missouri) knew that this picture was not a simple tribute to the pioneer spirit but a recognition of the precarious arrival of industry and commerce on the frontier. So, too, does John Szarkowski (born in 1925 in Wisconsin):

Morris's picture of the straight-backed chair describes without obvious inflection a modern industrial product, made in Michigan, perhaps, that stands on another modern industrial product, a linoleum probably bought from Sears Roebuck and probably made in Georgia. It is interesting to note that nothing in the picture is native to the place where the picture was made. The door and the baseboard and trim came from the pineries of Wisconsin or Minnesota, and were milled into interchangeable parts somewhere on the banks of the Mississippi. The surface-mounted door latch and the porcelain knob may have come from Connecticut or Massachusetts, or perhaps from Ohio, but not from Nebraska. If we had eaten dinner at a settler's table, we would have tasted no drink native to the place, and after dinner heard no song written there. This is not meant as a criticism of the settlers, who were of course still colonists, importing from home such tools and modest comforts that might help them find a way to live in a strange new landscape, and who were defeated and sent packing before they had much chance to become intimate with the place, and begin to make it their own.[2]

Without the help of an Evans or a Szarkowski, few viewers born later and elsewhere would be able to analyze Morris's picture in this way, and thus few would be prepared to grasp why Evans saw in it "all the heartbreak of the century." To observers who have assumed that Evans's impersonal style addresses only impersonal matters, his appeal to emotion may come as a surprise. But it helps to explain the preponderance of domestic interiors in Evans's work—scenes in which the artifacts of a collective culture are also dense with evidence of the living of individual lives.

1. Evans, "Photography," in Louis Kronenberger, ed., *Quality: Its Image in the Arts* (New York: Atheneum, 1969), p. 180.

2. John Szarkowski, "Wright Morris the Photographer," in Sandra S. Phillips and Szarkowski, *Wright Morris: Origin of a Species*, exh. cat. (San Francisco: San Francisco Museum of Modern Art, 1992), p. 16.

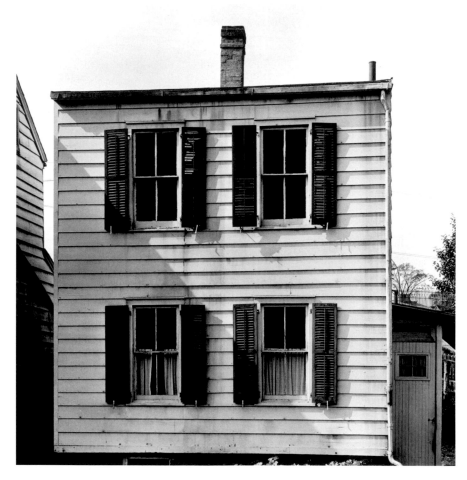

154. Walker Evans. *Wooden House in Ossining.* 1930

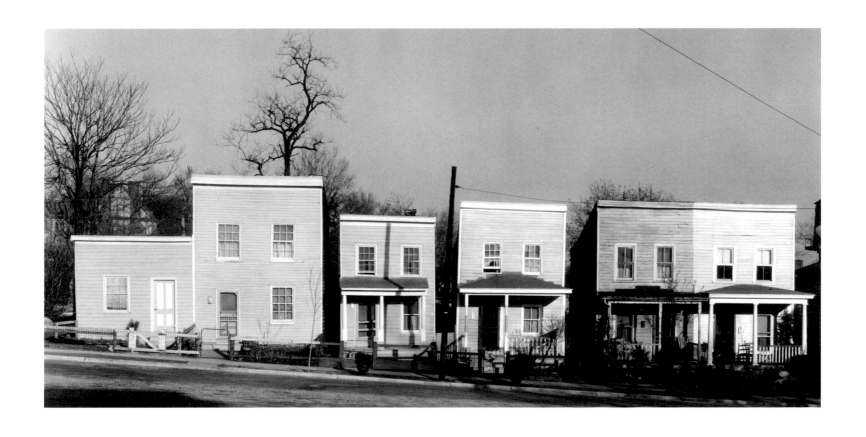

155. Walker Evans. *Frame Houses in Virginia.* 1936

156. Walker Evans. *New York State Farm Interior*. 1931

157. Walker Evans. *Bed and Stove, Truro, Massachusetts*. 1931

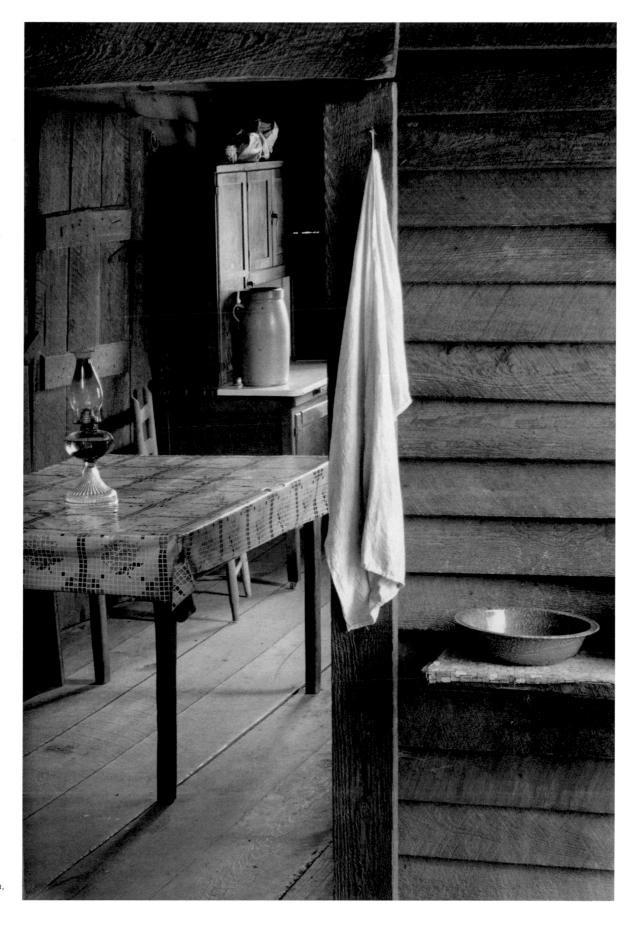

158. Walker Evans. *Farmer's Kitchen,
Hale County, Alabama.* 1936

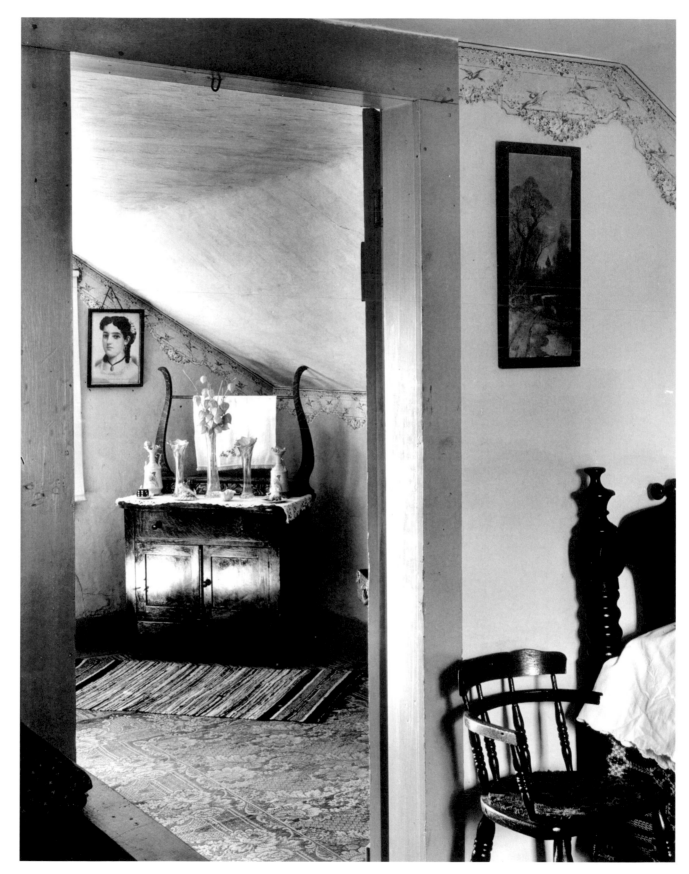

159. Walker Evans. *Interior near Copake, New York*. 1933

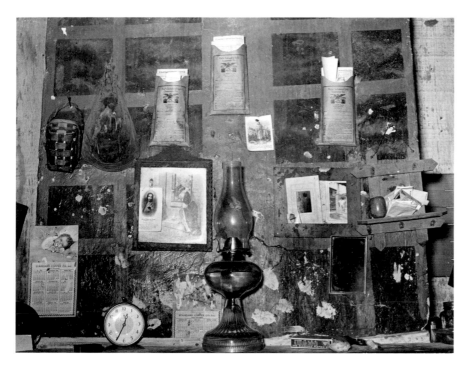

160. Russell Lee. *Decorations above Mantel in Negro
Home along the Levee, Norco, Louisiana.* 1938

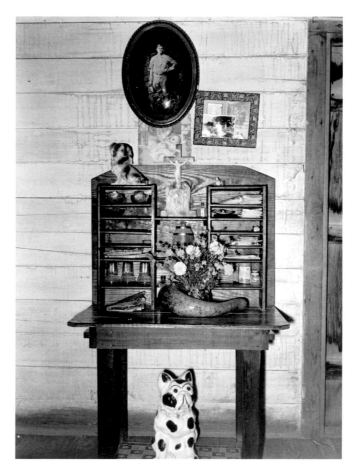

161. Russell Lee. *Desk in Home of Acadian Family near Breaux
Bridge, Louisiana.* 1938

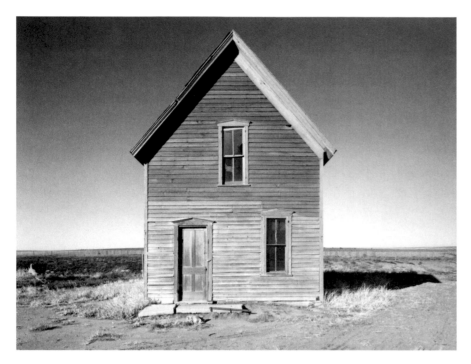

162. Wright Morris. *Farmhouse near McCook, Nebraska.* 1941

163. John Szarkowski. *Screen Porch, Hudson, Wisconsin.* 1950

161. Wright Morris. *Straightback Chair, Home Place.* 1947

165. Russell Lee. *New Houses Built by Negroes in Better Residential Section, South Side of Chicago, Illinois.* 1941

166. Robert Venturi. *Vanna Venturi House, Chestnut Hill, Pennsylvania, Preliminary Version F (Final)*. c. 1961–62

167 (opposite). Dan Graham. *"Baroque" Bedroom, "Model Home," Staten Island, New York; Motel, San Francisco*. 1967/1982

Top: 'Baroque' Bedroom, 'Model Home', Staten Island, N.Y. Bottom: Motel, San Francisco 1982 *signature*
1967

168. Garry Winogrand. *New Mexico*. 1957

169. Robert Adams. *Tract House, Longmont, Colorado.* 1973

170. Robert Adams. *Colorado Springs, Colorado.* 1970

171. William Eggleston. *Untitled.* Late 1960s

172. James Casebere. *Subdivision with Spotlight.* 1982

173. Joe Deal. *Model Home, Phillips Ranch, California*, 1984

174. Joel Sternfeld. *Lake Oswego, Oregon*. 1979

175. Thomas Roma. *Dutch House.* 1975

176. Frank Gohlke. *House and Cypress Trees, Hellsboro, Texas.* 1978

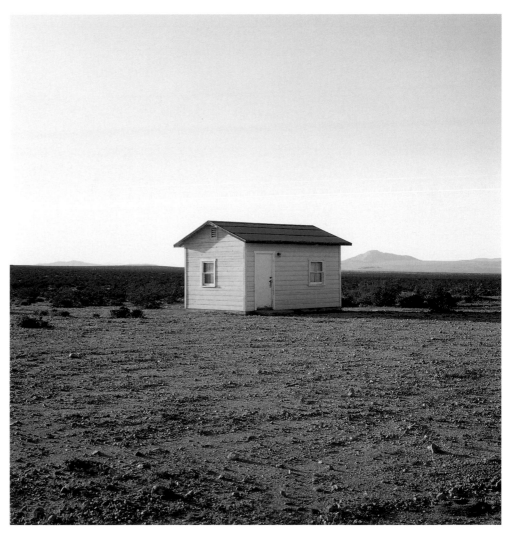

177. John Divola. *N34° 14.264' W116° 09.877'*. 1995–98

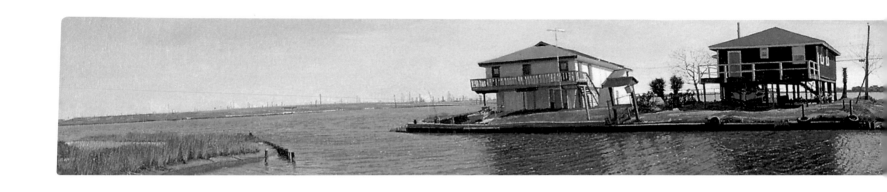

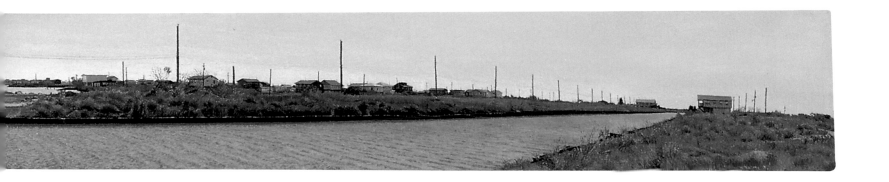

178. Rackstraw Downes. *Canal Home at Bayou Vista*. 1993

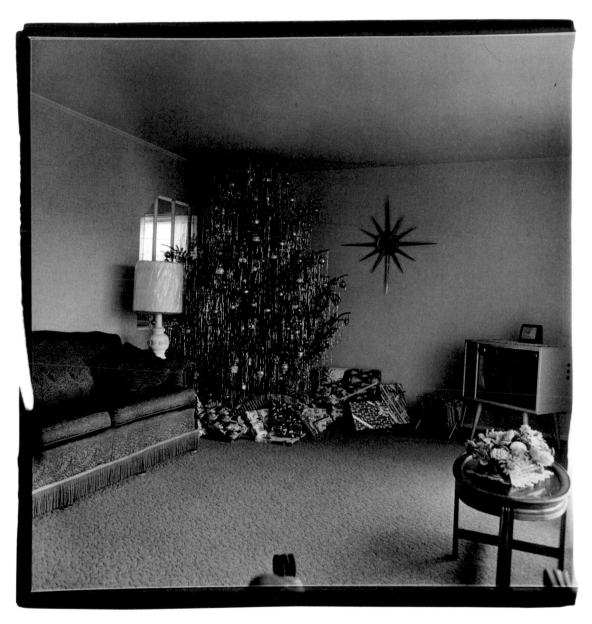

179. Diane Arbus. *Xmas Tree in a Living Room in Levittown, Long Island*. 1963

180 (opposite). William Eggleston. *Memphis*. c. 1972

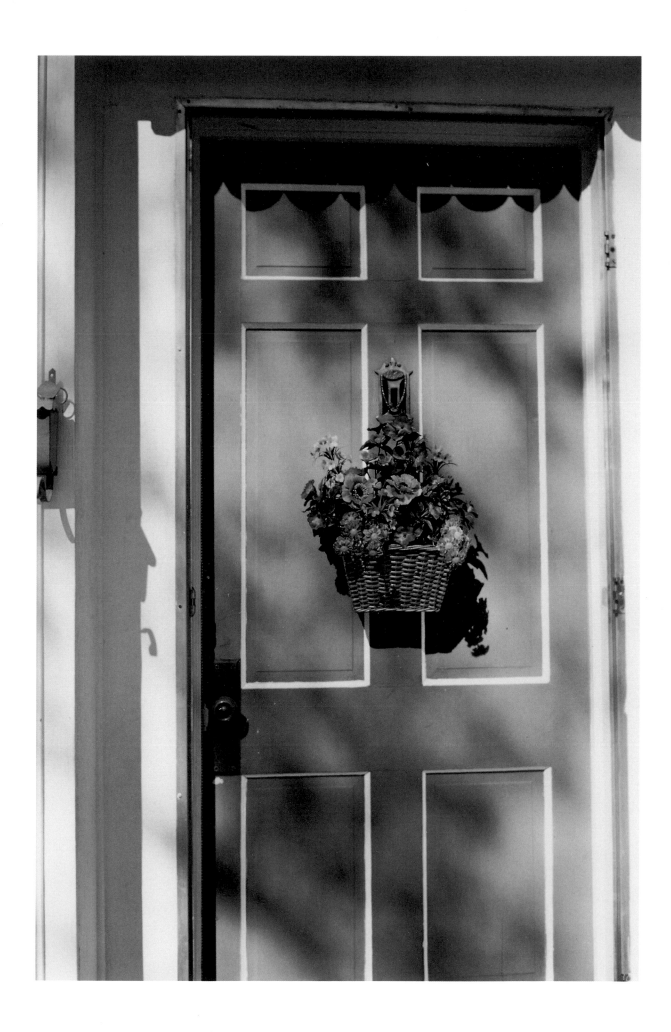

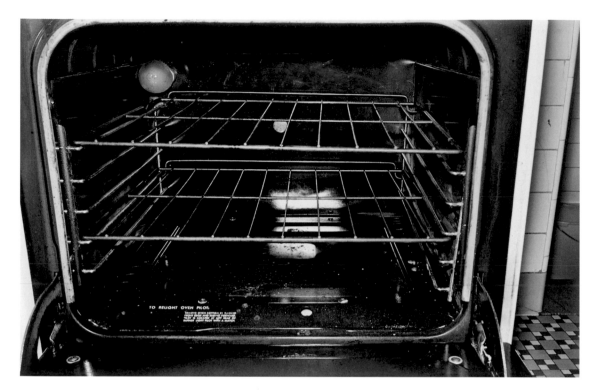

181. William Eggleston. *Memphis*. c. 1972

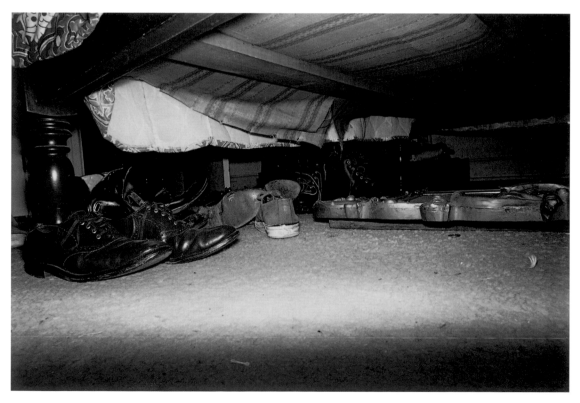

182. William Eggleston. *Memphis*. c. 1972

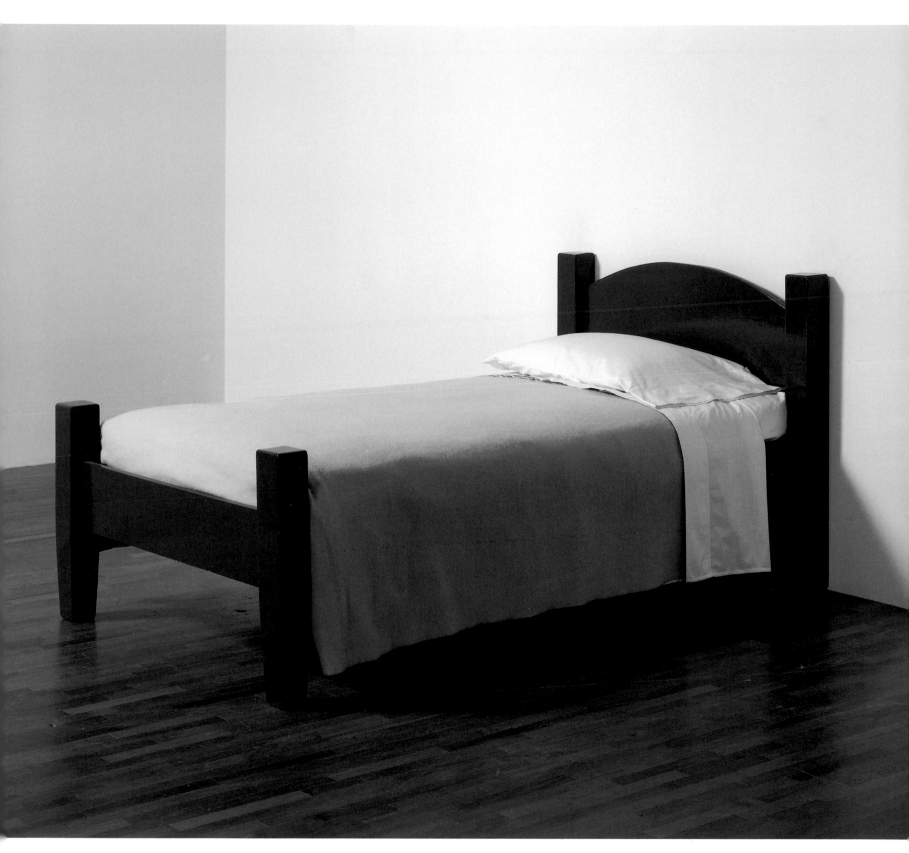

183. Robert Gober. Untitled. 1986

Walker Evans, *License Photo Studio, New York*. 1934. Detail of plate 204

E vans often spoke of photography as a form of collecting. What he collected were things (and people) that struck his eye as signs of the times. It is not surprising, then, that he often photographed signs in the literal sense—words and images that had been deliberately designed to communicate. Or perhaps one may simply say that he often photographed images, since in his pictures the graphic form of the written word is as meaningful as its sense.[1]

Evans obviously loved handmade signs, which in his American iconography represent the survival of a preindustrial folk art. The authenticity of the sign derived not from its age—many of Evans's examples were quite new—but from the inevitable fact that the maker could not help but betray his or her individuality. Just as Evans pictured both the premodern farmhouse and the modern automobile that stood in front of it, however, the vernacular flavor of handmade signs mingles in his pictures with the brand new taste of professional advertising. The contrast is sometimes sharp, but both sides are presented as part of the common culture. And it is not always easy to separate the two; the amateur sign in plate 191 clearly emulates a professional model. Evans's equanimity—his disinclination either to applaud modern commerce or to pretend it does not exist—is part of what makes his work forward-looking.

Photography is the perfect vehicle for the selfless aesthetic of the collector, who chooses and then steps aside to permit his choices to speak. But what are we to make of this aesthetic when Evans chooses to photograph a photograph? For now photography is both (as medium) the means of collecting and (as subject) a cultural icon like any other, loaded with symbolic allusions—a product of the industrial revolution that had thoroughly insinuated itself into everyday American life (e.g., plates 202–5). Since the 1840s, when the cheap new medium made portraits for millions who could never before have afforded them, the photograph had been both a mundane, disposable record and a cherished talisman of identity. By using photography itself to create a passageway between these two roles, Evans plunged modern art into a hall of mirrors whose reflections have not ceased to reverberate. Even the most candid photographic observation of the most obvious fact lost its innocence and henceforth circulated as a pictorial sign.

Evans's work drew upon Cubist collage for its sense of the picture as a lively mosaic of shapes, each one connoting the worldly role it had once played as a newspaper headline or advertisement or tram ticket or package wrapper before it became a shape in a picture. Before Evans, Kurt Schwitters had discovered the exquisite beauty of junk (plate 184), and Max Ernst had treated advertising as an adventure (plate 187). But, thanks to a sleight of hand that upped the symbolic ante of photography while appearing to reconfirm its passive clarity, Evans's work now seems closer to what has come after than to what came before.

1. For Evans on photography and collecting, see Leslie Katz, "Interview with Walker Evans," *Art in America* 59 no. 2 (March–April 1971): 85, and "Walker Evans, Visiting Artist: A Transcript of His Discussion with the Students of the University of Michigan," 1971, in Beaumont Newhall, ed., *Photography: Essays & Images* (New York: The Museum of Modern Art, 1980), p. 317. Later in life, Evans extended his habit of photographing signs to the collecting of actual signs, which he displayed in his home. See John T. Hill's photographs of Evans's living room in Hill and Jerry L. Thompson, eds., *Walker Evans at Work* (New York: Harper & Row, 1982), p. 231.

184. Kurt Schwitters. *Merz Drawing 83. Drawing F.* 1920

185. Pablo Picasso. *Guitar.* 1913

186. Christian Schad. *Schadograph.* 1919

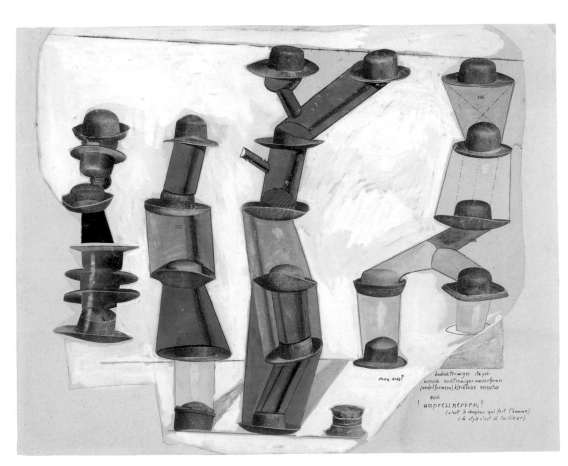

187. Max Ernst. *The Hat Makes the Man.* 1920

188. Ralph Steiner. *Sign, Saratoga Springs*. 1929

189. Stuart Davis. *Odol*. 1924

190 (opposite). Paul Strand. *Truckman's House, New York*. 1920

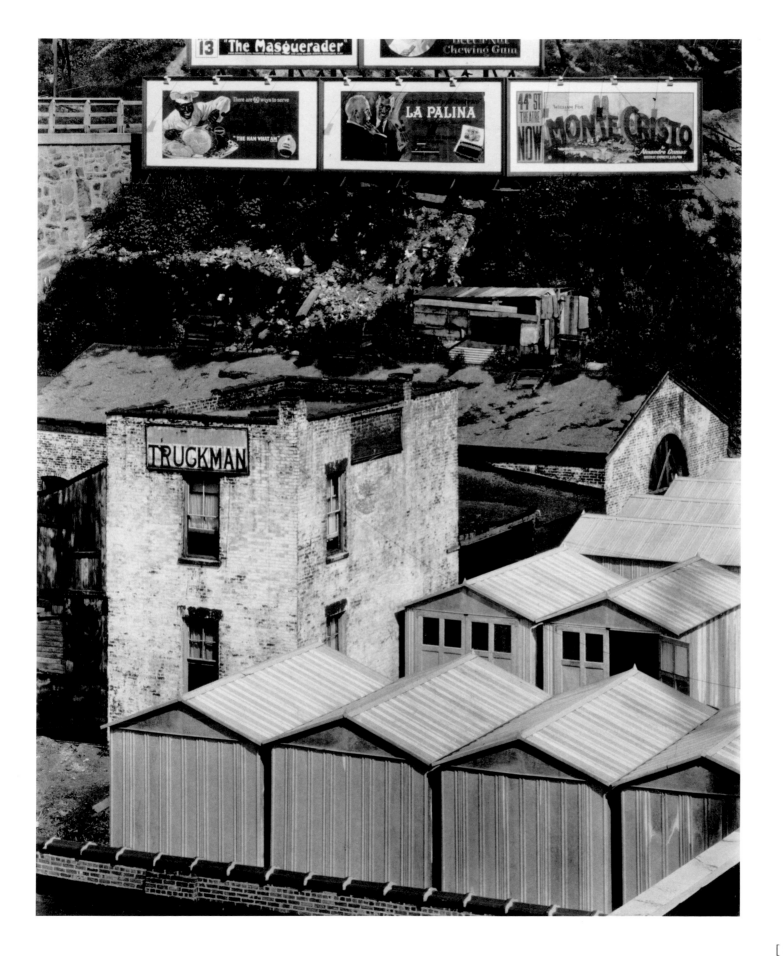

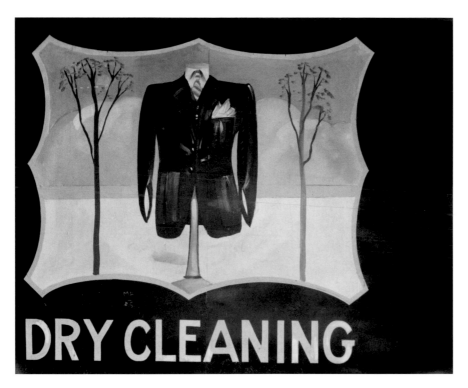

191. Walker Evans. *Outdoor Advertising Sign near Baton Rouge, Louisiana.* 1935

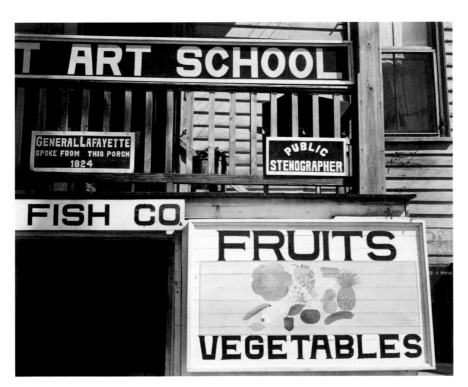

192. Walker Evans. *Signs, South Carolina.* 1936

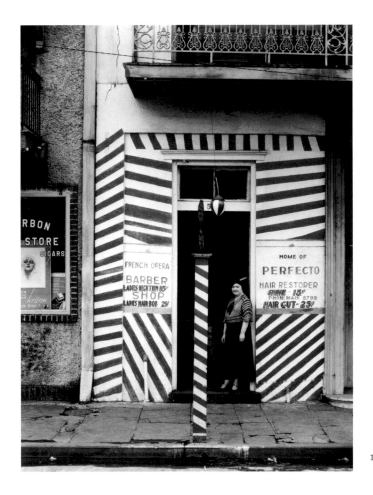

193. Walker Evans. *Sidewalk and Shopfront, New Orleans*. 1935

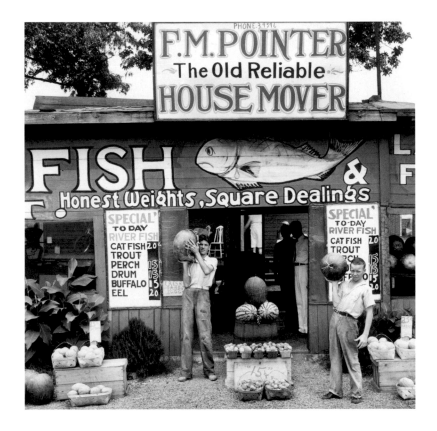

194. Walker Evans. *Roadside Stand near Birmingham*. 1935

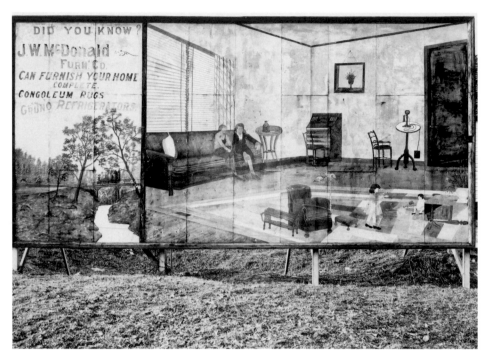

195. Walker Evans. *Furniture Store Sign near Birmingham, Alabama.* 1936

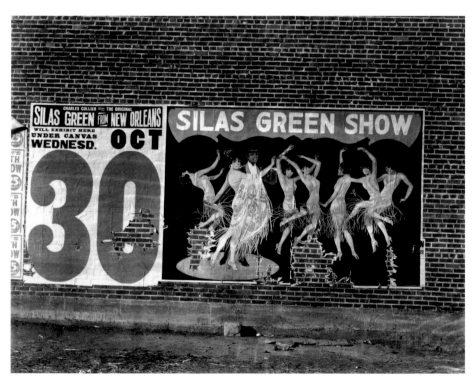

196. Walker Evans. *Show Bill, Demopolis, Alabama.* 1936

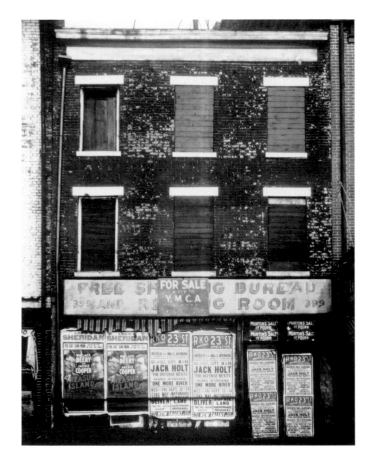

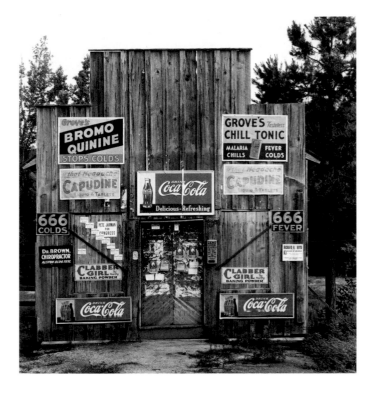

197. Walker Evans. *House on West Street, New York.* 1934

198. Walker Evans. *Roadside Store between Tuscaloosa and Greensboro, Alabama.* 1936

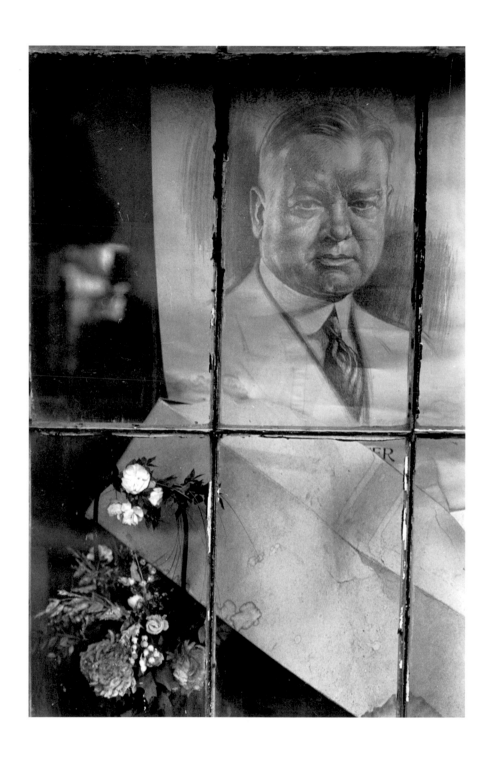

199. Walker Evans. *Political Poster, Massachusetts Village.* 1929

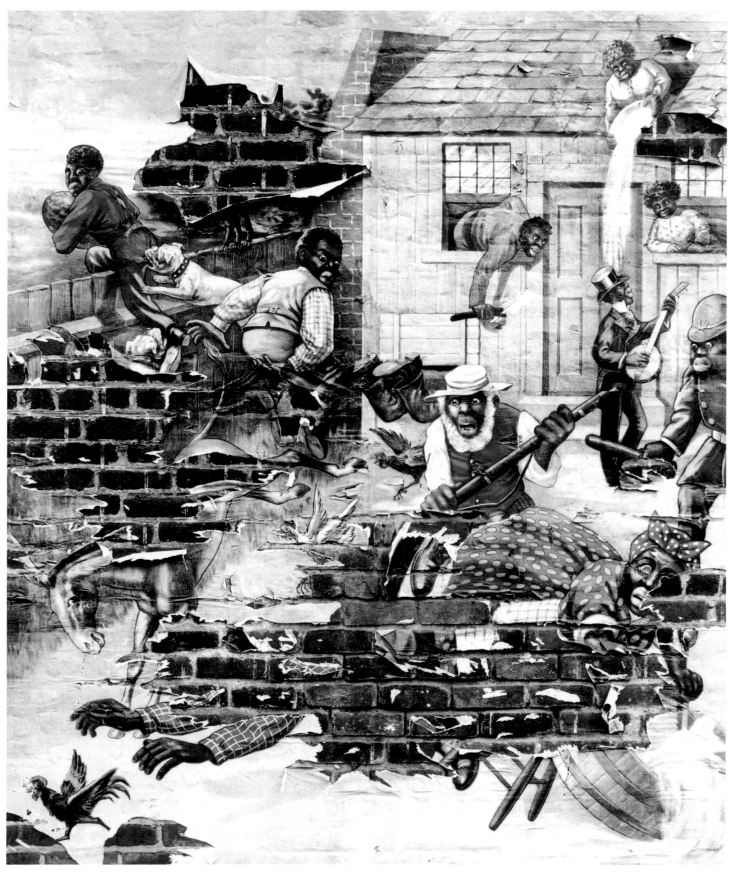

200. Walker Evans. *Minstrel Showbill*. 1936

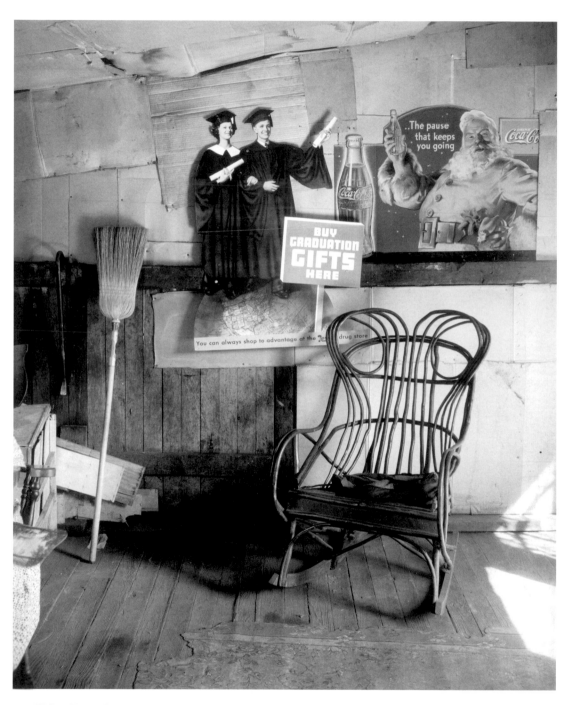

201. Walker Evans. *Interior Detail of West Virginia Coal Miner's House.* 1935

202. Walker Evans. *Bedroom Wall, Shrimp Fisherman's House, Biloxi, Mississippi.* 1945

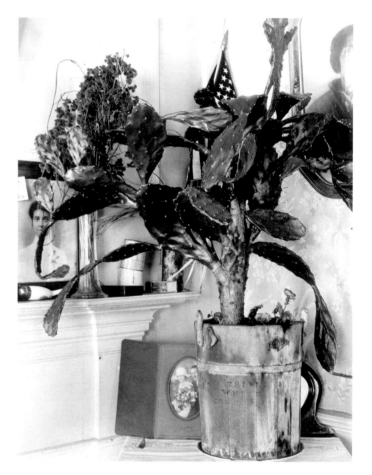

203. Walker Evans. *Interior Detail of Portuguese House.* 1930

204. Walker Evans. *License Photo Studio, New York*. 1934

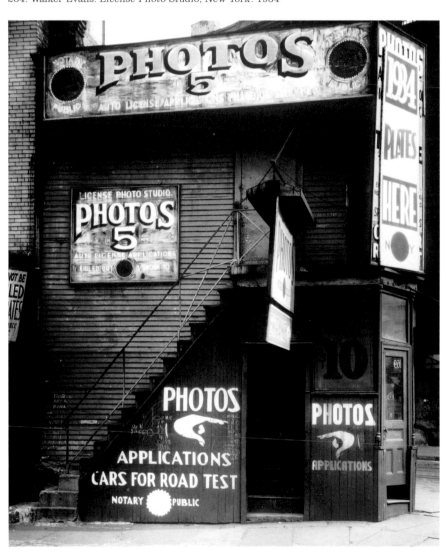

205 (opposite). Walker Evans. *Penny Picture Display, Savannah*. 1936

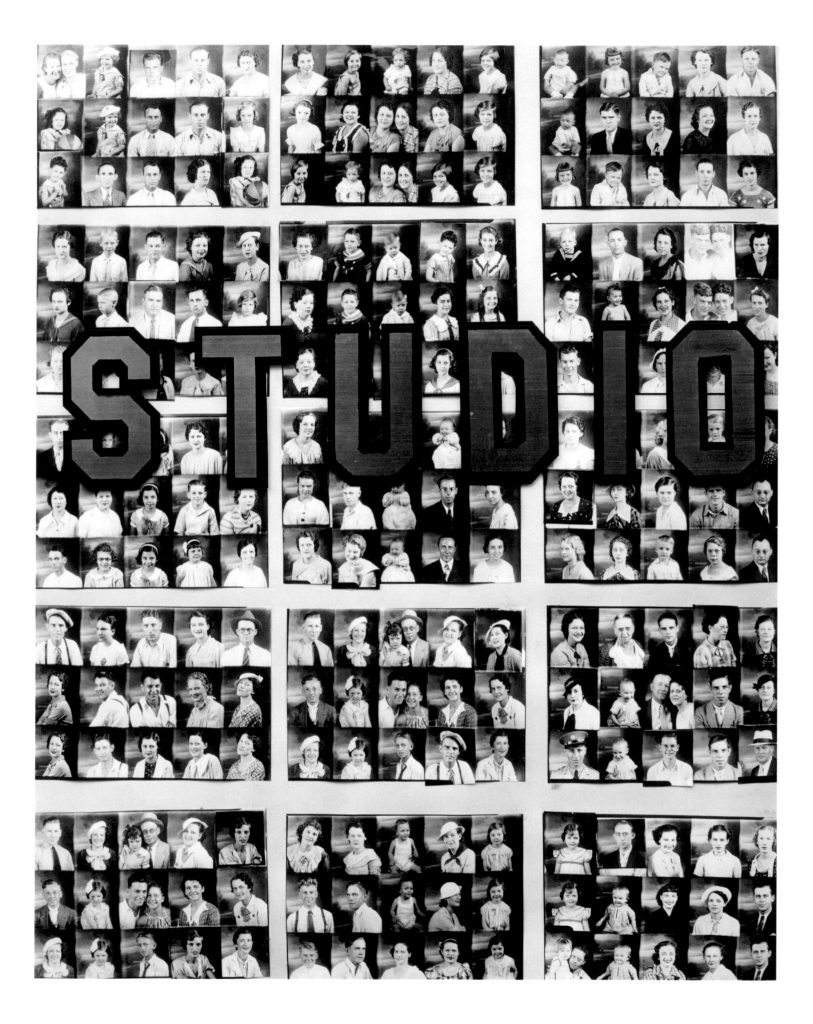

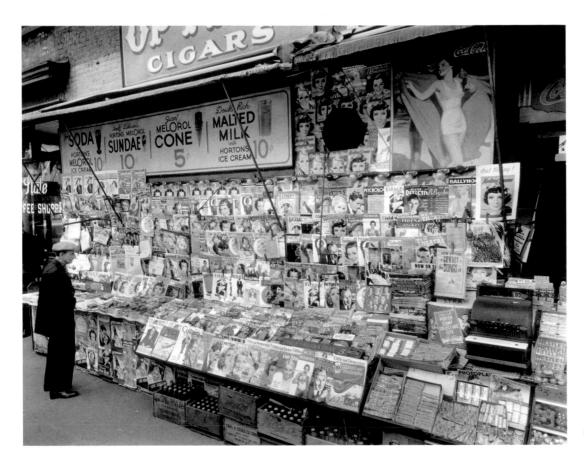

206. Berenice Abbott. *Newsstand, East 32nd Street and Third Avenue, Manhattan.* 1935

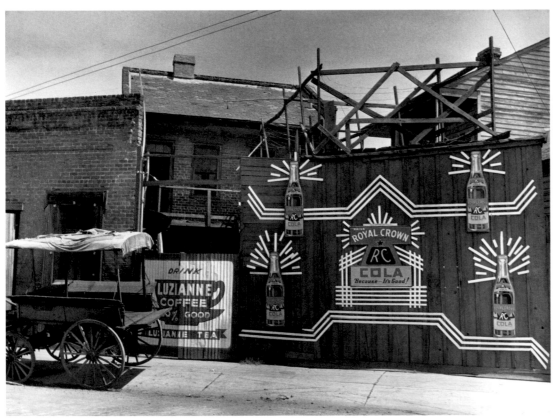

207. Clarence John Laughlin. *The Sparkle of Commercial Greed.* 1938–40

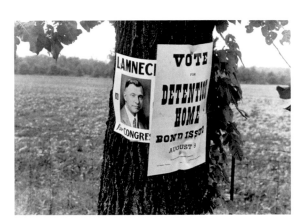

Left to right, top to bottom:

208. Russell Lee. *Sign in Country Store near Vacherie, Louisiana.* 1938

209. Russell Lee. *Bulletin Board in Post Office Showing a Large Collection of "Wanted Men" Signs, Ames, Iowa.* 1936

210. Marion Post Wolcott. *Movie Advertisement on the Side of a Building, "Birth of a Baby," Welch, West Virginia.* 1938

211. Ben Shahn. *Campaign Posters, Central Ohio, Route 40.* 1938

212. Russell Lee. *Sign, Harlingen, Texas.* 1939

213. John Vachon. *Decoration in Store at Alger, Montana.* 1937

214. Russell Lee. *Sign on Wholesale Grocery Store, San Angelo, Texas.* 1939

215. Arthur Rothstein. *Drover's Hotel opposite Stockyards, Kansas City, Kansas.* 1936

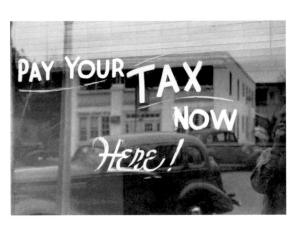
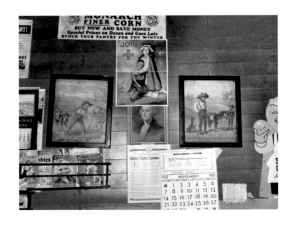
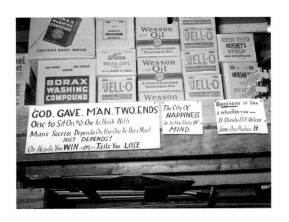

216. Edward Weston. *Hot Coffee, Mojave Desert*. 1937

217. Aaron Siskind.
Chicago. 1949

218. Irving Penn. *O'Sullivan's Heels, New York*. 1939

219. Rudy Burckhardt. *Alabama*. 1948

220. Robert Frank. *Luncheonette, Butte, Montana*. 1956

221. Robert Frank. *Hoover Dam*. 1956

222. William Klein. *Gun, Gun, Gun, New York*. 1955

Pp. 182–83: 223. Andy Warhol. *Campbell's Soup Cans*. 1962

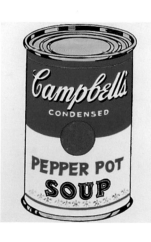

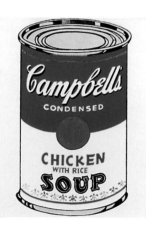

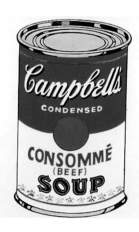

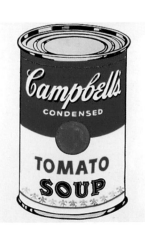

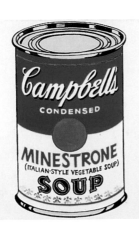 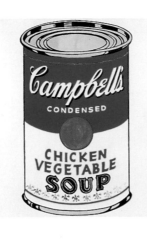 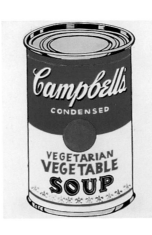 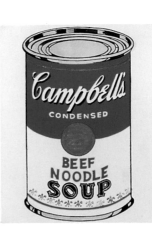

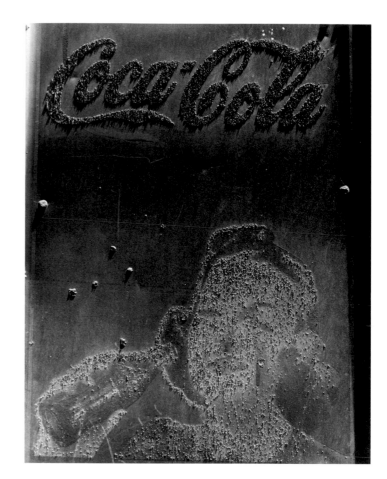

224. Clarence John Laughlin. *Spectre of Coca-Cola*. 1962

225. Philip Elliott. *Untitled*. Before 1952

226. Jacques Mahé de la Villeglé. *122 rue du Temple*. 1968

227. Hollis Frampton. *Untitled*. 1961

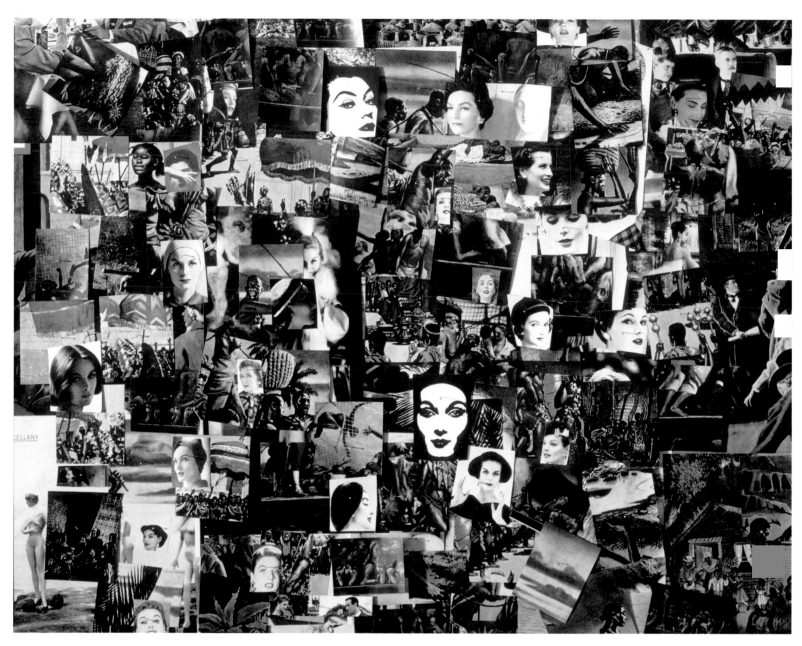

228. Harry Callahan. *Collages*. c. 1956

229 (opposite). James Rosenquist. *Marilyn Monroe, I.* 1962

230. Robert Frank. *Store Window, Washington, D.C.* 1956

231. Robert Rauschenberg. *Mark.* Frontispiece from the book *XXXIV Drawings for Dante's Inferno.* 1964

232. Lee Friedlander. *Washington, D.C.* 1962

233. Garry Winogrand. *Dallas.* 1964

234. Rachel Harrison. *Twenty Dollars.* 1996

235. Edward Ruscha. *OOF*. 1962, reworked 1963

236. William Eggleston. *Greenwood, Mississippi.* 1973

237. Lee Friedlander. *Galax, Virginia.* 1962

238. Lee Friedlander. *Denver, Colorado.* 1965

239. Diane Arbus. *A Lobby in a Building, New York City*. 1966

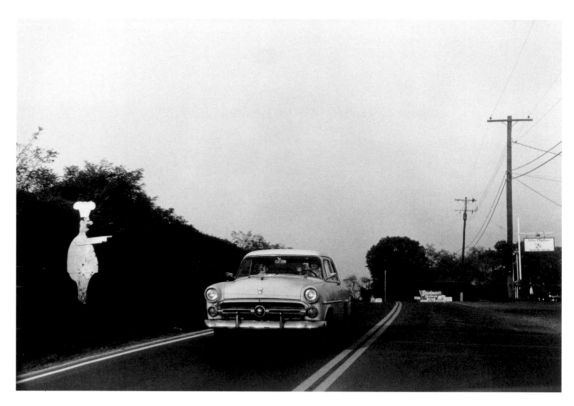

240. Simpson Kalisher. *Untitled*. 1962

241. Henry Wessel, Jr. *Untitled*. 1971

242. Bill Dane. Untitled postcard from Pasadena, California. Postmarked April 1, 1976

243. Joel Meyerowitz. *Los Angeles*. 1964

244.

245.

246.

247.

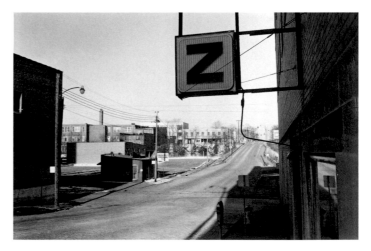

248.

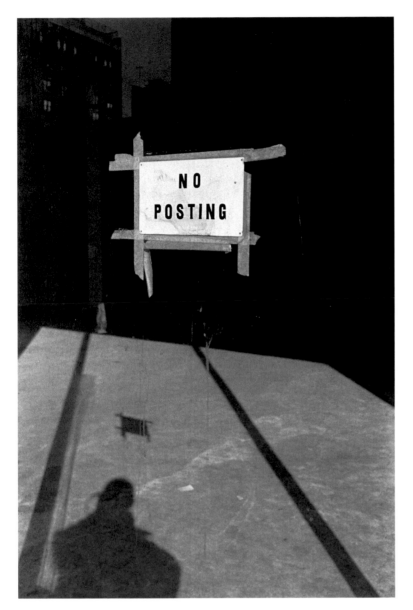

249.

244–250. Lee Friedlander. From the
series Letters from the People

244. *New Orleans*, 1979.
245. *Suffern, New York*, 1979.
246. *Boston, Massachusetts*, 1979.
247. *New Orleans*, 1979.
248. *Akron, Ohio*, 1980.
249. *New York City*, 1985.
250. *New York City*, 1987

250.

CATS
INBAG
BAGS
IN
RIVER

251. Christopher Wool. *Untitled*. 1990

252 and 253 (opposite). Felix Gonzalez-
Torres. *Untitled (Death by Gun)*. 1990

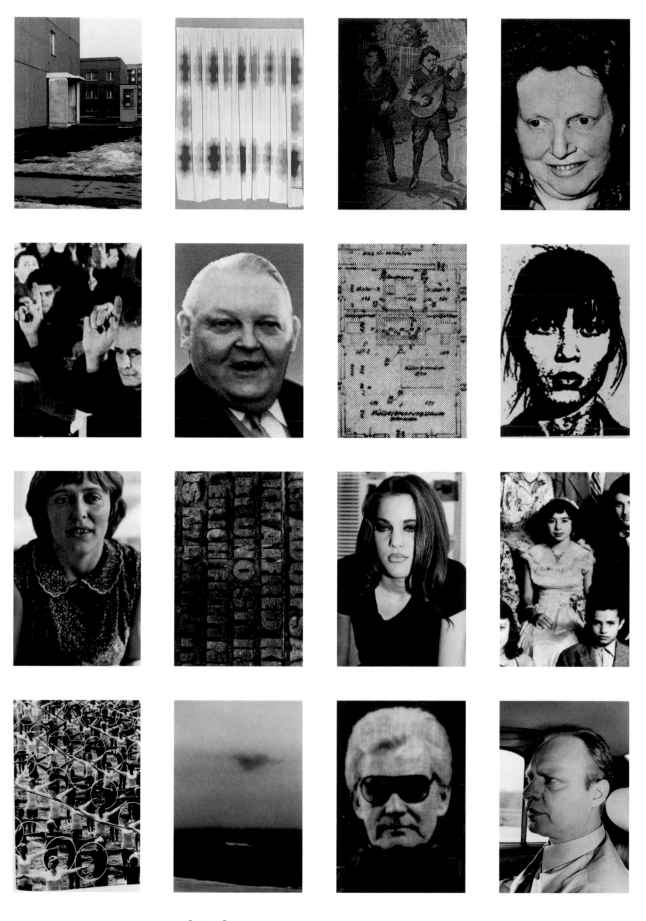

254. Michael Schmidt. From
U-ni-ty (Ein-heit). 1991–94

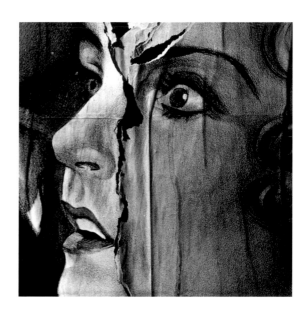

Walker Evans. *Torn Movie Poster*. 1930. Detail of plate 258

1. See Francis Steegmuller, *Flaubert and Madame Bovary: A Double Portrait* (New York: The Viking Press, 1939), pp. 352–404; and Dave Hickey, "Simple Hearts," in *Air Guitar: Essays on Art & Democracy* (Los Angeles: Art Issues Press, 1997), pp. 25–31.

Flaubert's Madame Bovary preferred the enchantments of fashion magazines and romantic novels to the travails of everyday life, and her merciless creator made her pay dearly for her illusions. But when asked to identify his model, the author invariably answered, "*I* am Madame Bovary." And, upon completing his masterpiece of clinical realism, he immediately plunged back into fantasy: *Madame Bovary* (1857) was followed by *Salammbô* (1862), a gaudy tale of exotic antiquity.[1]

The silver-screen culture that appears in Evans's photographs, circa 1930, is a descendant of the shamelessly sentimental fiction into which Emma Bovary escaped from her provincial boredom. For most Americans, then as now, motion pictures were not the high art of the cinema but the seductive, vulgar illusion of the movies. Made by the few and consumed by the many, the movies embody the triumph of modern commerce. Like it or not, they are part of who we are—part of what we share. For an hour or two at least, our singular passions and desires find a common object.

Surely it was partly this social dimension that drew Evans—and later Andy Warhol and Cindy Sherman—to the movies. For an artist who is curious about the relationship of the solitary individual to the bustling edifice of modern civilization, what better place is there to look? Besides, the movies are fun.

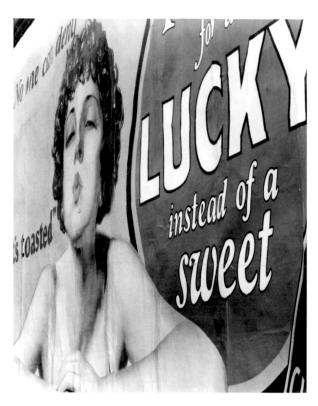

255. Ralph Steiner. *Saratoga Billboard*. c. 1929

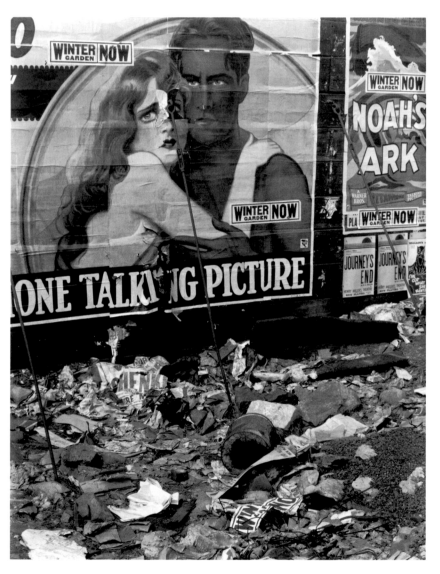

256. Ralph Steiner. *1925 Movies*. c. 1930

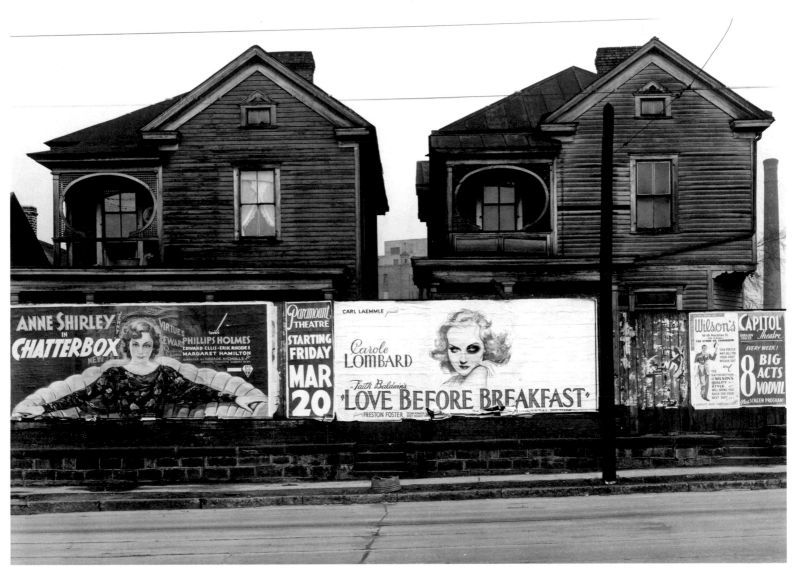

257. Walker Evans. *Houses and Billboards in Atlanta.* 1936

258. Walker Evans. *Torn Movie Poster*. 1930

259. Walker Evans. *Lunch Wagon Detail, New York*. 1931

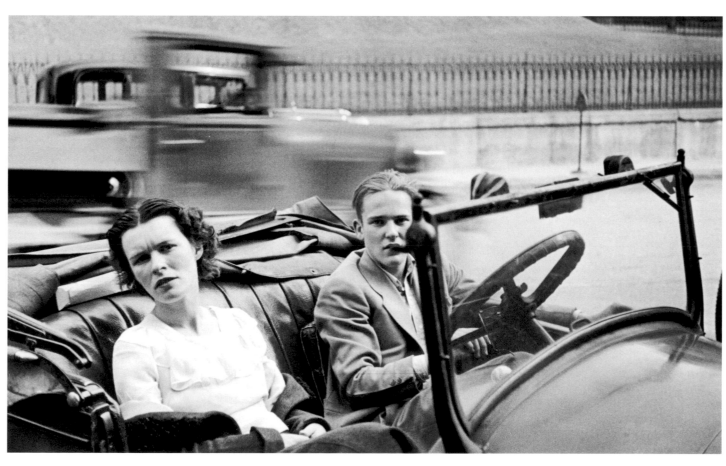

260. Walker Evans. *Parked Car, Small Town Main Street*. 1932

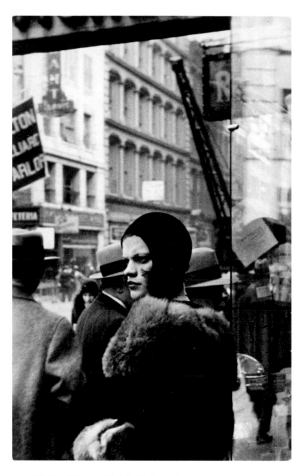

261. Walker Evans. *Girl in Fulton Street, New York*. 1929

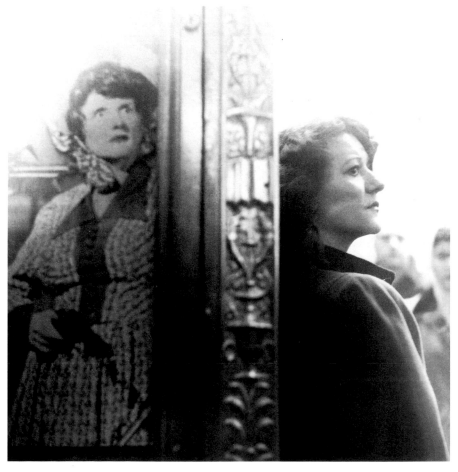

262. Louis Faurer. Untitled. 1938

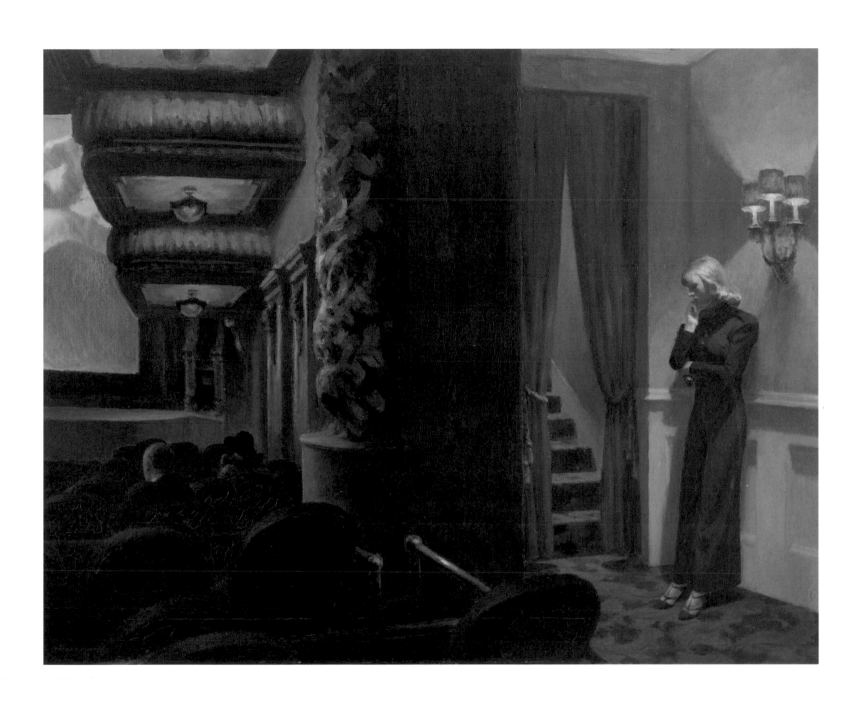

263. Edward Hopper. *New York Movie*. 1939

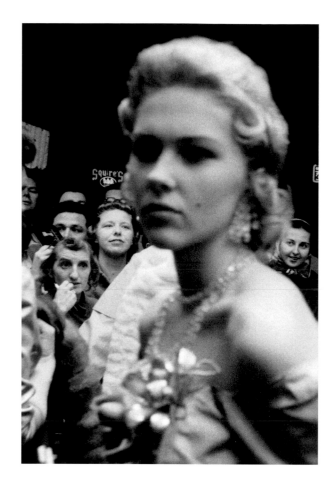

264. Robert Frank. *Movie Premiere, Hollywood.* 1955–56

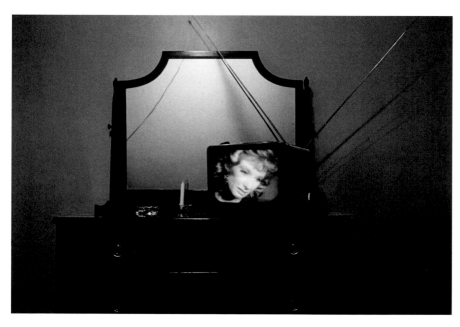

265. Lee Friedlander. *Portland, Maine.* 1962

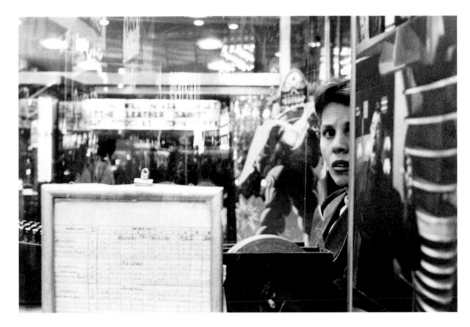

266. Frank Paulin. *Times Square*. 1954

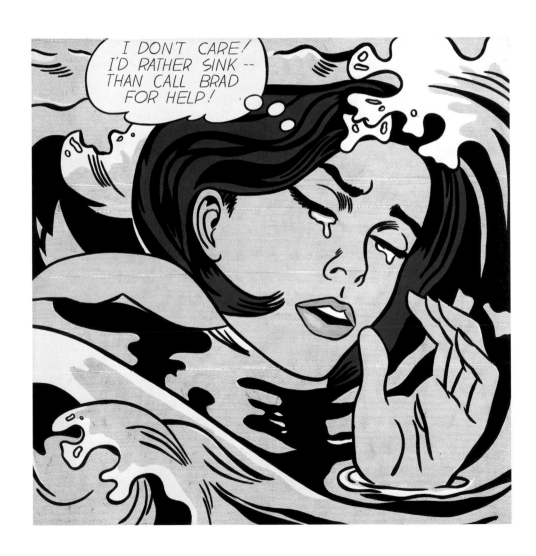

267. Roy Lichtenstein. *Drowning Girl*. 1963

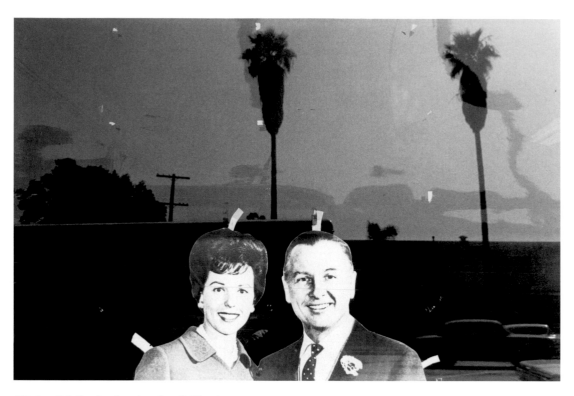

268. Lee Friedlander. *Los Angeles, California.* 1965

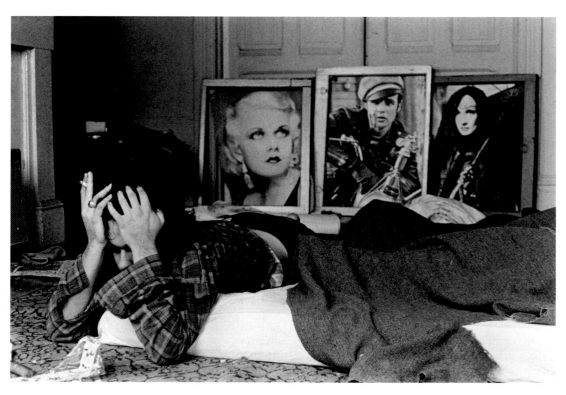

269. William Gedney. *Untitled.* 1967

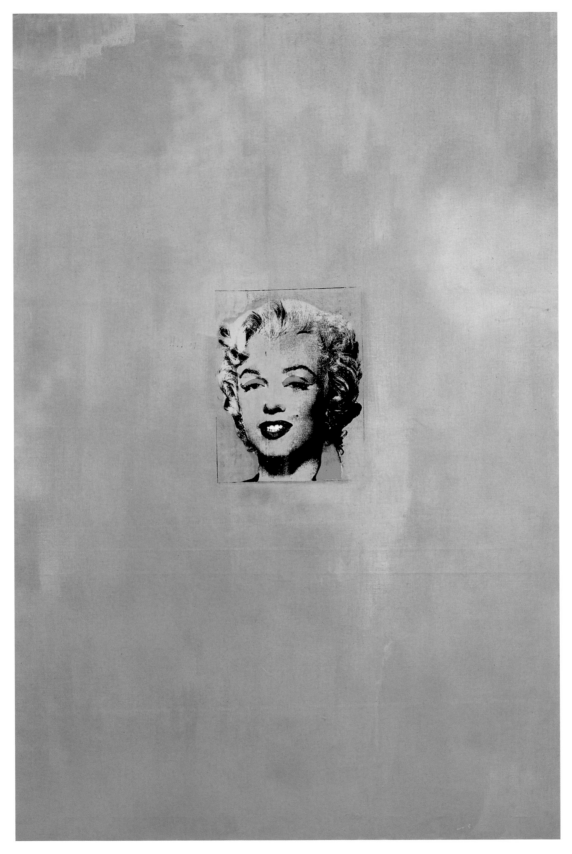

270. Andy Warhol. *Gold Marilyn Monroe*. 1962

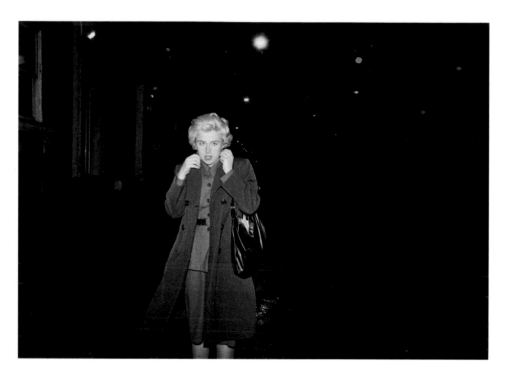

271. Cindy Sherman. *Untitled Film Still #54*. 1980

272. Cindy Sherman. *Untitled Film Still #32*. 1979

273. Cindy Sherman. *Untitled Film Still #21*. 1978

Walker Evans. *Church of the Nazarene, Tennessee.* 1936.
Detail of plate 281

One of the great adventures of modernism began when painters closed the window of Renaissance perspective and contemplated the shuttered field of the picture plane. In theory, the medium of photography—a perfect, mechanical embodiment of perspective—would seem to have had no role to play in such an enterprise. But the photograph is a picture too, and photography's modernist adventure might be described as a dialogue between the transparency of the open window and the impenetrable surface of the image.

Evans's frontal style advanced both sides of the conversation. On the one hand, by addressing their subjects head-on, his photographs seem to minimize the significance of his own point of view and so to strive for impersonal objectivity. On the other hand, by stressing the flatness of the image, his style calls attention to the picture's artifice. A photograph by Evans presents itself both as a discovery—a fragment of fact that existed before the photographer happened to notice it—and as an invention, an image created and decisively shaped by the will of the artist.

By the time Evans arrived, photographers had made millions of photographs in which the picture plane is parallel to the principal plane of the subject. He distilled what had been practical expediency or unexamined convention into a disciplined aesthetic. In doing so, he doubtless absorbed the lessons of painters such as Piet Mondrian. Like a painting by Mondrian, a photograph by Evans is once a precisely framed fragment of a boundless field of possibility and an irreducible whole, complete in itself. The frame simultaneously excludes and encloses; in a photograph by Evans, it is also the frame of a window on the world.

Since Evans, photographers have deployed frontality both as an abstracting style of great elegance and as an efficient technique of artless observation. In the rulebook of modern art, the two strategies define opposing poles of purpose and sensibility. But of course rules are made to be broken.

274. Walker Evans. *Cottage at Ossining Camp Woods, New York*. 1930

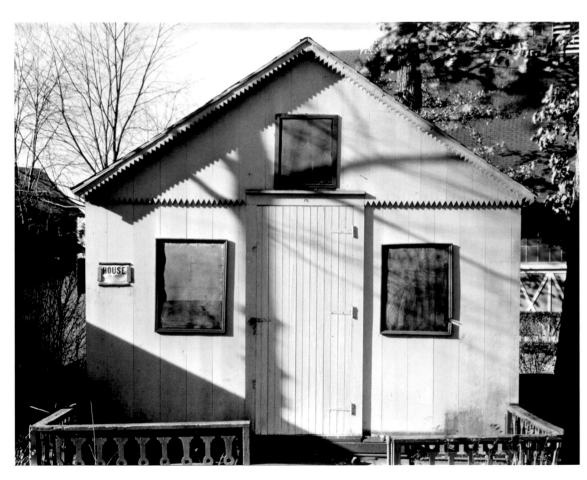

275. Walker Evans. *Cottage at Ossining Camp Woods, New York*. 1930

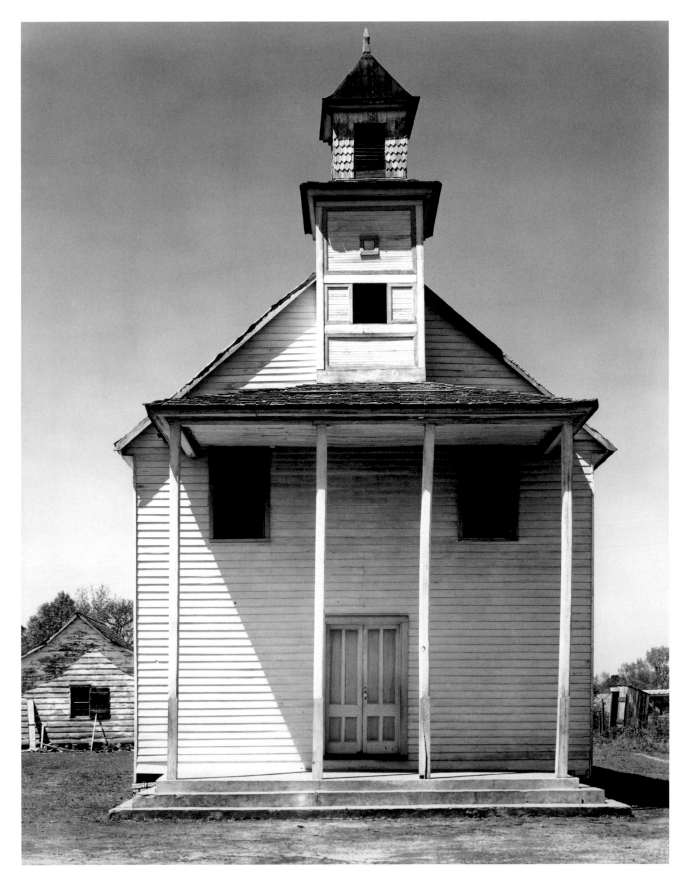

276. Walker Evans. *Negro Church, South Carolina.* 1936

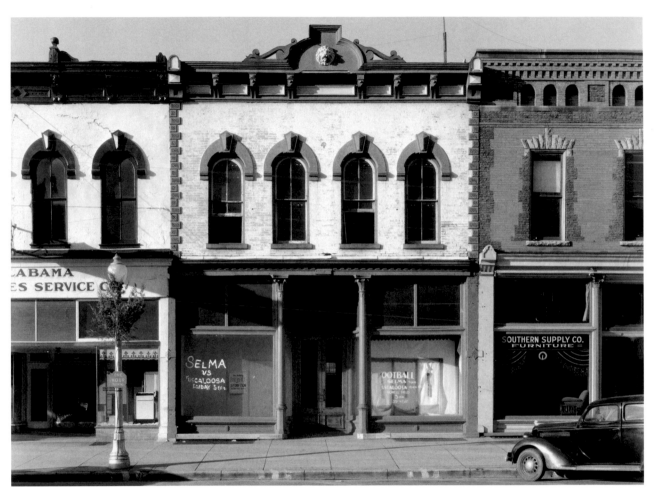

277. Walker Evans. *Main Street Block, Selma, Alabama*. 1936

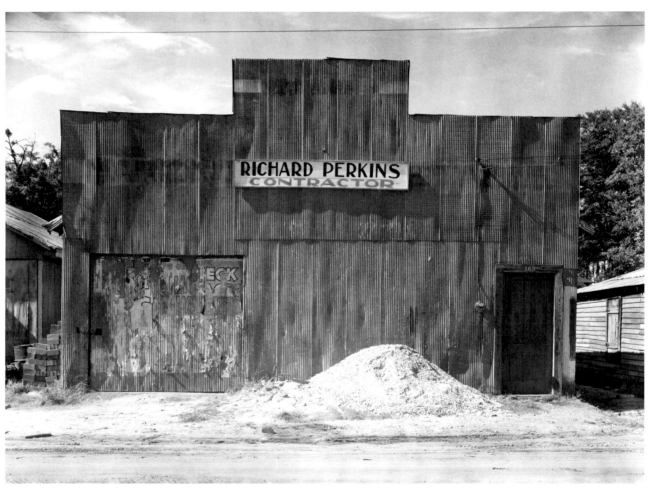

278. Walker Evans. *Corrugated Tin Façade*. 1936

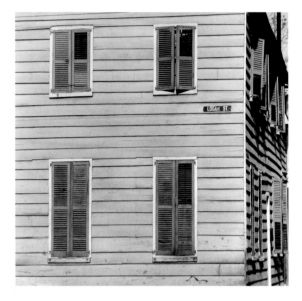

279. Walker Evans. *Part of a House in Charleston.* 1935

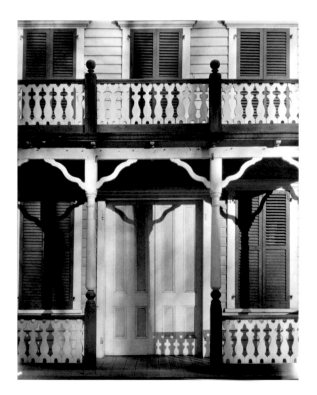

280. Walker Evans. *Detail of a Frame House in Ossining,*
New York. 1931

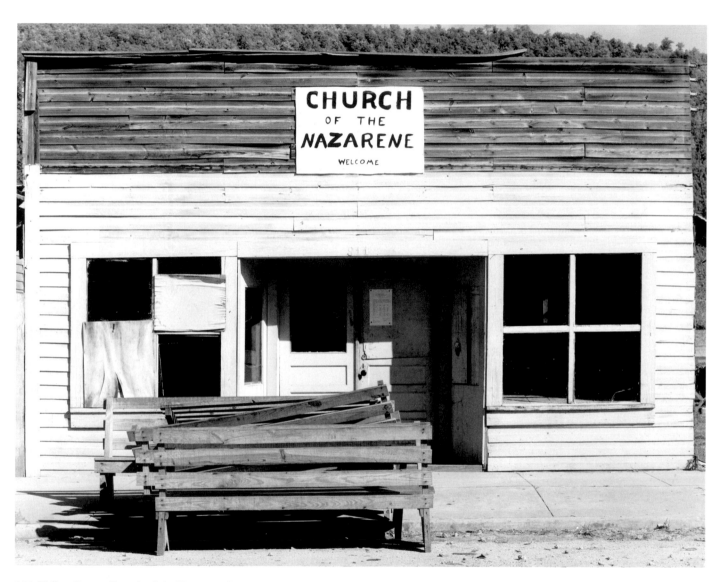

281. Walker Evans. *Church of the Nazarene, Tennessee.* 1936

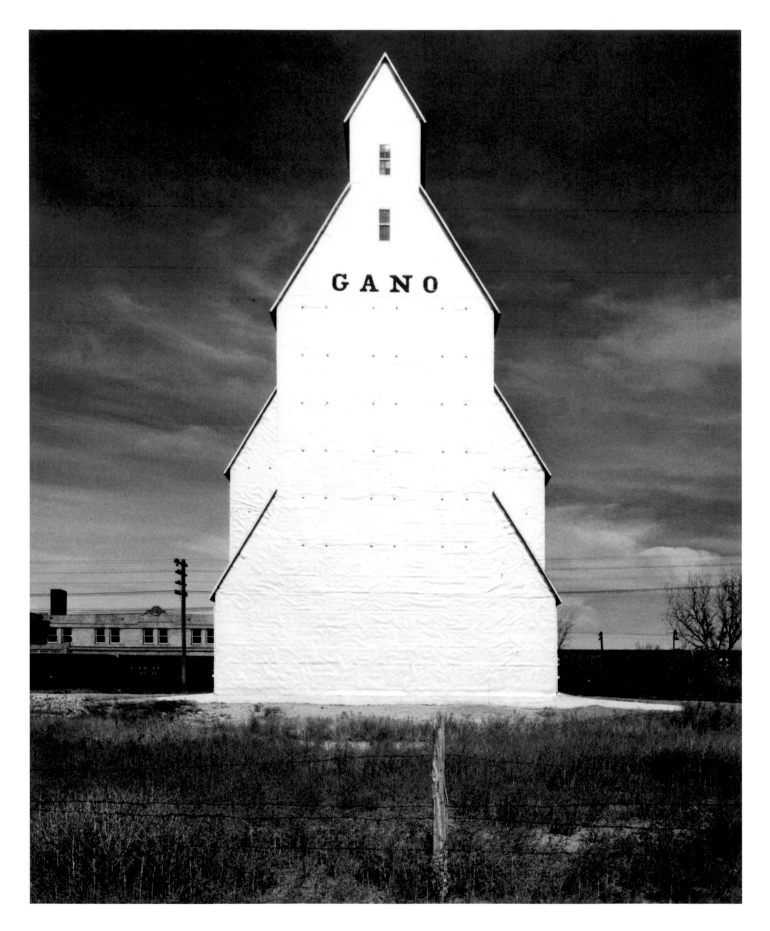

283. Jack Delano. *Hurricane Lumber, Ledyard, Connecticut.* 1940

284. Russell Lee. *Kitchen of Tenant Purchase Client, Hidalgo County, Texas.* 1939

282 (opposite). Wright Morris. *Gano Grain Elevator, Western Kansas.* 1939

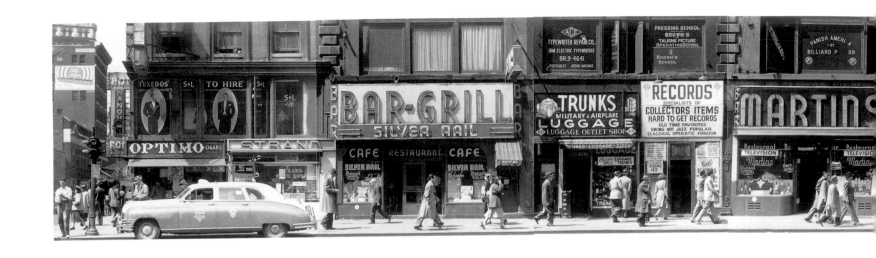

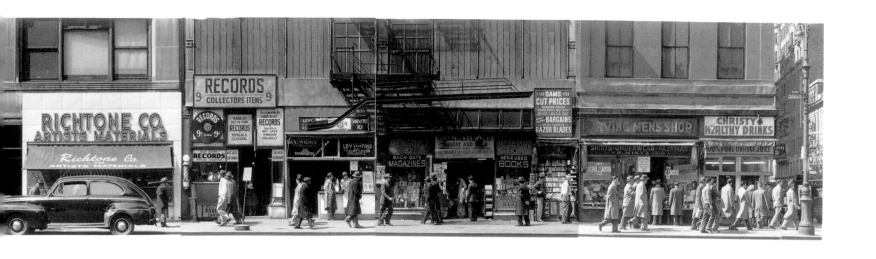

285. Todd Webb. *Sixth Avenue between 43rd and 44th Streets, New York*. 1948

286. Harry Callahan. *Wells Street, Chicago.* 1949

287. Harry Callahan. *Dearborn Street, Chicago.* 1948

288. Jan Groover. Untitled. 1977

289. Aaron Siskind. *New York I.* 1951

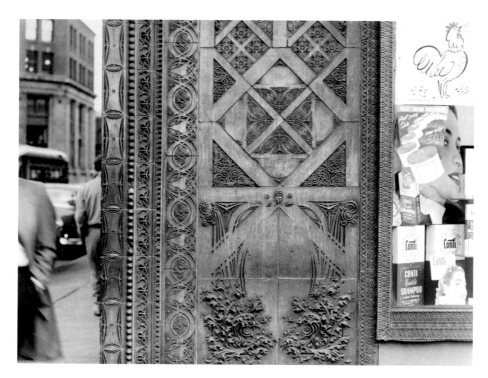

290. John Szarkowski. *Guaranty (Prudential) Building, Buffalo, Corner Column.* 1951–52

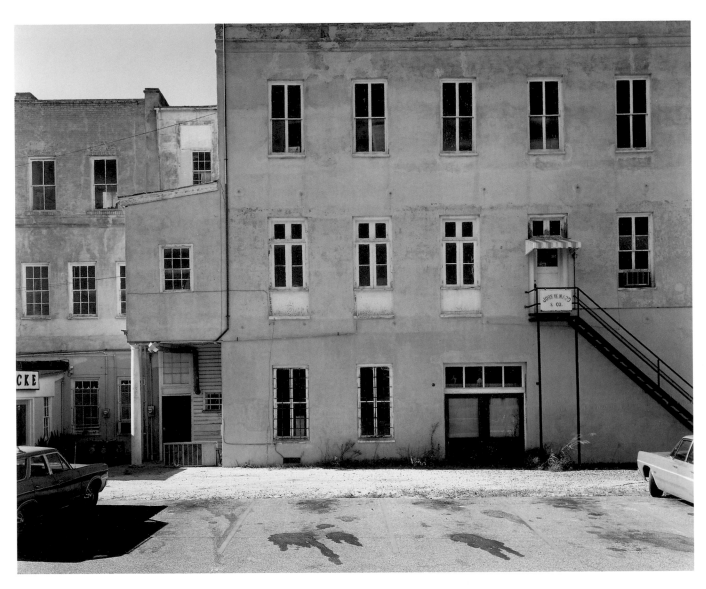

291. Stephen Shore. *Meeting Street, Charleston, South Carolina.* 1975

292. Edward Ruscha. *Every Building on the Sunset Strip* (detail). 1966

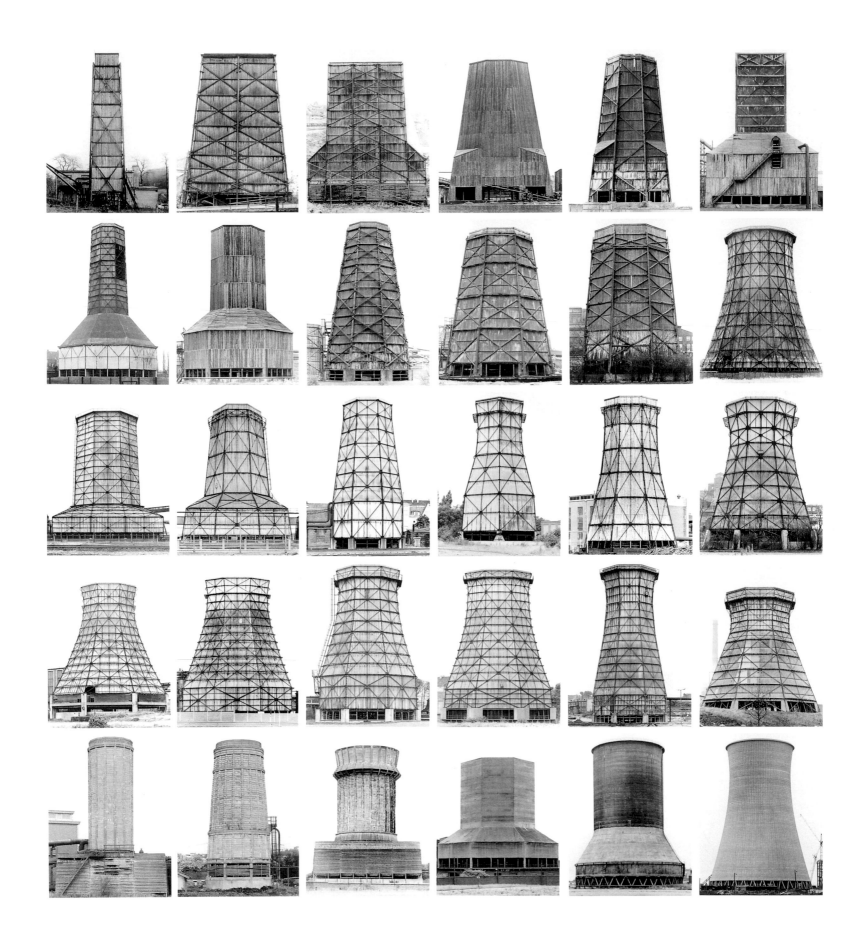

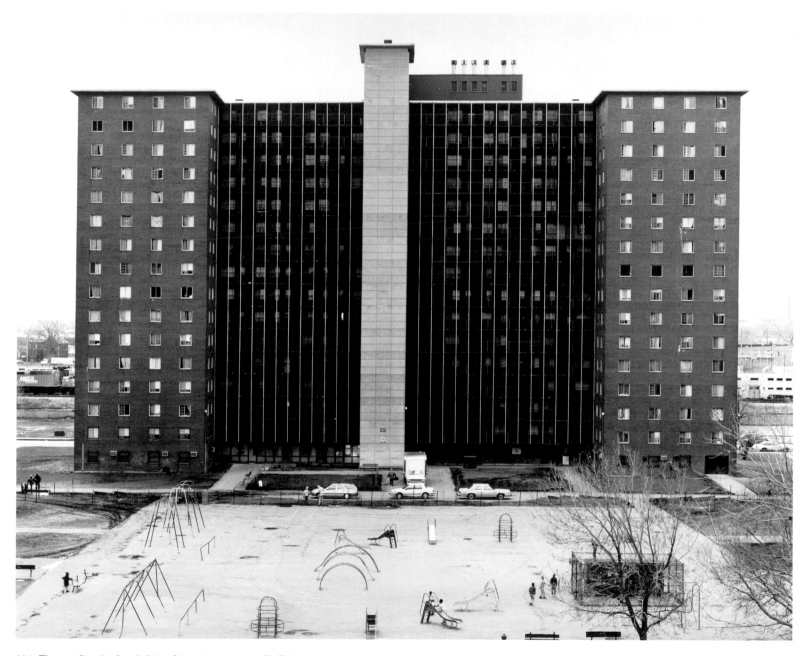

294. Thomas Struth. *South Lake Street Apartments II, Chicago*. 1990

293 (opposite). Bernd and Hilla Becher. *Anonymous Sculpture*. 1970

295. Sol LeWitt. *Brick Wall.* 1977

296. Brian Wood *Elevator.* 1978

297. Christo (Christo Javacheff). *Store Front Project*. 1964

298. Lewis Baltz. *Construction Detail, East Wall, Xerox, 1821 Dyer Road, Santa Ana*. 1974

299. Robert Adams. *Loveland, Colorado.* 1973

300. Wijnanda Deroo. *Mobile Home.* 1992

301. Andreas Gursky.
Times Square,
New York. 1997

Walker Evans. *Subway Portrait*. 1938–41. Detail of plate 312

E vans's subway photographs of 1938–41 are a bundle of contradictions. They describe people as individuals, and in that fundamental sense the pictures are portraits. But each person is presented as a single unit in a potentially infinite series, and the environment could hardly be more impersonal. Unlike most photographic portraits, these exclude any possibility of exchange between sitter and photographer (and thus between sitter and viewer). On the contrary, the intimacy of the pictures depends upon their subjects' utter lack of awareness of the photographer. That intimacy is in itself contradictory: Evans's subway portraits address the deepest of inner secrets, only to assert that they are incommunicable.

When eighty-nine of the photographs were published in a book, in 1966, they were introduced by a text that James Agee had written in 1940, before Evans had completed the series. Agee observed that every person "has a wound and nakedness to conceal, and guards and disguises by which he conceals it. Scarcely ever, in the whole of his living, are those guards down."[1] But they are down, Agee implied, in Evans's portraits.

Evans himself drafted five different introductions to the book, and in each one he took an approach very different from Agee's. One of the drafts concluded, "Whoever chooses to decide from [these pictures] that people are wonderful or that what America needs is a political revolution is at liberty to do so."[2] This gem of sardonic wit is the true voice of Evans. But so, too, are the photographs themselves, and surely their author had not failed to see in them what Agee saw. It is no insult to Agee to suggest that Evans simply declined to substitute his own emotions for the emotions of his subjects—or of his audience.

The reserve of Evans's subway portraits is consistent with the whole of his aesthetic, but their intimacy invites us to consider the rest of his work from an angle that might not otherwise come to mind. The student of civilization has no need to examine the life of any individual person, but the study of what people share does not necessarily imply indifference to what they do not. One might say that in all of his work Evans explored the relationship between the two, without ever expecting to resolve it; certainly many of the artists who have learned from his example have attempted such an exploration. His friend Diane Arbus once said, "What I'm trying to describe is that it is impossible to get out of your skin into somebody else's. . . . That somebody else's tragedy is not the same as your own."[3]

1. James Agee, "Introduction," in Evans, *Many Are Called* (Boston: Houghton Mifflin, 1966), n.p.

2. All five of Evans's drafts were published in John T. Hill and Jerry L. Thompson, eds., *Walker Evans at Work* (New York: Harper & Row, 1982), pp. 160–61.

3. Diane Arbus, quoted in Doon Arbus and Marvin Israel, eds., *Diane Arbus* (Millerton, N.Y.: Aperture, 1972), p. 2.

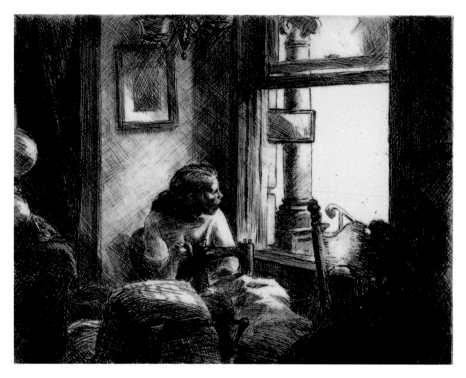

302. Edward Hopper. *East Side Interior*. 1922

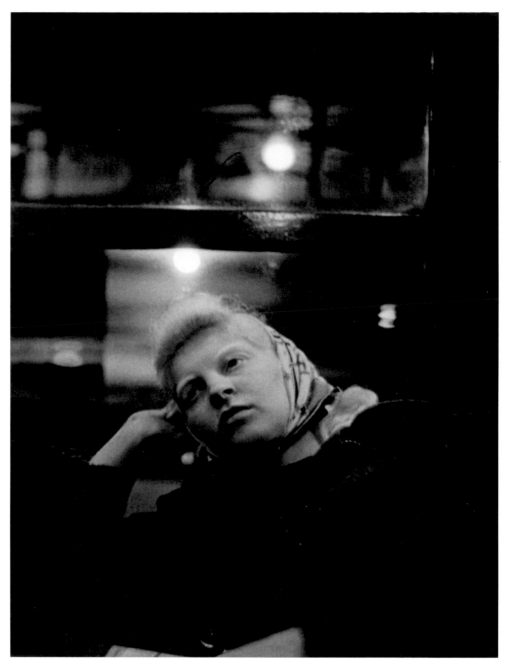

303. Walker Evans. *Subway Portrait*. 1938–41

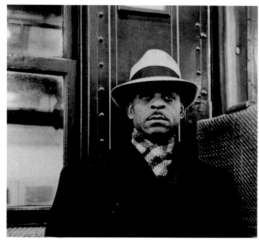 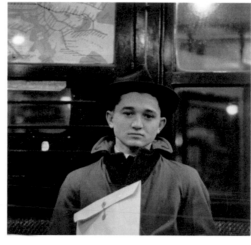 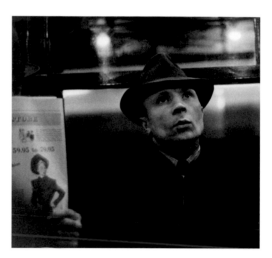

304. 305. 306.

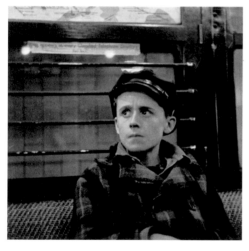 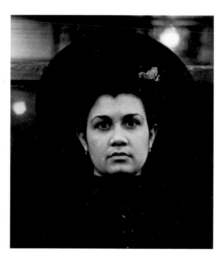 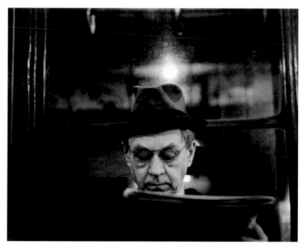

307. 308. 309.

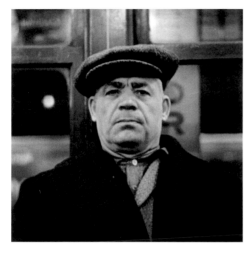

310.

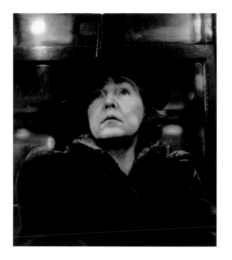

311.

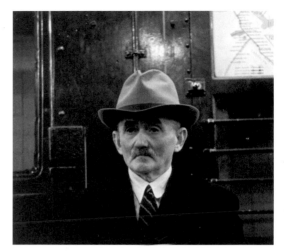

312.

304–313. Walker Evans. Subway Portraits. 1938–41

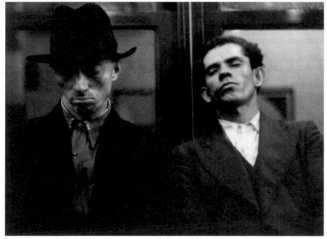

313.

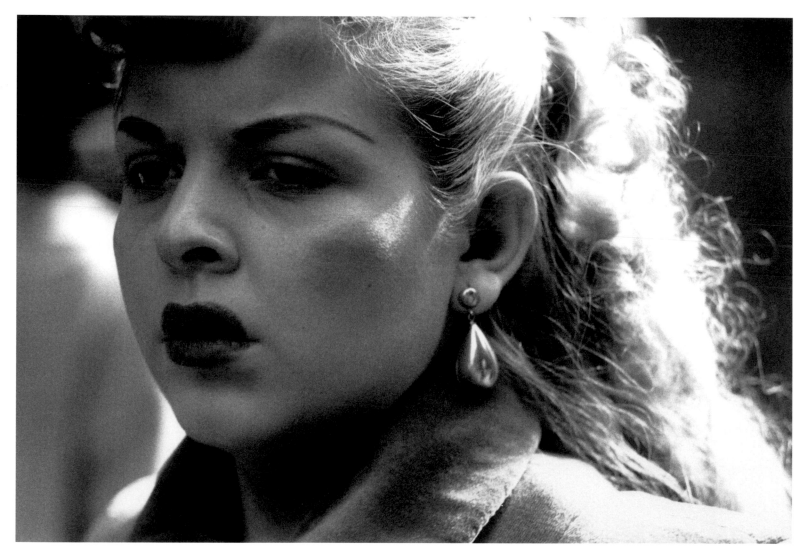

314. Harry Callahan. *Chicago.* 1950

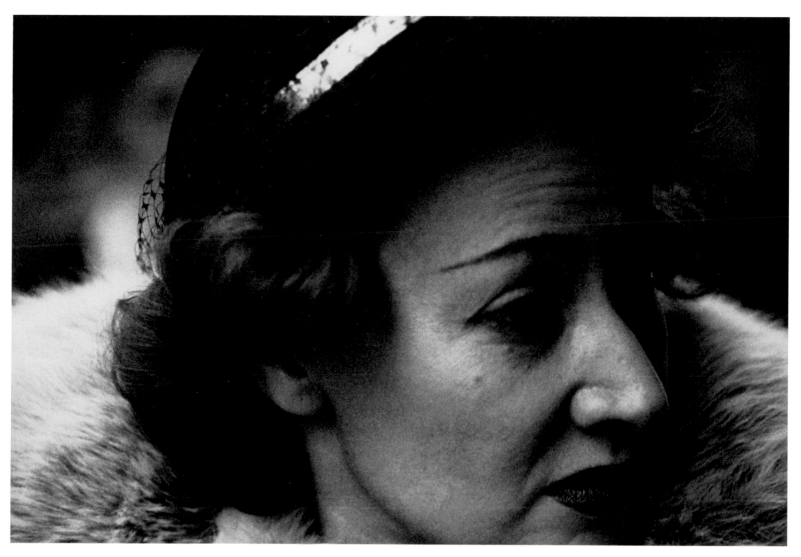

315. Harry Callahan. *Chicago.* 1950

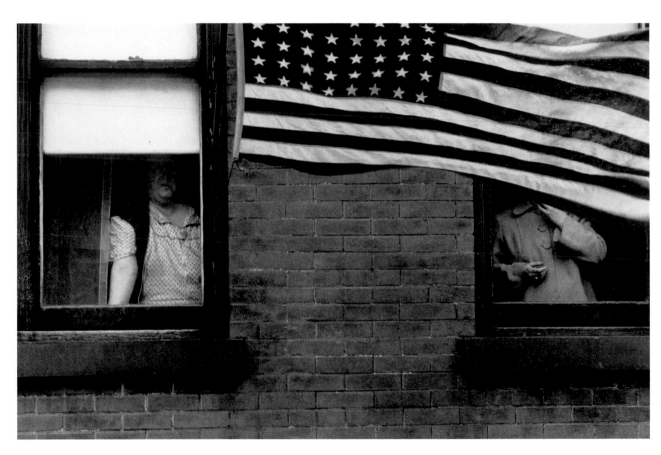

316. Robert Frank. *Parade, Hoboken, New Jersey.* 1955

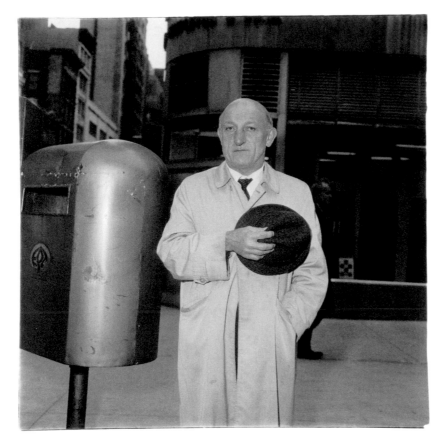

317. Diane Arbus. *Man at a Parade on Fifth Avenue, New York City.* 1969

318. Lee Friedlander. *New York City.* 1964

319. Lee Friedlander. *Galax, Virginia.* 1962

320. Robert Adams. *Colorado Springs, Colorado.* 1968

321. Judith Joy Ross. *Untitled*. 1984. From the series Portraits at
the Vietnam Veterans Memorial, Washington, D.C. 1983–84

322. Philip-Lorca diCorcia. *Eddie Anderson; 21 years old; Houston, Texas; $20.* 1990–92

323. Philip-Lorca diCorcia. *Marilyn; 28 years old; Las Vegas, Nevada; $30.* 1990–92

324. Philip-Lorca diCorcia. *Major Tom; Kansas City, Kansas; $20.* 1990–92

List of Plates

The works are listed first in alphabetical order by artist, then in the order in which they appear in the book. Each is keyed to its plate number. In the dimensions, height precedes width, followed, when applicable, by depth. All works are in the collection of The Museum of Modern Art.

Berenice Abbott (American, 1898–1991)

PLATE 54. *Doorway, 204 West 13th Street, Manhattan*. 1937
Gelatin silver print, 9½ x 7⅝ in. (24.2 x 19.3 cm)
Gift of the Robert and Joyce Menschel Foundation

63. *Father Duffy, Times Square*. 1936
Gelatin silver print, 9⁵⁄₁₆ x 7⅝ in. (23.7 x 19.4 cm)
Gift of Ronald A. Kurtz

206. *Newsstand, East 32nd Street and Third Avenue, Manhattan*. 1935
Gelatin silver print, 7⁹⁄₁₆ x 9⅝ in. (19.3 x 24.4 cm)
Gift of Connecticut Valley Boys' School, per J. D. Hatch, Jr.

Robert Adams (American, born 1937)

56. *El Paso County Fairgrounds, Calhan, Colorado*. 1968
Gelatin silver print, printed 1988, 7¹¹⁄₁₆ x 11¾ in. (19.5 x 29.8 cm)
Gift of Wendy Larsen

110. *Eden, North of Pueblo, Colorado*. 1970
Gelatin silver print, 5⁹⁄₁₆ x 5⅞ in. (14.2 x 14.9 cm)
David H. McAlpin Fund

169. *Tract House, Longmont, Colorado*. 1973
Gelatin silver print, 5¹⁵⁄₁₆ x 7⅝ in. (15.2 x 19.4 cm)
Purchase

170. *Colorado Springs, Colorado*. 1970
Gelatin silver print, 5¹⁵⁄₁₆ x 5¹³⁄₁₆ in. (15.2 x 14.8 cm)
David H. McAlpin Fund

299. *Loveland, Colorado*. 1973
Gelatin silver print, 5¹⁵⁄₁₆ x 5⁹⁄₁₆ in. (15.1 x 15.1 cm)
Bequest of Arthur M. Bullowa (by exchange)

320. *Colorado Springs, Colorado*. 1968
Gelatin silver print, 5¹⁵⁄₁₆ x 5¹⁵⁄₁₆ in. (15.2 x 15.2 cm)
Gift of Lily Auchincloss

Diane Arbus (American, 1923–1971)

152. *Teenage Couple on Hudson Street, New York City*. 1963
Gelatin silver print, 14¾ x 14⅞ in. (37.5 x 37.8 cm)
Purchase

179. *Xmas Tree in a Living Room in Levittown, Long Island*. 1963
Gelatin silver print, 9¼ x 9⅛ in. (23.5 x 23.2 cm)
Purchase

239. *A Lobby in a Building, New York City*. 1966
Gelatin silver print, 13¾ x 13⅜ in. (35 x 34 cm)
Mrs. Armand P. Bartos Fund

317. *Man at a Parade on Fifth Avenue, New York City*. 1969
Gelatin silver print, 14½ x 14¼ in. (36.8 x 36.2 cm)
Mrs. Armand P. Bartos Fund

Eugène Atget (French, 1857–1927)

13. *Old Farmhouse, Gif*. 1924
Albumen silver print from a glass negative, 6¹⁵⁄₁₆ x 9¼ in. (17.6 x 23.5 cm)
All Atget works Abbott-Levy Collection. Partial gift of Shirley C. Burden

14. *Old Courtyard, 22 rue Saint-Sauveur, Paris*. 1914
Albumen silver print from a glass negative, 8½ x 7⅛ in. (21.6 x 18.1 cm)

15. *Pavillon Français, Petit Trianon, Versailles*. 1923–24
Albumen silver print from a glass negative, 6¹⁵⁄₁₆ x 8⅜ in. (17.6 x 21.2 cm)

PLATE 16. *Door, 6 rue Saint-Florentin, Paris*. 1912
Albumen silver print from a glass negative, 9¼ x 7 in. (23.5 x 17.8 cm)

17. *A Corner of the quai de la Tournelle, Fifth Arrondissement, Paris*. 1910–11
Albumen silver print from a glass negative, 6¹⁵⁄₁₆ x 8½ in. (17.6 21.7 cm)

18. *Canal, Saint-Denis*. 1925–27
Albumen silver print from a glass negative, 7½ x 9½ in. (19 x 24.1 cm)

19. *Courtyard, 7 rue de Valence, Paris*. 1922
Albumen silver print from a glass negative, 7 x 8¹⁵⁄₁₆ in. (17.7 x 23.7 cm)

20. *Working Class Apartment, rue de Romainville, Paris*. 1910
Albumen silver print from a glass negative, 8⁷⁄₁₆ x 6⅞ in. (21.5 x 17.5 cm)

21. *Apartment of Mr. C., Interior Decorator, rue du Montparnasse, Paris*. 1910
Albumen silver print from a glass negative, printed 1984 by Chicago Albumen Works from the original negative in the Abbott-Levy Collection, 9⁵⁄₁₆ x 6⅞ in. (23.7 x 17.5 cm)

22. *Prostitute Taking Her Shift in front of Her Door, rue Asselin, La Villette, Nineteenth Arrondissement, Paris*. 1921
Albumen silver print from a glass negative, printed 1984 by Chicago Albumen Works from the original negative in the Abbott-Levy Collection, 9⁵⁄₁₆ x 7 in. (23.7 x 17.8 cm)

23. *Rue Saint-Vincent, Montmartre, Paris*. 1922
Albumen silver print from a glass negative, 8½ x 6⁹⁄₁₆ in. (21.6 x 17.3 cm)

24. *Fête du Trône, Paris*. 1925
Albumen silver print from a glass negative, 6½ x 8⁷⁄₁₆ in. (16.5 x 21.5 cm)

25. *Hairdresser, Palais Royal, Paris*. 1926–27
Albumen silver print from a glass negative, printed 1978 by Chicago Albumen Works from the original negative in the Abbott-Levy Collection, 6⅞ x 9¼ in. (17.5 x 23.5 cm)

26. *Automobile Showroom, avenue de la Grande Armée, Paris*. 1924–25
Albumen silver print from a glass negative, printed 1984 by Chicago Albumen Works from the original negative in the Abbott-Levy Collection, 7¹⁄₁₆ x 9⅜ in. (18 x 23.9 cm)

Lewis Baltz (American, born 1945)

298. *Construction Detail, East Wall, Xerox, 1821 Dyer Road, Santa Ana*. 1974
Gelatin silver print, 6 x 9 in. (15.3 x 22.9 cm)
Joseph G. Mayer Fund

George N. Barnard (American, 1819–1902)

1. *Nashville from the Capitol*. 1864–65. From *Photographic Views of Sherman's Campaign*, 1866
Albumen silver print from a glass negative, 10 x 14⅛ in. (25.4 x 35.8 cm)
Acquired by exchange

Adam Bartos (American, born 1953)

69. *East Wall of General Assembly Room, United Nations, New York*. 1990
Chromogenic color print (Ektacolor), 15⅛ x 22⁹⁄₁₆ in. (38.4 x 57.4 cm)
Gift of CameraWorks, Inc

Bernd and Hilla Becher (German, born 1931 and 1934)

293. *Anonymous Sculpture*. 1970
Thirty gelatin silver prints, overall 6 ft. 11⅝ in. x 6 ft. 2¼ in. (207.3 x 188.4 cm), each print 15⅞ x 11¾ in. (40.1 x 29.9 cm)
Gertrud A. Mellon Fund

Richard Benson (American, born 1943)

61. *Cannon, Vicksburg*. 1986
Photograph in acrylic paint on aluminum, 14½ x 18¼ in. (36.8 x 46.4 cm)
The Family of Man Fund

Laurenz Berges (German, born 1966)

68. *Perleberg*. 1992
Chromogenic color print, 19 x 14¹⁵⁄₁₆ in. (48.3 x 38 cm)
E. T. Harmax Foundation Fund

Dawoud Bey (American, born 1953)
PLATE 149. *A Man Looking at Pants on Fulton Street.* 1989
Gelatin silver print, 15⅞ x 23⅜ in. (40.3 x 59.4 cm)
E. T. Harmax Foundation Fund

Studio of Mathew B. Brady (American)
2. *Ruins of the Gallego Flour Mills, Richmond, Virginia.* 1865
Albumen silver print, 7⅛ x 8¹³⁄₁₆ in. (18.1 x 22.4 cm)
Purchase

Rudy Burckhardt (American, born Switzerland, 1914–1999)
94. *Queens.* 1942–43
Gelatin silver print, 8⁹⁄₁₆ x 11⁹⁄₁₆ in. (21.7 x 29.4 cm)
Gift of CameraWorks, Inc., and purchase

95. Untitled. From the album *An Afternoon in Astoria.* 1940
Gelatin silver print, 6½ x 9⅜ in. (16.6 x 23.8 cm)
Anonymous Fund and purchase

219. *Alabama.* 1948
Gelatin silver print, 9⁷⁄₁₆ x 6¾ in. (24 x 17.1 cm)
Gift of CameraWorks, Inc., and purchase

Harry Callahan (American, 1912–1999)
147. *Chicago.* 1961
Gelatin silver print, 15¾ x 10¼ in. (40 x 26 cm)
Purchase

228. *Collages.* c. 1956
Gelatin silver print, 7¹⁵⁄₁₆ x 9¹⁵⁄₁₆ in. (20.2 x 25.2 cm)
Gift of Richard E. Salomon in honor of Evanne Salomon

286. *Wells Street, Chicago.* 1949
Gelatin silver print, 6½ x 6 in. (16.5 x 17.3 cm)
Purchase

287. *Dearborn Street, Chicago.* 1948
Gelatin silver print, printed 1952, 7⅝ x 9⁹⁄₁₆ in. (19.4 x 24.3 cm)
Gift of the photographer

314. *Chicago.* 1950
Gelatin silver print, printed 1970s, 8⅜ x 12⁷⁄₁₆ in. (21.3 x 31.6 cm)
Acquired with matching funds from Shirley C. Burden
and the National Endowment for the Arts

315. *Chicago.* 1950
Gelatin silver print, 9½ x 13¹¹⁄₁₆ in. (24.1 x 34.8 cm)
Gift of Susan Paulsen MacGill

James Casebere (American, born 1953)
172. *Subdivision with Spotlight.* 1982
Gelatin silver print, 14¹³⁄₁₆ x 18¹⁵⁄₁₆ in. (37.6 x 48.1 cm)
Purchase

William Christenberry (American, born 1936)
62. *Red Building in Forest, Hale County, Alabama.* 1983
Chromogenic color print (Ektacolor), 17⁵⁄₁₆ x 22¹⁄₁₆ in. (43.9 x 56 cm)
Partial Gift of Shirley C. Burden (by exchange)

Christo (Christo Javacheff) (American, born Bulgaria 1935)
297. *Store Front Project.* 1964
Wood, Plexiglas, paper, fabric, pencil, charcoal, enamel paint, wire mesh,
and electric light, 48⅛ x 63 x 4 in. (122.2 x 160 x 10.2 cm)
Gift of Agnes Gund

Ted Croner (American, born 1922)
139. *Untitled.* 1947
Gelatin silver print, 11 x 13⅞ in. (27.8 x 35.2 cm)
Gift of the photographer

Charles H. Currier (American, 1851–1938)
PLATE 7. *Kitchen in the Vicinity of Boston, Massachusetts.* c. 1900
Gelatin silver print, 7¾ x 9⅞ in. (19.6 x 25 cm)
Gift of Ernst Halberstadt

Bill Dane (American, born 1938)
242. Untitled postcard from Pasadena, California. Postmarked April 1, 1976
Gelatin silver print, 4⅜ x 6⅝ in. (11.2 x 16.8 cm)
Gift of the photographer

Allan D'Arcangelo (American, 1930–1998)
106. *U.S. Highway 1, Number 5.* 1962
Synthetic polymer paint on canvas, 70 in. x 6 ft. 9½ in. (177.6 x 207 cm)
Gift of Mr. and Mrs. Herbert Fischbach

Stuart Davis (American, 1894–1964)
189. *Odol.* 1924
Oil on cardboard, 24 x 18 in. (60.9 x 45.6 cm)
Mary Sisler Bequest (by exchange) and purchase

Joe Deal (American, born 1947)
173. *Model Home, Phillips Ranch, California.* 1984
Gelatin silver print, 11⅛ x 14⅛ in. (28.4 x 36 cm)
The Family of Man Fund

Jack Delano (American, born Russia 1914)
283. *Hurricane Lumber, Ledyard, Connecticut.* 1940
Gelatin silver print, 7⅛ x 9⅝ in. (18.1 x 24.5 cm)
Purchase

Wijnanda Deroo (Dutch, born 1955)
300. *Mobile Home.* 1992
Gelatin silver print, 42 x 49 in. (106.7 x 124.5 cm)
Lois and Bruce Zenkel Fund

Philip-Lorca diCorcia (American, born 1951)
322. *Eddie Anderson; 21 years old; Houston, Texas; $20.* 1990–92
Chromogenic color print (Ektacolor), 25¹⁵⁄₁₆ x 37¹³⁄₁₆ in. (66 x 96 cm)
Gift of the photographer

323. *Marilyn; 28 years old; Las Vegas, Nevada; $30.* 1990–92
Chromogenic color print (Ektacolor), 25³⁄₁₆ x 37¹⁵⁄₁₆ in. (64 x 96.5 cm)
E. T. Harmax Foundation Fund

324. *Major Tom; Kansas City, Kansas; $20.* 1990–92
Chromogenic color print (Ektacolor), 15⅛ x 22¾ in. (38.4 x 57.8 cm)
E. T. Harmax Foundation Fund

John Divola (American, born 1949)
177. *N34° 14.264' W116° 09.877'.* 1995–98
Chromogenic color print, 19⅛ x 19⅛ in. (48.6 x 48.6 cm)
E. T. Harmax Foundation Fund

Otto Dix (German, 1891–1969)
115. *Café Couple.* 1921
Watercolor and pencil on paper, sheet: 20 x 16⅛ in. (50.8 x 41 cm)
Purchase

Arthur G. Dove (American, 1880–1946)
28. *Grandmother.* 1925
Collage of shingles, needlepoint, page from concordance, and pressed flowers
and ferns mounted on cloth-covered wood, 20 x 21¼ in. (50.8 x 54 cm)
Gift of Philip L. Goodwin (by exchange)

Rackstraw Downes (British, born 1939)
178. *Canal Home at Bayou Vista.* 1993
Oil on canvas, 11¼ in. x 10 ft. ½ in. (28.5 x 306 cm)
Gift of Lily Auchincloss

William Eggleston (American, born 1939)

PLATE 59. *Nashville*. 1971
Dye transfer print, 13¼ x 19⅛ in. (33.5 x 48.6 cm)
Gilman Foundation Fund

104. *Memphis*. 1971
Dye transfer print, 12¹⁵⁄₁₆ x 19¼ in. (32.9 x 48.9 cm)
Gilman Foundation Fund

138. *Sumner, Mississippi, Cassidy Bayou in Background*. c. 1969–70
Dye transfer print, 7¹³⁄₁₆ x 12 in. (19.9 x 30.5 cm)
Purchase

146. *Untitled*. Late 1960s
Gelatin silver print, 11 x 16⁷⁄₁₆ in. (28 x 41.7 cm)
Gift of the photographer

171. *Untitled*. Late 1960s
Gelatin silver print, 11 x 16½ in. (28 x 41.9 cm)
Gift of the photographer

180. *Memphis*. c. 1972
Dye transfer print, 17 x 11⅛ in. (43.1 x 28.3 cm)
Gift of the John E. Galvin Charitable Trust on behalf of the Crouse Family

181. *Memphis*. c. 1972
Dye transfer print, 13³⁄₁₆ x 20⅜ in. (33.4 x 52.2 cm)
Gift of the John E. Galvin Charitable Trust on behalf of the Crouse Family

182. *Memphis*. c. 1972
Dye transfer print, 12¹⁵⁄₁₆ x 19¹⁄₁₆ in. (33 x 48.5 cm)
Gilman Foundation Fund

236. *Greenwood, Mississippi*. 1973
Dye transfer print, 12⅞ x 19¹⁄₁₆ in. (32.1 x 48.4 cm)
Gift of the photographer

Philip Elliott (American, 1903–1985)

225. *Untitled*. Before 1952
Gelatin silver print, 8¹³⁄₁₆ x 13⁵⁄₁₆ in. (22.4 x 33.9 cm)
Gift of Virginia Cuthbert Elliott

Max Ernst (French, born Germany, 1891–1976)

187. *The Hat Makes the Man*. 1920
Gouache, pencil, ink, and cut-and-pasted collotypes,
14 x 18 in. (35.6 x 45.7 cm)
Purchase

Elliott Erwitt (American, born France 1928)

105. *Hollywood*. 1959
Gelatin silver print, 13⅜ x 9 in. (33.9 x 22.9 cm)
Gift of the photographer

Walker Evans (American, 1903–1975)

FRONTISPIECE. *Billboard Painters, Florida*. c. 1934
Gelatin silver print, printed c. 1970, 7½ x 8⅞ in. (19 x 22.5 cm)
David H. McAlpin Fund

PLATE 34. *Maine Pump*. 1933
Gelatin silver print, 7¹³⁄₁₆ x 5¹¹⁄₁₆ in. (19.8 x 14.4 cm)
Gift of the photographer

35. *Church Organ and Pews, Alabama*. 1936
Gelatin silver print, printed c. 1970, 7⁹⁄₁₆ x 9⅝ in. (19.3 x 24.4 cm)
Mr. and Mrs. John Spencer Fund

36. *Kitchen Wall, Alabama Farmstead*. 1936
Gelatin silver print, 6¹⁵⁄₁₆ x 8⅞ in. (17.7 x 22.6 cm)
Purchase

37. *Negro Barber Shop Interior, Atlanta*. 1936
Gelatin silver print, 7⁷⁄₁₆ x 9⅛ in. (18.9 x 23.2 cm)
Purchase

PLATE 38. *Sharecropper, Hale County, Alabama*. 1936
Gelatin silver print, printed c. 1970, 9½ x 7⁹⁄₁₆ in. (24.2 x 19.2 cm)
Stephen R. Currier Memorial Fund

39. *Alabama Cotton Tenant Farmer Wife*. 1936
Gelatin silver print, 8¹¹⁄₁₆ x 6¹⁵⁄₁₆ in. (22.1 x 17.7 cm)
Gift of the photographer

40. *Sharecropper's Family, Hale County, Alabama*. 1936
Gelatin silver print, 7¾ x 9⅝ in. (19.7 x 24.4 cm)
Gift of the Farm Security Administration

41. *Wooden Church, South Carolina*. 1936
Gelatin silver print, 8⅜ x 7⅜ in. (21.3 x 18.7 cm)
John Parkinson III Fund

42. *Breakfast Room at Belle Grove Plantation, White Chapel, Louisiana*. 1935
Gelatin silver print, 6¹⁵⁄₁₆ x 8⁹⁄₁₆ in. (17.7 x 21.7 cm)
Anonymous Fund

43. *Main Street of Pennsylvania Town*. 1935
Gelatin silver print, printed 1988, 9¼ x 7⁷⁄₁₆ in. (23.5 x 18.8 cm)
Purchase

44. *Battlefield Monument, Vicksburg, Mississippi*. 1936
Gelatin silver print, 7⅝ x 9⅝ in. (19.3 x 24.5 cm)
Gift of the photographer

45. *Stamped Tin Relic*. 1929
Gelatin silver print, printed c. 1970, 4¹¹⁄₁₆ x 6⅝ in. (11.9 x 16.9 cm)
Lily Auchincloss Fund

81. *Roadside View, Alabama Coal Area Company Town*. 1936
Gelatin silver print, printed c. 1970, 7⁹⁄₁₆ x 9½ in. (19.2 x 24.2 cm)
Gift of the photographer

82. *Part of Morgantown, West Virginia*. 1935
Gelatin silver print, 6¹¹⁄₁₆ x 9³⁄₁₆ in. (17 x 23.3 cm)
Anonymous Fund

83. *Louisiana Factory and Houses*. 1935
Gelatin silver print, 4¹¹⁄₁₆ x 7½ in. (11.9 x 19.1 cm)
Anonymous Fund

84. *Farmhouse in Westchester County, New York*. 1931
Gelatin silver print, 6⅞ x 7⅜ in. (17.5 x 18.8 cm)
Anonymous Fund

85. *Factory Street in Amsterdam, New York*. 1930
Gelatin silver print, 5½ x 6¹³⁄₁₆ in. (14 x 17.3 cm)
Anonymous Fund

86. *Bethlehem, Pennsylvania*. 1935
Gelatin silver print, 7¹¹⁄₁₆ x 9⁹⁄₁₆ in. (19.5 x 24.3 cm)
Gift of the Farm Security Administration

87. *Main Street, Saratoga Springs, New York*. 1931
Gelatin silver print, 7¹⁄₁₆ x 5⁹⁄₁₆ in. (18 x 14.2 cm)
Gift of the photographer

88. *Mining Town, West Virginia*. 1936
Gelatin silver print, printed c. 1970, 7⁹⁄₁₆ x 9⁹⁄₁₆ in. (19.2 x 24.3 cm)
Purchase

89. *Roadside Gas Sign*. 1929
Gelatin silver print, 3¹⁵⁄₁₆ x 5⅞ in. (10.1 x 15 cm)
Purchase

90. *Joe's Auto Graveyard, Pennsylvania*. 1936
Gelatin silver print, printed c. 1970, 4⅝ x 6¹³⁄₁₆ in. (11.7 x 17.3 cm)
John Parkinson III Fund

121. *Main Street Faces*. 1935
Gelatin silver print, printed 1988, 6⁵⁄₁₆ x 9⅜ in. (16.1 x 23.9 cm)
Purchase

Walker Evans (continued)

PLATE 122. *Citizen in Downtown Havana*. 1932
Gelatin silver print, printed c. 1970, 9⅜ x 5¹⁄₁₆ in. (23.8 x 12.9 cm)
Lily Auchincloss Fund

123. *Posed Portraits, New York*. 1931
Gelatin silver print, 6¹⁵⁄₁₆ x 5½ in. (17.7 x 13.9 cm)
Anonymous Fund

124. *Couple at Coney Island, New York*. 1929
Gelatin silver print, printed c. 1970, 9³⁄₁₆ x 6⁷⁄₁₆ in. (23.3 x 16.4 cm)
Purchase

125. *42nd Street*. 1929
Gelatin silver print, 4¼ x 6½ in. (10.8 x 16.6 cm)
Purchase

126. *City Lunch Counter, New York*. 1929
Gelatin silver print, 4³⁄₁₆ x 6⁵⁄₁₆ in. (10.7 x 16.1 cm)
Gift of the photographer

127. *Sons of the American Legion*. 1936
Gelatin silver print, printed c. 1960, 7 x 9⁷⁄₁₆ in. (17.8 x 24 cm)
Purchase

128. *American Legionnaire*. 1936
Gelatin silver print, 5¾ x 5⅛ in. (14.6 x 13 cm)
Gift of the Farm Security Administration

129. *Resorters at St. Petersburg*. 1941
Gelatin silver print, 5¼ x 6½ in. (13.4 x 16.6 cm)
Gift of the photographer

130. *Corner of State and Randolph Streets, Chicago*. 1946
Gelatin silver print, 9⁵⁄₁₆ x 7⅜ in. (23.7 x 18.8 cm)
Purchase

131. *Shoppers, Randolph Street, Chicago*. 1947
Gelatin silver print, 7¹³⁄₁₆ x 7¹³⁄₁₆ in. (19.8 x 19.8 cm)
Gift of the photographer

154. *Wooden House in Ossining*. 1930
Gelatin silver print, 5¾ x 5⅝ in. (14.6 x 14.3 cm)
Anonymous Fund

155. *Frame Houses in Virginia*. 1936
Gelatin silver print, 3⅞ x 7¹⁵⁄₁₆ in. (9.9 x 20.3 cm)
Gift of Willard Van Dyke

156. *New York State Farm Interior*. 1931
Gelatin silver print, printed c. 1970, 6¹³⁄₁₆ x 8¼ in. (15.7 x 20.9 cm)
Lily Auchincloss Fund

157. *Bed and Stove, Truro, Massachusetts*. 1931
Gelatin silver print, 5¹⁵⁄₁₆ x 7⅜ in. (14.8 x 18.8 cm)
Purchase

158. *Farmer's Kitchen, Hale County, Alabama*. 1936
Gelatin silver print, printed c. 1970, 9⅜ x 6¾ in. (23.9 x 17.2 cm)
Stephen R. Currier Memorial Fund

159. *Interior near Copake, New York*. 1933
Gelatin silver print, printed c. 1970, 8¹⁄₁₆ x 6⅛ in. (20.5 x 15.6 cm)
Lily Auchincloss Fund

191. *Outdoor Advertising Sign near Baton Rouge, Louisiana*. 1935
Gelatin silver print, printed c. 1970, 7¹⁵⁄₁₆ x 9⅞ in. (20.3 x 25.1 cm)
Purchase

192. *Signs, South Carolina*. 1936
Gelatin silver print, printed c. 1960, 7⅜ x 9⅜ in. (18.7 x 23.8 cm)
Purchase

193. *Sidewalk and Shopfront, New Orleans*. 1935
Gelatin silver print, 8⁷⁄₁₆ x 6⁵⁄₁₆ in. (21.4 x 16 cm)
Gift of Willard Van Dyke

PLATE 194. *Roadside Stand near Birmingham*. 1935
Gelatin silver print, 7¼ x 7½ in. (18.4 x 19 cm)
Purchase

195. *Furniture Store Sign near Birmingham, Alabama*. 1936
Gelatin silver print, 6⁵⁄₁₆ x 8¾ in. (16.1 x 22.3 cm)
John Parkinson III Fund

196. *Show Bill, Demopolis, Alabama*. 1936
Gelatin silver print, printed c. 1970, 7½ x 9½ in. (19.1 x 24.2 cm)
Purchase

197. *House on West Street, New York*. 1934
Gelatin silver print, 7³⁄₁₆ x 5¹¹⁄₁₆ in. (18.3 x 14.5 cm)
Anonymous Fund

198. *Roadside Store between Tuscaloosa and Greensboro, Alabama*. 1936
Gelatin silver print, 6⁹⁄₁₆ x 6⅛ in. (16.7 x 15.6 cm)
Gift of the photographer

199. *Political Poster, Massachusetts Village*. 1929
Gelatin silver print, printed c. 1970, 4⁵⁄₁₆ x 2¹⁵⁄₁₆ in. (11.2 x 7.4 cm)
Purchase

200. *Minstrel Showbill*. 1936
Gelatin silver print, 7⁷⁄₁₆ x 6⁵⁄₁₆ in. (18.9 x 16 cm)
Gift of the photographer

201. *Interior Detail of West Virginia Coal Miner's House*. 1935
Gelatin silver print, 8⅞ x 7⁵⁄₁₆ in. (22.5 x 18.2 cm)
Purchase

202. *Bedroom Wall, Shrimp Fisherman's House, Biloxi, Mississippi*. 1945
Gelatin silver print, printed c. 1970, 7½ x 9³⁄₁₆ in. (19.1 x 23.4 cm)
Gift of the photographer

203. *Interior Detail of Portuguese House*. 1930
Gelatin silver print, 7¹⁵⁄₁₆ x 6⅛ in. (20.2 x 15.5 cm)
Purchase

204. *License Photo Studio, New York*. 1934
Gelatin silver print, 9¹⁵⁄₁₆ x 7¹⁵⁄₁₆ in. (25.3 x 20.2 cm)
Ben Schultz Memorial Collection. Gift of the photographer

205. *Penny Picture Display, Savannah*. 1936
Gelatin silver print, 8⅝ x 6¹⁵⁄₁₆ in. (21.9 x 17.6 cm)
Gift of Willard Van Dyke

257. *Houses and Billboards in Atlanta*. 1936
Gelatin silver print, 6½ x 9⅛ in. (16.5 x 23.2 cm)
Purchase

258. *Torn Movie Poster*. 1930
Gelatin silver print, 6⅜ x 4⅜ in. (16.2 x 11.2 cm)
Purchase

259. *Lunch Wagon Detail, New York*. 1931
Gelatin silver print, 8⅞ x 6³⁄₁₆ in. (22.5 x 15.7 cm)
Gift of the photographer

260. *Parked Car, Small Town Main Street*. 1932
Gelatin silver print, printed c. 1970, 5½ x 8¹⁵⁄₁₆ in. (14 x 22.7 cm)
Lily Auchincloss Fund

261. *Girl in Fulton Street, New York*. 1929
Gelatin silver print, 7⁵⁄₁₆ x 4⅝ in. (18.6 x 11.8 cm)
Gift of the photographer

274. *Cottage at Ossining Camp Woods, New York*. 1930
Gelatin silver print, 5¾ x 6⁵⁄₁₆ in. (14.7 x 18.6 cm)
Anonymous Fund

275. *Cottage at Ossining Camp Woods, New York*. 1930
Gelatin silver print, printed c. 1970, 6³⁄₁₆ x 7¾ in. (15.7 x 19.7 cm)
Gift of the photographer

PLATE 276. *Negro Church, South Carolina.* 1936
Gelatin silver print, 9 x 6¹⁵⁄₁₆ in. (22.9 x 17.6 cm)
Gift of Willard Van Dyke

277. *Main Street Block, Selma, Alabama.* 1936
Gelatin silver print, 6⅝ x 9¹⁄₁₆ in. (16.9 x 23 cm)
Gift of Willard Van Dyke

278. *Corrugated Tin Façade.* 1936
Gelatin silver print, printed c. 1970, 6½ x 9¹⁄₁₆ in. (16.6 x 23.1 cm)
David H. McAlpin Fund

279. *Part of a House in Charleston.* 1935
Gelatin silver print, 5⁷⁄₁₆ x 5½ in. (13.8 x 13.9 cm)
Anonymous Fund

280. *Detail of a Frame House in Ossining, New York.* 1931
Gelatin silver print, printed c. 1970, 7¹⁵⁄₁₆ x 6⁵⁄₁₆ in. (20.1 x 16 cm)
Purchase

281. *Church of the Nazarene, Tennessee.* 1936
Gelatin silver print, 6⅛ x 7¹⁵⁄₁₆ in. (15.6 x 20.1 cm)
Gift of the photographer

303. *Subway Portrait.* 1938–41
Gelatin silver print, 5 x 3¹⁵⁄₁₆ in. (12.8 x 10 cm)
Purchase

304. *Subway Portrait.* 1938–41
Gelatin silver print, 7⁵⁄₁₆ x 7⅞ in. (18.6 x 20 cm)
Purchase

305. *Subway Portrait.* 1938–41
Gelatin silver print, 5 x 5¹⁄₁₆ in. (12.7 x 12.8 cm)
Purchase

306. *Subway Portrait.* 1938–41
Gelatin silver print, 6¹⁵⁄₁₆ x 7½ in. (17.6 x 19.1 cm)
Purchase

307. *Subway Portrait.* 1938–41
Gelatin silver print, 7 x 7⅜ in. (17.8 x 18.7 cm)
Purchase

308. *Subway Portrait.* 1938–41
Gelatin silver print, 6¹¹⁄₁₆ x 5 in. (17 x 12.7 cm)
Purchase

309. *Subway Portrait.* 1938–41
Gelatin silver print, 6½ x 8 in. (16.5 x 20.4 cm)
Purchase

310. *Subway Portrait.* 1938–41
Gelatin silver print, 6⅞ x 6¹⁄₁₆ in. (17.5 x 15.4 cm)
Purchase

311. *Subway Portrait.* 1938–41
Gelatin silver print, 7 x 6⁷⁄₁₆ in. (17.8 x 16.3 cm)
Purchase

312. *Subway Portrait.* 1938–41
Gelatin silver print, 6¹³⁄₁₆ x 7⁹⁄₁₆ in. (17.3 x 19.3 cm)
Purchase

313. *Subway Portrait.* 1938–41
Gelatin silver print, 3¾ x 5¼ in. (9.6 x 13.4 cm)
Purchase

Louis Faurer (American, born 1916)

262. *Untitled.* 1938
Gelatin silver print, 10¹¹⁄₁₆ x 10¼ in. (27.1 x 26 cm)
John Parkinson III Fund

Hollis Frampton (American, 1936–1984)

PLATE 227. *Untitled.* 1961
Gelatin silver print, 7¼ x 9³⁄₁₆ in. (18.5 x 23.4 cm)
Purchase

Robert Frank (American, born Switzerland 1924)

58. *Barber Shop through Screen Door, McClellanville, South Carolina.* 1955
Gelatin silver print, 10¹³⁄₁₆ x 16⅛ in. (25.7 x 41 cm)
John Spencer Fund

102. *Covered Car, Long Beach, California.* 1955–56
Gelatin silver print, 13⅛ x 19³⁄₁₆ in. (33.3 x 48.8 cm)
John Spencer Fund

137. *Trolley, New Orleans.* 1955
Gelatin silver print, 9¹⁄₁₆ x 13⅜ in. (23.1 x 34 cm)
The Fellows of Photography Fund, The Family of Man Fund,
and Anonymous Purchase Fund

143. *St. Petersburg, Florida.* 1957
Gelatin silver print, 8⁷⁄₁₆ x 12¾ in. (21.5 x 32.4 cm)
Purchase

151. *East Side, New York City.* 1955
Gelatin silver print, 12¹³⁄₁₆ x 8⅞ in. (32.5 x 22.5 cm)
Purchase

220. *Luncheonette, Butte, Montana.* 1956
Gelatin silver print, 11¾ x 16⅝ in. (29.9 x 42.2 cm)
John Spencer Fund

221. *Hoover Dam.* 1956
Gelatin silver print, printed c. 1975, 12³⁄₁₆ x 7¹⁵⁄₁₆ in. (30.9 x 20.1 cm)
Gift of Paul A. Katz and Arthur Penn

230. *Store Window, Washington, D.C.* 1956
Gelatin silver print, 8⁵⁄₁₆ x 12¹¹⁄₁₆ in. (21.1 x 32.3 cm)
Robert and Joyce Menschel Fund

264. *Movie Premiere, Hollywood.* 1955–56
Gelatin silver print, 10¹⁄₁₆ x 6¾ in. (25.6 x 17.2 cm)
Purchase

316. *Parade, Hoboken, New Jersey.* 1955
Gelatin silver print, 8¹⁄₁₆ x 12¼ in. (20.5 x 31.1 cm)
Purchase

Lee Friedlander (American, born 1934)

60. *Baltimore.* 1962
Gelatin silver print, 8½ x 5½ in. (21.7 x 14 cm)
Stephen R. Currier Memorial Fund

64. *Bellows Falls, Vermont.* 1971
Gelatin silver print, 7⁹⁄₁₆ x 11¼ in. (19.1 x 28.5 cm)
Gift of Shirley C. Burden

65. *Mount Rushmore, South Dakota.* 1969
Gelatin silver print, 8¹⁄₁₆ x 12³⁄₁₆ in. (20.5 x 31 cm)
Gift of the photographer

103. *New York City.* 1963
Gelatin silver print, 6⅜ x 9¾ in. (16.2 x 24.8 cm)
Purchase

109. *New Orleans.* 1969
Gelatin silver print, 6½ x 9¾ in. (16.5 x 24.8 cm)
Purchase

232. *Washington, D.C.* 1962
Gelatin silver print, 5¹¹⁄₁₆ x 8¹¹⁄₁₆ in. (14.4 x 22 cm)
Purchase

237. *Galax, Virginia.* 1962
Gelatin silver print, 6 x 9⅛ in. (15.2 x 23.2 cm)
Gift of the photographer

Lee Friedlander (continued)

PLATE 238. *Denver, Colorado*. 1965
Gelatin silver print, 5⅝ x 8⅝ in. (14.4 x 21.8 cm)
Stephen R. Currier Memorial Fund

244. *New Orleans*. 1979. From the series Letters from the People
Gelatin silver print, 22⅜ x 15⅛ in. (56.8 x 38.5 cm)
The Family of Man Fund and Anonymous Purchase Fund

245. *Suffern, New York*. 1979. From the series Letters from the People
Gelatin silver print, 12⅜ x 18⅝ in. (31/5 x 47.3 cm)
The Family of Man Fund and Anonymous Purchase Fund

246. *Boston, Massachusetts*. 1979. From the series Letters from the People
Gelatin silver print, 22⅜ x 15⅛ in. (56.8 x 38.5 cm)
The Family of Man Fund and Anonymous Purchase Fund

247. *New Orleans*. 1979. From the series Letters from the People
Gelatin silver print, 8⅝ x 12¹⁵⁄₁₆ in. (21.9 x 32.8 cm)
The Family of Man Fund and Anonymous Purchase Fund

248. *Akron, Ohio*. 1980. From the series Letters from the People
Gelatin silver print, 15⅛ x 22⅜ in. (38.2 x 56.8 cm)
The Family of Man Fund and Anonymous Purchase Fund

249. *New York City*. 1985. From the series Letters from the People
Gelatin silver print, 12¹⁵⁄₁₆ x 8⅝ in. (32.8 x 21.9 cm)
The Family of Man Fund and Anonymous Purchase Fund

250. *New York City*. 1987. From the series Letters from the People
Gelatin silver print, 18⅝ x 12⅜ in. (47.3 x 31.5 cm)
The Family of Man Fund and Anonymous Purchase Fund

265. *Portland, Maine*. 1962
Gelatin silver print, 5¹¹⁄₁₆ x 8½ in. (14.4 x 21.7 cm)
Purchase

268. *Los Angeles, California*. 1965
Gelatin silver print, 6⅜ x 9⅝ in. (16.2 x 24.5 cm)
Purchase

318. *New York City*. 1964
Gelatin silver print, 6⅜ x 9¾ in. (16.2 x 24.8 cm)
Gift of the International Program

319. *Galax, Virginia*. 1962
Gelatin silver print, 5⅞ x 8⅞ in. (14.9 x 22.5 cm)
Gift of Mrs. Armand P. Bartos

William Gedney (American, 1932–1989)

269. *Untitled*. 1967
Gelatin silver print, 8¹⁄₁₆ x 11¹⁵⁄₁₆ in. (20.5 x 30.7 cm)
Mr. and Mrs. John Spencer Fund

L. S. Glover (American, dates unknown)

5. *In the Heart of the Copper Country, Calumet, Michigan*. 1905
Gelatin silver print, 7 x 56⁹⁄₁₆ in. (17.8 x 143.7 cm)
Lois and Bruce Zenkel Fund

Robert Gober (American, born 1954)

183. Untitled. 1986
Enamel paint on wood, cotton, wool, and down, 36½ in. x 43 in. x
6 ft. 4⅜ in. (92.7 x 109.2 x 194 cm)
Fractional gift of Werner and Elaine Dannheisser

Frank Gohlke (American, born 1942)

57. *Brick Building in the Shadow of a Grain Elevator, Cashion, Oklahoma*. 1973–74
Gelatin silver print, 8 x 8 in. (20.3 x 20.3 cm)
Gift of Pierre N. Leval

176. *House and Cypress Trees, Hellsboro, Texas*. 1978
Gelatin silver print, 13¹⁵⁄₁₆ x 7¹¹⁄₁₆ in. (35.5 x 45 cm)
Anonymous gift

David Goldblatt (South African, born 1930)

PLATE 74. *Café-de-Move-On, Braamfontein, Johannesburg*. 1964
Gelatin silver print, 13⁹⁄₁₆ x 9¹⁄₁₆ in. (34.5 x 23 cm)
Gift of Paul F. Walter in honor of Matthew Bergey

75. *Stairway, Meerlust Wine Farm near Stellenbosch*. 1990
Gelatin silver print, 10¹⁵⁄₁₆ x 13¹¹⁄₁₆ in. (27.9 x 34.8 cm)
Gift of Wm. Brian Little

76. *House near Phuthaditjhaba, Qwa Qwa*. 1989
Gelatin silver print, 10¹⁵⁄₁₆ x 13⁹⁄₁₆ in. (27.9 x 34.5 cm)
Purchase

77. *A New Shack under Construction, Lenasia Extension 9, Lenasia,
Transvaal*. 1990 Gelatin silver print, 10⅞ x 13¹¹⁄₁₆ in. (27.7 x 34.8 cm)
Purchase

78. *Garage Wall of a House in Verwoerdburg, Transvaal*. 1986
Gelatin silver print, 10⅞ x 13¹¹⁄₁₆ in. (27.7 x 34.8 cm)
Purchase

Felix Gonzalez-Torres (American, born Cuba, 1957–1996)

252 and 253. *Untitled (Death by Gun)*. 1990
Nine-inch stack of photolithographs. Edition: unlimited.
Sheet: 44¹⁵⁄₁₆ x 32¹⁵⁄₁₆ in. (114.1 x 83.6 cm)
Purchased in part with funds from Arthur Fleischer, Jr., and
Linda Barth Goldstein

Dan Graham (American, born 1942)

167. *"Baroque" Bedroom, "Model Home," Staten Island, New York;
Motel, San Francisco*. 1967/1982
Two chromogenic color prints, each 9¹⁵⁄₁₆ x 14 in. (23.6 x 35.6 cm),
overall 35¼ x 25⅞ in. (89.5 x 65.7 cm)
Gift of the Dannheisser Foundation

Jan Groover (American, born 1943)

288. Untitled. 1977
Three chromogenic color prints, each 19¹⁄₁₆ x 12¾ in. (48.4 x 32.4 cm),
overall 19¹⁄₁₆ x 38⁹⁄₁₆ in. (48.4 x 97 cm)
Gift of Lily Auchincloss

George Grosz (American, born Germany, 1893–1959)

116. *Dr. Huelsenbeck at the End*. 1920. From the book *Ecce Homo* (Berlin:
Der Malik-Verlag, 1923)
Photolithographic reproduction after a drawing, page: 13¾ x 9¾ in.
(34.9 x 24.8 cm)
The Louis E. Stern Collection

Andreas Gursky (German, born 1955)

301. *Times Square, New York*. 1997
Chromogenic color print, 57³⁄₁₆ in. x 6 ft. 9⅝ in. (145.3 x 207.3 cm)
The Family of Man Fund

Chauncey Hare (American, born 1934)

66. *Escalon Hotel before Demolishment, San Joaquin Valley, California*. 1968
Gelatin silver print, 8¼ x 11¾ in. (20.9 x 29.8 cm)
Purchase

Rachel Harrison (American, born 1966)

234. *Twenty Dollars*. 1996
Chromogenic color print, 15¹¹⁄₁₆ x 23³⁄₁₆ in. (39.9 x 58.9 cm)
E. T. Harmax Foundation Fund

Edward Hopper (American, 1882–1967)

29. *House by the Railroad*. 1925
Oil on canvas, 24 x 29 in. (61 x 73.7 cm)
Given anonymously

79. *Box Factory, Gloucester*. 1928
Watercolor and pencil on paper, sheet: 13⅞ x 19⅞ in. (35.2 x 50.5 cm)
Gift of Abby Aldrich Rockefeller

PLATE 118. *Girl on a Bridge.* 1923
Etching, comp.: 6¹³⁄₁₆ x 8⅞ in. (17.4 x 22.5 cm),
sheet: 13¼ x 16½ in. (33.8 x 41.9 cm)
Abby Aldrich Rockefeller Fund

263. *New York Movie.* 1939
Oil on canvas, 32¼ x 40⅛ in. (81.9 x 101.9 cm)
Given anonymously

302. *East Side Interior.* 1922
Etching, comp.: 7⅞ x 9¹³⁄₁₆ in. (20 x 25 cm), sheet: 13⁹⁄₁₆ x 16¾ in.
(34.4 x 42.6 cm)
Gift of Abby Aldrich Rockefeller

Simpson Kalisher (American, born 1926)

140. *Untitled.* 1961
Gelatin silver print, 8⅞ x 13⁷⁄₁₆ in. (22.6 x 34.2 cm)
Purchase

240. *Untitled.* 1962
Gelatin silver print, 9¼ x 13½ in. (23.5 x 34.3 cm)
Ben Schultz Memorial Collection. Gift of the photographer

William Klein (American, born 1928)

222. *Gun, Gun, Gun, New York.* 1955
Gelatin silver print, 9½ x 13⁵⁄₁₆ in. (24.2 x 33.8 cm)
The Fellows of Photography Fund

Clarence John Laughlin (American, 1905–1985)

55. *Black and White (No. 1).* 1938–40
Gelatin silver print, 10⅜ x 13⅜ in. (26.2 x 34.6 cm)
Gift of the photographer

207. *The Sparkle of Commercial Greed.* 1938–40
Gelatin silver print, 10³⁄₁₆ x 13¹¹⁄₁₆ in. (25.9 x 34.7 cm)
Gift of the photographer

224. *Spectre of Coca-Cola.* 1962
Gelatin silver print, printed 1981, 13¼ x 10⅜ in. (33.6 x 26.4 cm)
Robert B. Menschel Fund

Russell Lee (American, 1903–1986)

51. *Old Lamps in House of Jim Hardin, Two Bit near Deadwood, South Dakota.* 1937
Gelatin silver print, 7⁵⁄₁₆ x 9⅝ in. (18.6 x 24.5 cm)
Purchase

160. *Decorations above Mantel in Negro Home along the Levee, Norco, Louisiana.* 1938
Gelatin silver print, 7¼ x 9⅝ in. (18.3 x 24.4 cm)
Purchase

161. *Desk in Home of Acadian Family near Breaux Bridge, Louisiana.* 1938
Gelatin silver print, 9⅝ x 7³⁄₁₆ in. (24.4 x 18.2 cm)
Purchase

165. *New Houses Built by Negroes in Better Residential Section, South Side of Chicago, Illinois.* 1941
Gelatin silver print, 7³⁄₁₆ x 9⁹⁄₁₆ in. (18.2 x 24.2 cm)
Purchase

208. *Sign in Country Store near Vacherie, Louisiana.* 1938
Gelatin silver print, 6⁷⁄₁₆ x 9 in. (16.3 x 22.8 cm)
Purchase

209. *Bulletin Board in Post Office Showing a Large Collection of "Wanted Men" Signs, Ames, Iowa.* 1936
Gelatin silver print, 7⁷⁄₁₆ x 9⅛ in. (19 x 23.2 cm)
Purchase

212. *Sign, Harlingen, Texas.* 1939
Gelatin silver print, 6³⁄₁₆ x 8¹³⁄₁₆ in. (15.7 x 22.3 cm)
Purchase

PLATE 214. *Sign on Wholesale Grocery Store, San Angelo, Texas.* 1939
Gelatin silver print, 7¼ x 9⅝ in. (18.4 x 24.4 cm)
Purchase

284. *Kitchen of Tenant Purchase Client, Hidalgo County, Texas.* 1939
Gelatin silver print, 7½ x 9⅜ in. (19 x 23.9 cm)
Courtesy of the Library of Congress, Washington, D.C.

Sol LeWitt (American, born 1928)

295. *Brick Wall.* 1977
Two gelatin silver prints, overall 10⅞ x 17⅛ in. (27.6 x 43.6 cm)
Acquired with matching funds from Mrs. John D. Rockefeller 3rd and the National Endowment for the Arts

Roy Lichtenstein (American, 1923–1997)

267. *Drowning Girl.* 1963
Oil and synthetic polymer paint on canvas, 67⅝ x 66¾ in.
(171.6 x 169.5 cm)
Philip Johnson Fund and gift of Mr. and Mrs. Bagley Wright

Edwin Hale Lincoln (American, 1848–1938)

3. *Figurehead of U.S.S. Frigate Niagara.* c. 1900
Platinum print, 7⁵⁄₁₆ x 9⁷⁄₁₆ in. (18.6 x 24 cm)
John Parkinson III Fund

William Preston Mayfield (American, 1896–1974)

8. *Grocery Store.* 1920s or 1930s
Gelatin silver print, 7¹¹⁄₁₆ x 9⁹⁄₁₆ in. (19.6 x 24.3 cm)
The Family of Man Fund

Joel Meyerowitz (American, born 1938)

243. *Los Angeles.* 1964
Gelatin silver print, 9 x 13 ½ in. (22.9 x 34.3 cm)
Gift of the International Program

Wright Morris (American, 1910–1998)

52. *Barber Shop Utensils and Cabinet, Cahow's Barber Shop.* 1942
Gelatin silver print, printed 1967, 7½ x 9½ in. (19 x 24.2 cm)
Gift of the photographer

92. *Mailboxes, Western Nebraska.* 1947
Gelatin silver print, printed 1967, 7⅛ x 9⁷⁄₁₆ in. (18.1 x 24 cm)
Gift of the photographer

162. *Farmhouse near McCook, Nebraska.* 1941
Gelatin silver print, printed 1967, 7⅛ x 9½ in. (18 x 24 cm)
Gift of the photographer

164. *Straightback Chair, Home Place.* 1947
Gelatin silver print, 13⅝ x 11⅛ in. (34.7 x 28.2 cm)
Gift of the photographer

282. *Gano Grain Elevator, Western Kansas.* 1939
Gelatin silver print, 9½ x 7¾ in. (24.1 x 19.7 cm)
Purchase

Nicholas Nixon (American, born 1947)

112. *View of Kenmore Square, Boston.* 1974
Gelatin silver print, 7¹¹⁄₁₆ x 9¹¹⁄₁₆ in. (19.6 x 24.6 cm)
Gift of the photographer

Gabriele and Helmut Nothhelfer (German, both born 1945)

141. *Catholic at Corpus Christi Day, Berlin.* 1974
Gelatin silver print, 8½ x 11⅝ in. (21.6 x 29.6 cm)
Purchase

Tod Papageorge (American, born 1940)

108. *Kansas.* 1969
Gelatin silver print, 8⅞ x 13¼ in. (22.5 x 33.7 cm)
Purchase

Frank Paulin (American, born 1926)

PLATE 266. *Times Square.* 1954
Gelatin silver print, 11⅜ x 16¼ in. (28.9 x 41.3 cm)
Arthur M. Bullowa Fund

Irving Penn (American, born 1917)

218. *O'Sullivan's Heels, New York.* 1939
Gelatin silver print, 11¼ x 10¹¹⁄₁₆ in. (28.5 x 27.2 cm)
Gift of the photographer

Pablo Picasso (Spanish, 1881–1973)

185. *Guitar.* 1913
Pasted paper, charcoal, ink, and chalk on blue paper mounted on ragboard,
26⅛ x 19½ in. (66.4 x 49.6 cm)
Nelson A. Rockefeller Bequest

Robert Rauschenberg (American, born 1925)

101. *First Landing Jump.* 1961
Combine painting: cloth, metal, leather, electric fixture, cable, and oil
paint on composition board; overall, including automobile tire and wooden
plank on floor, 7 ft. 5⅛ in. x 6 ft. x 8⅞ in. (226.3 x 182.8 x 22.5 cm)
Gift of Philip Johnson

231. *Mark.* Frontispiece from the book *XXXIV Drawings for Dante's Inferno.* 1964
Lithograph, comp.: 13¹⁵⁄₁₆ x 16¼ in. (35.5 x 41.3 cm),
sheet: 15¾ x 16¼ in, (40 x 41.3 cm)
Gift of the Celeste and Armand Bartos Foundation

Thomas Roma (American, born 1950)

175. *Dutch House.* 1975
Gelatin silver print, 22¹³⁄₁₆ x 33¹⁵⁄₁₆ in. (58 x 86.3 cm)
Polaroid Foundation Fund

James Rosenquist (American, born 1933)

229. *Marilyn Monroe, I.* 1962
Oil and spray enamel on canvas, 7 ft. 9 in. x 6 ft. ¼ in. (236.2 x 183.3 cm)
The Sidney and Harriet Janis Collection

Judith Joy Ross (American, born 1946)

321. *Untitled.* 1984. From the series Portraits at the Vietnam Veterans Memorial,
Washington, D.C. 1983–84
Four gelatin silver printing-out-paper prints, each 9⅝ x 7⅝ in.
(24.4 x 19.6 cm)
Gift of Scripps Howard Broadcasting Co. in honor of Jack R. Howard

Arthur Rothstein (American, 1915–1985)

215. *Drover's Hotel opposite Stockyards, Kansas City, Kansas.* 1936
Gelatin silver print, 7½ x 9⅝ in. (19.1 x 24.4 cm)
Purchase

Edward Ruscha (American, born 1937)

107. *Standard Station.* 1966
Screenprint, comp.: 19⅝ x 36¹⁵⁄₁₆ in. (49.6 x 93.8 cm), sheet: 25⅝ x 40 in.
(65.1 x 101.6 cm)
John B. Turner Fund

235. *OOF.* 1962, reworked 1963
Oil on canvas, 71½ x 67 in. (181.5 x 170.2 cm)
Gift of Agnes Gund, the Louis and Bessie Adler Foundation, Inc., Robert
and Meryl Meltzer, Jerry I. Speyer, Anna Marie and Robert F. Shapiro,
Emily and Jerry Spiegel, an anonymous donor, and purchase

292. *Every Building on the Sunset Strip* (Los Angeles: Edward Ruscha, 1966)
Photolithographic halftone book in foil-covered slipcase, closed: 7 x 5½ in.
(17.9 x 14 cm), unfolds to 27 ft. (823 cm) long
The Museum of Modern Art Library

August Sander (German, 1876–1964)

31. *The Earthbound Farmer.* 1910
Gelatin silver print, 11½ x 9¹⁄₁₆ in. (29.2 x 23 cm)
Gift of the photographer

PLATE 32. *Peasant Woman.* 1914
Gelatin silver print, 11½ x 9⅛ in. (29.2 x 23.2 cm)
Gift of the photographer

33. *Farming Generations.* 1912
Gelatin silver print, 8⅝ x 11⁷⁄₁₆ in. (21.9 x 29 cm)
Gift of the photographer

117. *Unemployed Sailor.* 1928
Gelatin silver print, printed 1944–53, 11⁷⁄₁₆ x 8⅞ in. (29 x 22.6 cm)
Gift of the photographer

Jeffrey Scales (American, born 1954)

142. *Woman Smoking, Fifth Avenue.* 1985
Gelatin silver print, 18½ x 18⁹⁄₁₆ in. (47 x 47.1 cm)
The Family of Man Fund

Christian Schad (German, 1894–1982)

186. *Schadograph.* 1919
Gelatin printing-out-paper print, 6⅝ x 5 in. (16.8 x 12.7 cm)
Purchase

Michael Schmidt (German, born 1945)

67. *Chausseestrasse, West Berlin.* 1976–77
Gelatin silver print, 8 x 11 in. (20.3 x 28 cm)
The Family of Man Fund

254. From *U-ni-ty (Ein-heit).* 1991–94
32 of the 163 gelatin silver prints constituting this work,
each c. 19⅞ x 13½ in. (50.5 x 34.3 cm)
Anonymous Purchase Fund and purchase

Kurt Schwitters (British, born Germany, 1887–1948)

184. *Merz Drawing 83. Drawing F.* 1920
Cut-and-pasted printed papers with cardboard border, 5¾ x 4½ in.
(14.6 x 11.4 cm)
Katherine S. Dreier Bequest

Ben Shahn (American, born Lithuania, 1898–1969)

132. *Scene at Smithland, Kentucky.* 1935
Gelatin silver print, 6⁵⁄₁₆ x 9½ in. (16.1 x 24 cm)
Purchase

133. *Women at Fourth of July Carnival and Fish Fry, Ashville, Ohio.* 1938
Gelatin silver print, 6⅜ x 9⁹⁄₁₆ in. (16.2 x 24.3 cm)
Gift of the Farm Security Administration

136. *Deputy in a West Virginia Mining Town.* 1935
Gelatin silver print, 5½ x 9½ in. (14 x 24.2 cm)
Courtesy of the Library of Congress, Washington, D.C.

211. *Campaign Posters, Central Ohio, Route 40.* 1938
Gelatin silver print, 6⁹⁄₁₆ x 9½ in. (16.8 x 24.1 cm)
Purchase

G. Willard Shear (American, active 1880s–1890s)

6. Two-page spread from *Panorama of the Hudson, showing both sides of
the river from New York to Albany,* Red Line edition (New York: Bryant
Literary Union, 1900)
Relief halftone book, closed: 7½ x 12⅜ x ⅜ in. (19.1 x 31.4 x .9 cm),
open: 7½ x c. 24 ¾ in. (19 x c. 63 cm)
The Museum of Modern Art Library, Special Collections

Charles Sheeler (American, 1883–1965)

27. *White Barn, Bucks County, Pennsylvania.* 1914–17
Gelatin silver print, 10¼ x 12¾ in. (26.1 x 32.4 cm)
Gift of the photographer

Cindy Sherman (American, born 1954)

271. *Untitled Film Still #54.* 1980
Gelatin silver print, 6¹³⁄₁₆ x 9⁷⁄₁₆ in. (17.3 x 24 cm)
Purchase

PLATE 272. *Untitled Film Still #32.* 1979
Gelatin silver print, 7½ x 9⁷⁄₁₆ in. (19 x 24 cm)
Purchase

273. *Untitled Film Still #21.* 1978
Gelatin silver print, 7½ x 9½ in. (19 x 24.1 cm)
Purchase

Stephen Shore (American, born 1947)

111. *U.S. 10, Post Falls, Idaho.* 1974
Chromogenic color print, 7½ x 9½ in. (19 x 24.2 cm)
Gift of the photographer

291. *Meeting Street, Charleston, South Carolina.* 1975
Chromogenic color print, 12 x 15 in. (30.5 x 38.2 cm)
Gift of the John R. Jacobson Foundation, Inc.

Art Sinsabaugh (American, 1924–1983)

99. *Chicago Landscape #85.* 1964
Gelatin silver print, 7⅝ x 19⅜ in. (19.4 x 49.3 cm)
Gift of the International Program

Aaron Siskind (American, 1903–1991)

217. *Chicago.* 1949
Gelatin silver print, 14 x 17⅞ in. (35.6 x 45.3 cm)
Gift of Robert and Joyce Menschel

289. *New York I.* 1951
Gelatin silver print, printed 1970s, 9 x 12⁷⁄₁₆ in. (22.9 x 31.6 cm)
Gift of Frances F. L. Beatty

Souvenir Post Card Co.

10. *Wall Street, New York.* 1895
Relief halftone postcard, 5⁷⁄₁₆ x 3⁷⁄₁₆ in. (13.8 x 8.8 cm)
Purchase

11. *Post Office, New York.* 1895
Relief halftone postcard, 5⅜ x 3⁷⁄₁₆ in. (13.6 x 8.7 cm)
Purchase

Michael Spano (American, born 1949)

148. *81st and Broadway.* 1984
Gelatin silver print, 27 x 34½ in. (68.6 x 87.6 cm)
Robert B. Menschel Fund

Ralph Steiner (American, 1899–1986)

30. *American Rural Baroque.* c. 1928
Gelatin silver print, 7½ x 9½ in. (19 x 24.1 cm)
Gift of Lincoln Kirstein

80. *Saratoga Springs.* c. 1929
Gelatin silver print, 7⅝ x 9½ in. (19.3 x 24.1 cm)
Gift of the photographer

188. *Sign, Saratoga Springs.* 1929
Gelatin silver print, 9½ x 7½ in. (24.1 x 19 cm)
Gift of the photographer

255. *Saratoga Billboard.* c. 1929
Gelatin silver print, 9⁹⁄₁₆ x 7⁹⁄₁₆ in. (24.3 x 19.3 cm)
Gift of the photographer

256. *1925 Movies.* c. 1930
Gelatin silver print, 8⅛ x 6¼ in. (20.6 x 15.9 cm)
Gift of the photographer

Joseph Sterling (American, born 1936)

150. *Teenagers.* 1960
Gelatin silver print, 10¾ x 10⁷⁄₁₆ in. (27.3 x 26.5 cm)
Gift of the photographer

Joel Sternfeld (American, born 1944)

PLATE 114. *After a Flash Flood, Rancho Mirage, California.* 1979
Chromogenic color print, 13½ x 17¹⁄₁₆ in. (34.3 x 43.3 cm)
Acquired with matching funds from Shirley C. Burden and the National Endowment for the Arts

153. *Summer Interns, Wall Street, New York.* 1987
Chromogenic color print, 33¾ x 42½ in. (85.7 x 107.9 cm)
Gift of the photographer

174. *Lake Oswego, Oregon.* 1979
Chromogenic color print, 13½ x 16¹³⁄₁₆ in. (34.2 x 42.6 cm)
Gift of the photographer

Paul Strand (American, 1890–1976)

48. *Mr. Bennett, Vermont.* 1944
Gelatin silver print, 9 x 11⁵⁄₁₆ in. (22.9 x 28.8 cm)
Gift of the Estate of Vera Louise Fraser

49. *Church.* 1944
Gelatin silver print, 9½ x 7⁹⁄₁₆ in. (24.2 x 19.3 cm)
Gift of Mrs. Armand P. Bartos

119. *Man in a Derby.* 1916
Platinum print, 12¹⁵⁄₁₆ x 9⅜ in. (32.8 x 23.9 cm)
Gift of the photographer

120. *Blind.* 1916
Photogravure from *Camera Work*, 8⅝ x 6⁷⁄₁₆ in. (21.9 x 16.3 cm)
Gift of Edward Steichen

190. *Truckman's House, New York.* 1920
Gelatin silver print, 9⅜ x 7¹¹⁄₁₆ in. (23.8 x 19.5 cm)
Gift of the photographer

Thomas Struth (German, born 1954)

70. *Fischersand, Erfurt.* 1991
Gelatin silver print, 16¾ x 21¼ in. (42.54 x 54 cm)
Lois and Bruce Zenkel Fund

71. *Sommerstrasse, Düsseldorf.* 1980
Gelatin silver print, 15¾ x 22 in. (40 x 55.9 cm)
Lois and Bruce Zenkel Fund

72. *View of Sankt Salvator, Düsseldorf.* 1985
Gelatin silver print, 13⅞ x 21½ in. (35.2 x 54.6 cm)
The Family of Man Fund

73. *Hörder Brückenstrasse, Dortmund.* 1986
Gelatin silver print, 16³⁄₁₆ x 23¼ in. (41.1 x 59 cm)
The Family of Man Fund

294. *South Lake Street Apartments II, Chicago.* 1990
Gelatin silver print, 18⅝ x 22⅜ in. (47.3 x 56.8 cm)
Anonymous Purchase Fund

John Szarkowski (American, born 1925)

163. *Screen Porch, Hudson, Wisconsin.* 1950
Gelatin silver print, 12¹¹⁄₁₆ x 9¹¹⁄₁₆ in. (32.2 x 24.6 cm)
Gift of Christie Calder Salomon

290. *Guaranty (Prudential) Building, Buffalo, Corner Column.* 1951–52
Gelatin silver print, 9¹⁵⁄₁₆ x 13⅛ in. (25.3 x 33.4 cm)
Gift of Celeste C. Bartos

George A. Tice (American, born 1938)

53. *South Main Street, Hannibal, Missouri.* 1985
Gelatin silver print, 10⅝ x 13¼ in. (26.9 x 33.6 cm)
Purchase

Unknown (American)

4. *Shaker Building.* c. 1890
Gelatin silver print, 3³⁄₁₆ x 4¾ in. (9.7 x 12 cm)
John Parkinson III Fund

Unknown (American)

PLATE 9. *Vamp Building, Largest Shoe Factory in the World, Lynn, Massachusetts.*
1912 or before
Relief halftone postcard, 3⁷⁄₁₆ x 5½ in. (8.7 x 13.9 cm)
Purchase

Unknown (American)

12. *West Evans Street, Florence, South Carolina.* c. 1910
Relief halftone postcard, 3⅜ x 5⁵⁄₁₆ in. (8.6 x 13.5 cm)
Purchase

John Vachon (American, 1914–1975)

50. *Main Street of Starkweather, North Dakota.* 1940
Gelatin silver print, 7⅛ x 9⅝ in. (18 x 24.5 cm)
Purchase

134. *The Flag Is Going By, Sesquicentennial Parade, Cincinnati, Ohio.* 1938
Gelatin silver print, 6⁹⁄₁₆ x 9⁹⁄₁₆ in. (16.6 x 24.2 cm)
Purchase

213. *Decoration in Store at Alger, Montana.* 1937
Gelatin silver print, 7¹⁄₁₆ x 9⅝ in. (17.8 x 24.5 cm)
Purchase

Paul Vanderbilt (American, 1905–1992)

113. *Vicinity of Beetown, Wisconsin.* 1962
Gelatin silver print, 13⁷⁄₁₆ x 14⁹⁄₁₆ in. (34.2 x 37 cm)
Purchase

Robert Venturi (American, born 1925)

166. *Vanna Venturi House, Chestnut Hill, Pennsylvania, Preliminary Version F
(Final).* c. 1961–62
Model in cardboard and paper, 7¾ x 20½ x 6¾ in. (19.5 x 52 x 17 cm)
Gift of Venturi, Rauch, and Scott Brown, Inc.

Jacques Mahé de la Villeglé (French, born 1926)

226. *122 rue du Temple.* 1968
Torn-and-pasted printed papers on linen, 62⅝ in. x 6 ft. 10½ in.
(159.2 x 209.6 cm)
Gift of Joachim Aberbach (by exchange)

Andy Warhol (American, 1928–1987)

223. *Campbell's Soup Cans.* 1962
Synthetic polymer paint on thirty-two canvases, each 20 x 16 in.
(50.8 x 40.6 cm)
Gift of Irving Blum; Nelson A. Rockefeller Bequest, gift of Mr. and Mrs.
William A. M. Burden, Abby Aldrich Rockefeller Fund, gift of Nina and
Gordon Bunshaft in honor of Henry Moore, Lillie P. Bliss Bequest, Philip
Johnson Fund, Frances Keech Bequest, gift of Mrs. Bliss Parkinson, and
Florence B. Wesley Bequest (all by exchange)

270. *Gold Marilyn Monroe.* 1962
Synthetic polymer paint, silkscreened, and oil on canvas, 6 ft. 11¼ in. x 57 in.
(211.4 x 144.7 cm)
Gift of Philip Johnson

Todd Webb (American, born 1905)

285. *Sixth Avenue between 43rd and 44th Streets, New York.* 1948
Eight gelatin silver prints, overall 10⅝ x 85¾ in. (27 x 218 cm)
Purchase

Henry Wessel, Jr. (American, born 1942)

241. *Untitled.* 1971
Gelatin silver print, 7⅞ x 11¾ in. (20 x 29.9 cm)
John Spencer Fund

Brett Weston (American, 1911–1993)

98. *View of San Francisco Towards Telegraph Hill.* 1939
Gelatin silver print, 7⁹⁄₁₆ x 9⁹⁄₁₆ in. (19.2 x 24.3 cm)
Gift of Albert M. Bender

Edward Weston (American, 1886–1958)

PLATE 46. *Belle Grove Plantation House, Louisiana.* 1941
Gelatin silver print, 9⅝ x 7½ in. (24.5 x 19 cm)
Gift of David H. McAlpin

47. *Church Door, Hornitos.* 1940
Gelatin silver print, 7⁹⁄₁₆ x 9⁹⁄₁₆ in. (19.3 x 24.3 cm)
Gift of Merle Armitage

96. *Hills and Poles, Solano County.* 1937
Gelatin silver print, 7½ x 9½ in. (19.1 x 24.1 cm)
Anonymous gift

97. *Quaker State Oil, Arizona.* 1941
Gelatin silver print, 7⅝ x 9⅝ in. (19.4 x 24.5 cm)
Gift of Mrs. Armand P. Bartos

100. *Wrecked Car, Crescent Beach.* 1939
Gelatin silver print, 7⁹⁄₁₆ x 9½ in. (19.2 x 24.2 cm)
Anonymous gift

216. *Hot Coffee, Mojave Desert.* 1937
Gelatin silver print, 7½ x 9⁹⁄₁₆ in. (19 x 24.3 cm)
Purchase

Garry Winogrand (American, 1928–1984)

144. *New York City Airport.* c. 1972
Gelatin silver print, 8¾ x 13¹⁄₁₆ in. (21.9 x 33.2 cm)
Purchase

145. *Los Angeles.* 1964
Gelatin silver print, 8¹⁵⁄₁₆ x 13⁷⁄₁₆ in. (22.7 x 34.1 cm)
Purchase and gift of Barbara Schwartz in memory of Eugene M. Schwartz

168. *New Mexico.* 1957
Gelatin silver print, 9 x 13⅛ in. (22.8 x 33.3 cm)
Purchase

233. *Dallas.* 1964
Gelatin silver print, 9 x 13⅜ in. (22.9 x 34 cm)
Gift of the International Program

Marion Post Wolcott (American, 1910–1990)

91. *Winter Tourists.* 1940
Gelatin silver print, 8⅝ x 10⁹⁄₁₆ in. (21.1 x 26.9 cm)
John Parkinson III Fund

93. *Service Station, Used Cars for Sale. Alexandria, Louisiana.* 1940
Gelatin silver print, 7³⁄₁₆ x 9⁹⁄₁₆ in. (18.3 x 24.2 cm)
Purchase

135. *Mr. R. B. Whitley Visiting His General Store.* 1939
Gelatin silver print, printed c. 1978, 7⅞ x 11 in. (20.1 x 28 cm)
Gift of Arthur Rothstein

210. *Movie Advertisement on the Side of a Building, "Birth of a Baby,"
Welch, West Virginia.* 1938
Gelatin silver print, 7 x 8¾ in. (17.8 x 22.3 cm)
Purchase

Brian Wood (Canadian, born 1948)

296. *Elevator.* 1978
Four chromogenic color prints (Ektacolor), overall 13⁵⁄₁₆ x 42 in.
(33.8 x 106.7 cm)
Gift of Lois and Bruce Zenkel

Christopher Wool (American, born 1955)

251. *Untitled.* 1990
Enamel on aluminum, 9 x 6 ft. (274.3 x 182.9 cm)
Gift of the Louis and Bessie Adler Foundation, Inc.

Basic Bibliography

Publications that include more extensive bibliographies are so noted.

By or with Evans

BOOKS AND ARTICLES

Agee, James, and Walker Evans. *Let Us Now Praise Famous Men: Three Tenant Families.* Boston: Houghton Mifflin, 1941. Enlarged ed., with an essay by Evans, "James Agee in 1936," Boston: Houghton Mifflin, 1960. Reprinted Boston: Houghton Mifflin, 1981; and 1988, with an introduction by John Hershey.

Beals, Carleton. *The Crime of Cuba.* Philadelphia: J. B. Lippincott, 1933. With photographs by Evans.

Evans, Walker. "The Reappearance of Photography." *Hound and Horn* 5 no. 1 (October–December 1931): 125–28.

————. *American Photographs.* With an afterword by Lincoln Kirstein. New York: The Museum of Modern Art, 1938. Reprint ed. New York: The Museum of Modern Art, 1988.

————. "'Main Street Looking North from Courthouse Square.' A Portfolio of American Picture Postcards from the Trolley Car Period (ca. 1890–1910)." *Fortune* 37 (May 1948): 77–83.

————. "Robert Frank." In Tom Maloney, ed. *U.S. Camera Annual 1958*: 90. Reprinted in Anne Wilkes Tucker and Philip Brookman, eds. *Robert Frank: New York to Nova Scotia.* Exh. cat. Houston: The Museum of Fine Arts, 1986, p. 20.

————. "When 'Downtown' was a Beautiful Mess." *Fortune* 65 (January 1962): 100–106.

————. "Those Little Screens: A Photographic Essay by Lee Friedlander with a Comment by Walker Evans." *Harper's Bazaar* 96 (February 1963): 126–29.

————. *Many Are Called.* With an introduction by James Agee. Boston: Houghton Mifflin, 1966.

————. *Message from the Interior.* With an afterword by John Szarkowski. New York: Eakins Press, 1966.

————. "Photography." In Louis Kronenberger, ed. *Quality: Its Image in the Arts.* New York: Athenaeum, 1969, pp. 169–211.

INTERVIEWS AND LECTURES

Cummings, Paul. "Walker Evans." In Cummings. *Artists in Their Own Words.* New York: St. Martin's Press, 1979, pp. 82–100.

"Dialogue between Walker Evans, Robert Frank, and Various Students and Faculty Members of the Program in Graphic Design and Photography at Yale University." *Still* (Yale University) no. 3 (1973): 2–6.

Evans, Walker. "'The Thing Itself' Is Such a Secret and So Unapproachable." *Yale Alumni Magazine* 37 (February 1974): 12–16. Reprinted in *Image* 17 no. 4 (December 1974): 12–18.

————. "Walker Evans on Himself." Ed. Lincoln Caplan. *The New Republic* 175 (November 13, 1976): 23–27. Reprinted in *Exposure* 15 no. 1 (February 1977): 15–17.

————. "Walker Evans, Visiting Artist: A Transcript of His Discussion with the Students of the University of Michigan, 1971." In Beaumont Newhall, ed. *Photography: Essays & Images.* New York: The Museum of Modern Art, 1980, pp. 310–20.

Ferris, Bill. "A Visit with Walker Evans." In *Images of the South: Visits with Eudora Welty and Walker Evans.* Southern Folklore Reports no. 1. Memphis, Tenn.: Center for Southern Folklore, 1977, pp. 27–39.

Katz, Leslie. "Interview with Walker Evans." *Art in America* 59 no. 2 (March–April 1971): 82–89. Reprinted in Vicki Goldberg, ed. *Photography in Print: Writings from 1816 to the Present.* New York: Simon and Schuster, 1981, pp. 358–69.

On Evans

Baier, Lesley K. *Walker Evans at Fortune, 1945–1965.* Exh. cat. Wellesley, Mass.: Wellesley College Museum, 1977.

Brix, Michael, and Birgit Mayer, eds. *Walker Evans Amerika: Bilder aus den Jahren der Depression.* With a foreword by Armin Zweite and essays by Brix, Christine Heiss, and Ulrich Keller. Exh. cat. Munich: Städtische Galerie im Lenbachhaus, 1990. Translated into English as Brix and Mayer, eds. *Walker Evans, America.* New York: Rizzoli, 1991; this edition omits one of Brix's two essays and the essays of the other authors.

Greenough, Sarah. *Walker Evans: Subways and Streets*. Exh. cat. Washington, D.C.: National Gallery of Art, 1991. With bibliography.

Hill, John T., and Jerry L. Thompson, eds. *Walker Evans at Work: 745 Photographs together with Documents Selected from Letters, Memoranda, Interviews, Notes*. With an essay by Thompson. New York: Harper & Row, 1982.

Keller, Judith. *Walker Evans: The Getty Museum Collection*. Malibu: The J. Paul Getty Museum, 1995. With bibliography.

————, ed. *History of Photography* 17 no. 2 (Summer 1993): 135–71. A special issue on Evans.

Kingston, Rodger. *Walker Evans in Print: An Illustrated Bibliography*. Belmont, Mass.: self published, 1995.

Maddox, Jerald C., ed. *Walker Evans: Photographs for the Farm Security Administration, 1935–1938*. New York: Da Capo Press, 1973.

Mellow, James R. *Walker Evans*. New York: Basic Books, 1999.

Mora, Gilles. *Walker Evans: Havana 1933*. London: Thames & Hudson, 1989.

Mora, Gilles, and John T. Hill. *Walker Evans: The Hungry Eye*. New York: Harry N. Abrams, 1993. With bibliography.

Nickel, Douglas R. "American Photographs Revisited." *American Art* 6 no. 2 (Spring 1992): 79–97.

Rathbone, Belinda. *Walker Evans: A Biography*. Boston: Houghton Mifflin, 1995.

Rosenheim, Jeff, and Vicente Todoli. *Walker Evans, 1928–1974*. Exh. cat. Valencia: Conselleria de Cultura, Educació i Ciencia de la Generalitat Valenciana, 1983.

Soby, James Thrall. "The Muse Was Not for Hire." *Saturday Review* 45 (September 22, 1962): 57–58.

Stern, James. "Walker Evans (1903–1975): A Memoir." *London Magazine*, August–September 1977, pp. 5–29.

Szarkowski, John. *Walker Evans*. Exh. cat. New York: The Museum of Modern Art, 1971. With bibliography.

Thompson, Jerry L. *The Last Years of Walker Evans*. New York: Thames & Hudson, 1997.

Travis, David. *Walker Evans: Leaving Things as They Are. The Promised Gift of Mr. and Mrs. David C. Ruttenberg*. Exh cat. Chicago: The Art Institute of Chicago, 1987.

Williams, William Carlos. "Sermon with a Camera." *The New Republic* 96 (October 12, 1938): 282–83. A review of *American Photographs*.

On Evans and Others

Chevrier, Jean-François, Allan Sekula, and Benjamin H. D. Buchloh. *Walker Evans and Dan Graham*. Exh. cat. Rotterdam: Witte de With, 1992.

Green, Jonathan. *American Photography: A Critical History, 1945 to the Present*. New York: Harry N. Abrams, 1984.

Johnson, Robert Flynn. *America Observed: Etchings by Edward Hopper, Photographs by Walker Evans*. Exh. cat. San Francisco: The Fine Arts Museums of San Francisco, 1976.

Költzch, Georg-W., and Heinz Liesbrock, eds. *Edward Hopper und die Fotografie: Die Warheit des Sichtbaren*. Exh. cat. Essen: Museum Folkwang, 1992.

Papageorge, Tod. *Walker Evans and Robert Frank: An Essay on Influence*. Exh. cat. New Haven: Yale University Art Gallery, 1981.

Rosenheim, Jeff. *Walker Evans and Jane Ninas in New Orleans, 1935–36*. Exh. cat. New Orleans: The Historic New Orleans Collection, 1991.

Southall, Thomas W. *Of Time and Place: Walker Evans and William Christenberry*. Untitled no. 51. Exh. cat. San Francisco: The Friends of Photography, and Fort Worth: Amon Carter Museum, in association with the University of New Mexico Press, Albuquerque, 1990.

Storey, Isabelle. *The Presence of Walker Evans*. With essays by Storey and Alan Trachtenberg. Exh. cat. Boston: Institute of Contemporary Art, 1978.

Stott, William. "Walker Evans, Robert Frank, and the Landscape of Dissociation." *Arts Canada* nos. 192–95 (December 1974): 83–89.

Trilling, Lionel. "Greatness with One Fault in It." *Kenyon Review* 4 (Winter 1942): 99–102. A review of *Let Us Now Praise Famous Men*.

Ward, J. A. *American Silences: The Realism of James Agee, Walker Evans, and Edward Hopper*. Baton Rouge: Louisiana State University Press, 1985.

Photograph Credits

In general, copyright for the works reproduced in this book is held by the artist or his or her heirs; thus the works may not be reproduced in any form without the permission of the copyright holders. The following credits appear at the request of the artist or the artist's representative. Unless otherwise noted, references are to plate numbers.

© Aperture Foundation, Inc., Paul Strand Archive: fig. 2; plates 48, 49, 119, 120, 190.

© Artists Rights Society (ARS), New York: 223, 270, 295.

© 2000 Artists Rights Society (ARS), New York/ADAGP, Paris: 187, 226.

© 2000 Artists Rights Society (ARS), New York/VG Bild-Kunst, Bonn: 115, 116, 184, 301.

Courtesy Walt Burton, Cincinnati: 8.

© 1981 Center for Creative Photography, Arizona Board of Regents: 46, 47, 96, 97, 100, 216.

© Commerce Graphics: 54, 63, 206.

© Estate of Stuart Davis/Licensed by VAGA, New York, N.Y.: 189.

© Rackstraw Downes/Licensed by VAGA, New York, N.Y./Marlborough Gallery, N.Y.: 178.

© Walker Evans Archive, The Metropolitan Museum of Art: front cover, frontispiece, figs. 5, 6, 8; plates 34, 42, 45, 84, 85, 87, 89, 122–26, 129–31, 154–56, 157, 159, 191, 193, 197, 199, 202–4, 258–61, 274, 275, 280, 303–13.

© The Museum of Modern Art, New York. Photographs by Tom Griesel: 79, 293, 297. Photographs by Kate Keller: 29, 101, 116, 178, 185, 187, 226, 229, 252, 253, 267, 302. Photograph by Kate Keller and John Wronn: 223. Photographs by Mali Olatunji: 107, 115, 270. Photograph by Rolf Petersen: 231. Photograph by Soichi Sunami: 118. Photograph by Malcolm Varon: 106. Photographs by John Wronn: 166, 189.

© 2000 Estate of Pablo Picasso/Artists Rights Society (ARS), New York: 185.

© James Rosenquist/Licensed by VAGA, New York, N.Y.: 229.

© Peter Sekaer Estate: page 10.

© State Historical Society of Wisconsin: 113.

© Untitled Press, Inc./Licensed by VAGA, New York, N.Y.: 101, 231, back cover.

© The Brett Weston Archive: 98.

In general, all of the photographic works in this publication are reproduced from direct digital scans made by Kimberly Pancoast and Kelly Benjamin, with the exception of the following.

Courtesy Matthew Marks Gallery, New York: 301.

Courtesy Pace MacGill Gallery, New York: 324.

© The Museum of Modern Art, New York. Photographs by David Allison: figs. 9, 10; plates 6, 31–33, 56, 59, 61, 62, 68, 69, 99, 104, 113, 114, 117, 135, 138, 141, 146, 149, 150, 152, 153, 171, 172, 174, 176, 177, 180, 181, 217, 218, 221, 234, 236, 239, 244–46, 248, 250, 262, 266, 285, 289, 292, 295, 296, 300, 317, 321–23.